Nikon D7000:
From
Snapshots to
Great Shots

John Batdorff

**Peachpit
Press**

Nikon D7000: From Snapshots to Great Shots
John Batdorff

Peachpit Press
1249 Eighth Street
Berkeley, CA 94710
510/524-2178
510/524-2221 (fax)

Find us on the Web at www.peachpit.com
To report errors, please send a note to errata@peachpit.com
Peachpit Press is a division of Pearson Education

Editor: Susan Rimerman
Developmental/Copy Editor: Peggy Nauts
Proofreader: Bethany Stough
Production Editor: Rebecca Winter
Composition: WolfsonDesign
Indexer: James Minkin
Cover Design: Aren Straiger
Cover Image: John Batdorff
Interior Design: Riezebos Holzbaur Design Group

ISBN-13 978-0-321-76654-0
ISBN-10 0-321-76654-7

9 8 7 6 5 4 3 2 1
Printed and bound in the United States of America

ACKNOWLEDGMENTS

To my muse and daughter, Anna—thanks for providing balance and perspective to my life. I love you always, and remember, the first boyfriend who wants to take you to the movies is buying three tickets! To my partner, Staci, for encouraging me and supporting my every effort—none of this would have been possible without you. My mother for putting my very first camera in my hand—I truly wish you were still alive to see my work and collaborate with me on this project. My dad for giving me the passion for writing and drive to succeed. I love you and respect all that you have done for me. To the Peachpit crew—you folks have been incredibly professional and a joy to work with. Specifically, Susan Rimerman for holding my hand through the process and helping me hang on to what little hair I have left. Peggy Nauts for cleaning up my copy and making me look so darn smart. I would love to add you to my harem but you would tell me that's politically incorrect. A very special thanks to all blog followers who have supported me along the way. This book would never have happened without you. Most importantly, to you, the reader of this book—I hope you enjoy it. My blog door is always open for questions.

Contents

Introduction

Walk into any bookseller, go to the photography section, and you will see countless tomes on the subject of photography. Look a little further and you will locate the camera-specific ones. It is this unfilled divide between the camera-specific and the instructional photography books that inspired me to write this book. What I was seeing in the store was a lot of books that were tackling one area or the other, but not both. So, with that in mind, I set about to write this book on the Nikon D7000, not as a rehash of the owner's manual but as a resource to teach photographic concepts using the wonderful technology present in the D7000, with instructional photos and insights from my own work as a professional photographer. I have put together a short Q&A to help you get a better understanding of just what it is that you can expect from this book.

Q: IS EVERY CAMERA FEATURE GOING TO BE COVERED?

A: Nope, just the ones I think you need to know about in order to start taking great photos. Believe it or not, you already own a great resource that covers every feature of your camera: the owner's manual. (I know, we all hate reading manuals—we want to grab our new camera and start shooting. But if you look at your manual more closely you'll realize it can actually help you.) Writing a book that just rephrases this information would have been a waste of your time and money. What I did want to write about was how to harness certain camera features to benefit your photography. As you read through this book, you will also see references to specific pages in your owner's manual that are related to the topic being discussed. For example, in Chapter 6 the AE-L button is discussed, but there is more information available on this feature in the manual. I cover the function that applies to our specific needs and give you the page numbers in the manual to explore this function further.

Q: SO IF I ALREADY OWN THE MANUAL, WHY DO I NEED THIS BOOK?

A: The manual does a pretty good job of telling you how to use a feature or turn it on in the menus, but it doesn't necessarily tell you why and when you should use it. If you really want to improve your photography, you need to know the whys and the whens to put all of those great camera features to use at the right time. To that extent, the manual just isn't going to cut it. It is, however, a great resource on the camera's features, and for that reason I treat it like a companion to this book. You already own it, so why not get something of value from it?

Q: WHAT CAN I EXPECT TO LEARN FROM THIS BOOK?

A: My hope is that you will learn how to take great photographs. My goal, and the reason the book is laid out the way it is, is to guide you through the basics of photography as they relate to different situations and scenarios. By using the features of your D7000 and this book, you will learn about aperture, shutter speed, ISO, lens selection, depth of field, and many other photographic concepts. You will also find plenty of large full-page photos that include shooting data and comments from me so you can see how all of the photography fundamentals come together to make great images. Meanwhile, you will be learning how your camera works and how to apply its functions and features to your photography.

Q: DO I REALLY NEED TO DO THE ASSIGNMENTS?

A: In the shooting assignments at the end of the chapters, I give you some suggestions on how you can apply the lessons of the chapter to help reinforce everything you just learned. Can I make you do them? No, but let's face it—using the camera is much more fun than reading about it, so the assignments are a way of taking a little break after each chapter, having some fun, and trying out your new chops.

Q: SHOULD I READ THE BOOK STRAIGHT THROUGH OR CAN I SKIP AROUND FROM CHAPTER TO CHAPTER?

A: Here's the easy answer: yes and no. No, because the first four chapters give you the basic information that you need to know about your camera. These are the building blocks of using the D7000. After that, yes, you can move around the book as you see fit, because the following chapters are written to stand on their own as guides to specific types of photography or shooting situations. So you can bounce from portraits to landscapes and then maybe to a little action photography. It's all about your needs and how you want to address them. Or, you can read the book straight through. The choice is up to you.

Q: IS THAT IT?

A: One last thought before you dive into the first chapter. My goal in writing this book has been to give you a resource that will help you create great photographs with your Nikon D7000. Learning the basics is vital, but playing with them is what makes the photographer. Photography, like most things, takes time to master and requires practice. It has been a part of my life since my first Kodak 110 when I was seven years old, and I am still learning. Always remember, it's not the camera but the person using it who makes beautiful photographs. Have fun, make mistakes, and then learn from them. In no time, I'm sure you will transition from someone who takes nice snapshots to a photographer who makes great shots.

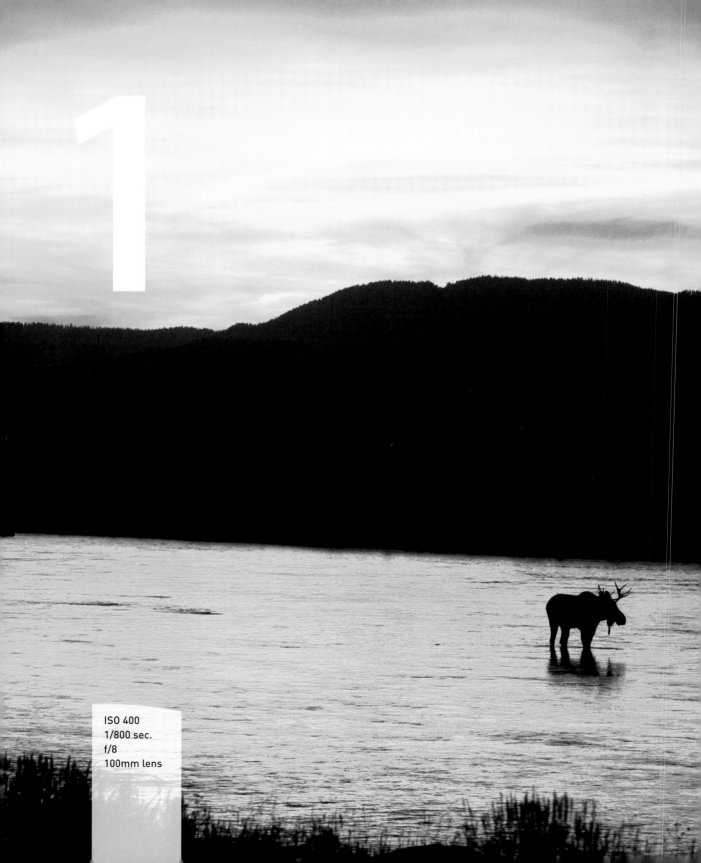

1

ISO 400
1/800 sec.
f/8
100mm lens

The D7000 Top Ten List

TEN TIPS TO MAKE YOUR SHOOTING MORE PRODUCTIVE RIGHT OUT OF THE BOX

Whenever I get a new camera the first thing I do is grab the battery and the memory card and start shooting. What I should be doing is taking the extra time and reading the manual, but that's not much fun. Instead, I thought, why not make a chapter for people like me who can't wait to start taking images but don't want to feel guilty about not setting up their camera first? Here are ten things you can do right now that are going to make your experience with your shiny new D7000 a ton better, from turning on the audible chirp for focusing to getting a feel for ISO settings, white balance settings, image review, focus settings, and several other custom functions that will help you right now. That doesn't mean I want you to skip over the other nine chapters, because they're filled with some really good tips, but this is a great starting point.

The D7000 is different from previous models in that many of the controls we use every day are available with a few clicks of a button. You no longer have to drill through two or three menus to make simple adjustments. But don't worry, for those of you who love menus, they're still there. I'll briefly discuss how to adjust settings using the buttons and then discuss some of the custom menu options for those of you looking to tweak your camera a bit.

CAMERA FRONT

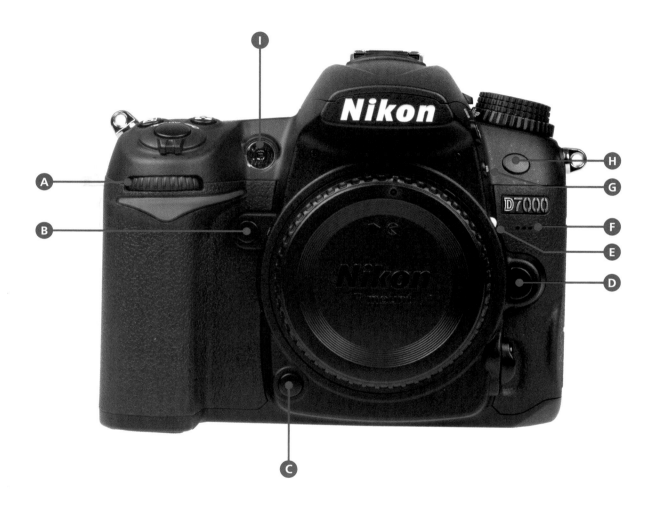

A Sub-command dial
B Function button
C Depth of field preview button
D Lens release button
E Lens mounting mark

F Microphone
G Bracketing button
H Infrared receiver
I AF-assist illuminator

CAMERA BACK

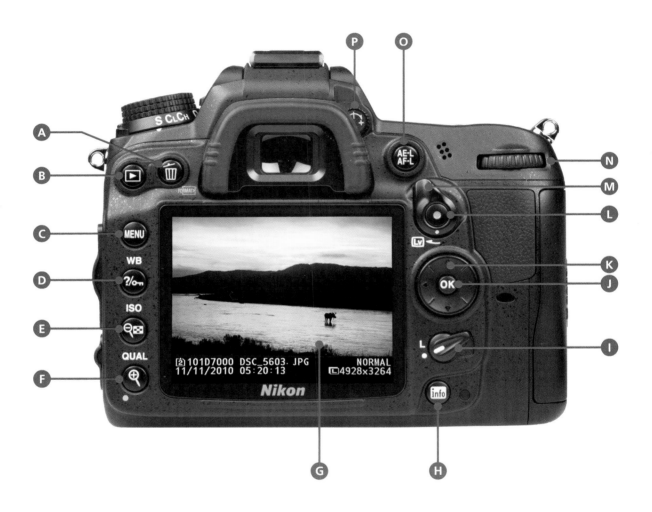

A Delete button
B Playback button
C Menu button
D White balance/help/protect button
E Thumbnail/playback/zoom-out button
F Qual/zoom-in button
G Monitor/LCD screen
H (info) button

I Focus selector lock
J (OK) button
K Multi selector dial
L Movie record button
M Live view switch
N Main command dial
O AutoExposure/AutoFocus Lock button
P Diopter adjustment control

CAMERA TOP

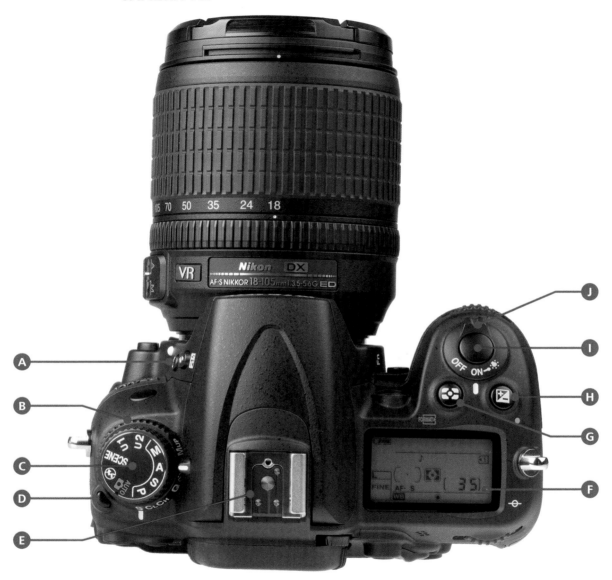

A Flash mode button
B Release mode dial
C Mode dial
D Release mode dial lock release
E Flash hot shoe
F Control panel
G Metering button
H Exposure compensation button
I Shutter release button
J Power switch

1. SET THE CORRECT WHITE BALANCE

Color balance correction is the process of rendering accurate colors in your final image. Most people don't even notice that light has different color characteristics because the human eye automatically adjusts to different color temperatures—so quickly, in fact, that everything looks correct in a matter of milliseconds.

When color film ruled the world, photographers would select which film to use depending on what their light source was going to be. The most common film was balanced for daylight, but you could also buy film that was color balanced for tungsten light sources. Most other lighting situations had to be handled by using color filters over the lens. This process was necessary for the photographer's final image to show the correct color balance of a scene.

Luckily, you don't need to have a deep understanding of color temperatures to control your camera's white balance (**Figures 1.1** and **1.2**). The choices are given to you in terms that are easy to relate to and that will make things pretty simple.

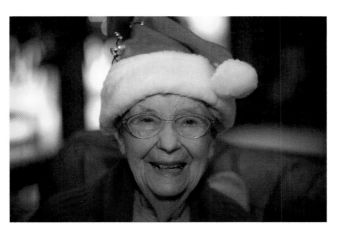

FIGURE 1.1
This image is the result of making a mistake and picking the wrong white balance.

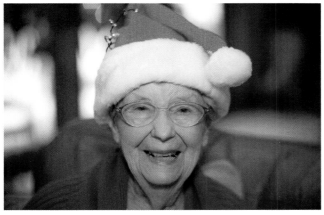

FIGURE 1.2
Here we have the correct white balance.

Your white balance choices are:

- **Auto:** The default setting for your camera. It is also the setting used by all of the automatic scene modes (see Chapter 3).

- **Daylight:** Most often used for general daylight/sunlit shooting.

- **Shade:** Used when working in shaded areas where sunlight is the dominant light source.

- **Cloudy:** The choice for overcast or very cloudy days. This and the Shade setting will eliminate the blue colorcast from your images.

- **Tungsten:** Appropriate for any occasion when you are using regular household-type bulbs for your light source. Tungsten is a very warm light source and will result in a yellow/orange cast if you don't correct for it.

- **Fluorescent:** Gets rid of the green-blue cast that can result from using regular fluorescent lights as your dominant light source. Some fluorescent lights are actually balanced for daylight, which would allow you to use the Daylight white balance setting.

- **Flash:** Used whenever you're employing the built-in flash or a flash on the hot shoe. You should select this white balance to adjust for the slightly cooler light that comes from using a flash. (The hot shoe is the small bracket located on the top of your camera, which rests just above the eyepiece. This bracket is used for attaching a more powerful flash to the camera—see Chapter 8 and the bonus chapter.)

- **Pre:** Indicates that you are using a customized white balance that is adjusted for a particular light source. This option can be adjusted using an existing photo you have taken or by taking a picture of something white or gray in the scene.

Your camera has two different "zones" of shooting modes to choose from. These are located on the Mode dial, which separates your choices into automatic scene modes and what I refer to as the professional modes. None of the automatic modes, which are chosen by turning the Mode dial to Scene and then rotating the Command dial to choose a particular mode, allow for much customization, including white balance. The professional modes, defined by the letter symbols M, A, S, P, U1, and U2, allow for much more control by the photographer (**Figure 1.3**).

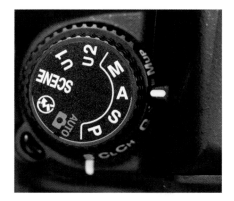

FIGURE 1.3
The camera's shooting modes are divided into the automatic scene modes and the professional modes (M, A, S, P, U1, and U2).

1. After turning on or waking the camera, select one of the professional shooting modes such as P (you can't select white balance when using any of the automatic modes).

2. Press and hold the WB button (**A**) on the back of the camera to activate White Balance, visible on the control panel or rear LCD.

3. While pressing the WB button, use your thumb to rotate the Command dial to the appropriate White Balance setting, and release it to make your selection (**B**).

A

B

2. TURN OFF THE AUTO ISO SETTING

The ISO setting in your camera allows you to choose the level of sensitivity of the camera sensor to light. The ability to change this sensitivity is one of the biggest advantages to using a digital camera. In the days of film cameras, you had to choose the ISO by film type. This meant that if you wanted to shoot in lower light, you had to replace the film in the camera with one that had a higher ISO. So not only did you have to carry different types of film, but you also had to remove one roll from the camera to replace it with another, even if you hadn't used up the current roll. Now all you have to do is go to your information screen and select the appropriate ISO.

Having this flexibility is powerful, but just as with the quality setting, the ISO setting has a direct bearing on the quality of the final image. The higher the ISO, the more digital noise the image will contain. Since our goal is to produce high-quality photographs, it is important to get control over all of the camera settings and bend them to our will. When you turn your camera on for the first time, the ISO will be set to Auto. This means that the camera is determining how much light is available and will choose what it believes is the correct ISO setting. Since you want to use the lowest ISO possible, you will need to turn this setting off and manually select the appropriate ISO.

Which ISO you choose depends on your level of available or ambient light. For sunny days or very bright scenes, use a low ISO such as 100. As the level of light is reduced, raise the ISO level. Cloudy days or indoor scenes might require you to use ISO 400 (**Figure 1.4**). Low-light scenes, such as when you are shooting at night, will mean you need to bump up that ISO to as high as 1600. The thing to remember is to shoot with the lowest setting possible for maximum quality.

FIGURE 1.4
View the control panel to see the selected ISO.

SETTING THE ISO

Press and hold the ISO button on the back of the camera while rotating the Command dial to select ISO Sensitivity based on available light, and release the button when you have made your selection.

You should know that the Auto ISO option is enabled as a default only when using one of the automatic scene modes. When using one of the professional modes (M, A, S, and P; we'll discuss these in Chapter 4), the Auto ISO feature will be automatically turned off. If you wish to use Auto ISO in one of these modes, you must activate it and set the auto parameters in the shooting menu. If you plan on shooting with the Auto mode, you cannot turn off the Auto ISO option at all.

NOISE

Noise is the enemy of digital photography, but it has nothing to do with the loudness of your camera operation. It is a term that refers to the electronic artifacts that appear as speckles in your image. Back in the days of film we would have simply called the image "grainy." Digital noise appears in darker shadow areas and is a result of the camera trying to amplify the signal to produce visible information. The more the image needs to be amplified—by raising the sensitivity through higher ISO—the greater the amount of noise there will be. To avoid digital noise, try to use a low ISO whenever possible.

3. SET YOUR IMAGE QUALITY

Your new D7000 has a number of image quality settings to choose from, and depending on your needs, you can adjust them accordingly.

This is probably one of the most important setting adjustments you can make. Most professional photographers shoot using RAW file format because it gives them the greatest control over their images. Now, if RAW is a completely new term for you and you have no experience in post-processing applications like Adobe's Lightroom or Apple's Aperture, then I recommend holding off on selecting this setting for now.

If you're familiar with RAW, then I highly suggest you select that option now.

For non-RAW shooters we will be focusing in on the JPEG option. JPEG is a format that has been around since 1994 and is widely accepted. Most of your photos that are e-mailed or uploaded to social network sites like Facebook are JPEG images. Moreover, most printing services such as Walgreens, Kodak, Shutterfly, and Mpix use JPEG.

The JPEG file format compresses your image before final storage on your memory card, meaning the camera, not you, is applying all of the image processing first. Image processing involves such factors as sharpening, color adjustment, contrast adjustment, noise reduction, and so on. Many photographers prefer to use the RAW file format to get greater control over the image processing. We will take a closer look at this in Chapter 2, but for now let's just make sure that we are using the best-quality JPEG possible.

The D7000 has nine settings for the JPEG format. There are three settings each for Large, Medium, and Small image sizes. These settings (Basic, Normal, and Fine) represent image compression. The Large, Medium, and Small settings determine the actual physical size of your image in pixels. Let's work with the highest-quality setting possible.

SETTING THE IMAGE QUALITY

1. Press and hold the Qual button on the bottom left of the camera while rotating the main Command dial to select the Fine image quality setting. You can view the changes on the LCD screen on the back or the control panel on the top right of the camera (**A**).

2. Then, while still holding down the Qual button on the left, rotate the Sub-command dial with your right finger to choose the file setting Large, which selects the largest image size available.

3. Release the Qual button when you have made your selection (**B**).

4. If you've set up your camera properly it should read L Fine in the control panel (the LCD on the top of the camera).

A

B

As you will see when scrolling through the quality settings, the higher the quality, the fewer pictures you will be able to fit on your card. If you have an 8 GB memory card, the quality setting we have selected will allow you to shoot about 813 photographs before you fill up your card. I always try to choose quality over quantity.

Manual Callout

For a complete chart that shows the image quality settings with the number of possible shots for each setting, turn to page 320 in your user manual.

4. SET YOUR FOCUS POINT AND MODE

The Nikon focusing system is well known for its speed and accuracy. The automatic focus modes will give you a ton of flexibility in your shooting. There is, however, one small problem inherent with any focusing system. No matter how intelligent it is, the camera is looking at all of the subjects in the scene and noting which is closest to the camera. It then uses this information to determine where the proper focus point should be. It has no way of knowing what your main emphasis is, so it is using a "best guess" system. To eliminate this factor, you should set the camera to single-point focusing so that you can ensure that you are focusing on the most important feature in the scene.

The camera has 39 separate focus points to choose from. They are arranged in a grid, but I always like to start by selecting the focus point in the center. Once you have become more familiar with the focus system, you can experiment with the other points, as well as the automatic point selection.

You should also change the focus mode to AF-S so that you can focus on your subject and then recompose your shot while holding that point of focus.

SETTING THE FOCUS POINT AND FOCUS MODE

1. To choose a single point of focus, wake the camera (if necessary) by lightly pressing the shutter release button.
2. Press and hold the AF-mode button on the front of the camera near the lens, using your left thumb. Now rotate the Command dial to select AF-S (Single-servo AF) mode. This mode is used for photographing stationary objects but can be used in some motion shots as well.

The camera is now ready for single focusing. You will know if your subject is in focus by pressing the shutter button halfway while watching for the in-focus indicator to appear in the viewfinder. (Please review page 38 of your manual for a visual.) To focus on your subject and then recompose your shot, just place the focus point in the viewfinder on your subject, depress the shutter release button halfway until the in-focus indicator appears, and without letting up on the shutter button, recompose your shot and then press the shutter button all the way down to make your exposure (**Figure 1.5**).

FIGURE 1.5
Using the center
single focus point
in AF-S mode
allows you to focus
on your subject in
the center, then
recompose your
photograph.

5. MANUAL FOCUS

As good as the Nikon autofocus system is, there are times when it just isn't doing
the job for you. Often this has to do with how you would like to compose a scene
and where the actual point of focus should be. This can be especially true when you
are using the camera on a tripod, where you can't prefocus and then recompose
before shooting (as discussed earlier). To take care of this problem, you will need
to manually focus the lens. I am only going to cover the kit lens that came with my
D7000 (the 18–105mm VR), so if you have purchased a different lens be sure to check
the accompanying instruction manual for the lens.

On the 18-105mm kit lens, you simply need to slide the switch located at the base of
the lens (located on the lens barrel near the body of the camera) from the A setting
to the M setting (**Figure 1.6**). You can now turn the focus ring at the end of the lens
to set your focus. Now that you're in manual focus mode, the camera will not give
you any notification when you have correctly focused.

We'll cover more manual focus situations in greater detail in future chapters.

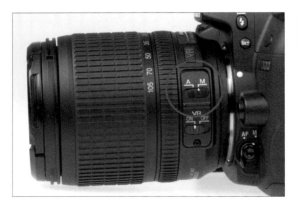

FIGURE 1.6
Slide the focus switch on the lens to
the M position to manually focus.

6. REVIEW YOUR SHOTS

One of the greatest features of a digital camera is its ability to give us instant feedback. By reviewing your images on the camera's LCD screen, you can instantly tell if you got your shot. This visual feedback allows you to make adjustments on the fly.

When you first press the shutter release button, your camera quickly processes your shot and then displays the image on the LCD. The default setting for that display is four seconds. Four seconds works for me, but if you want to increase the amount of time you have to view a shot, such as up to 10 seconds, you can do that.

1. Menu

2. C Timers/AE Lock

3. C4 Monitor Off Delay

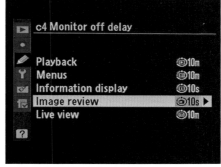

4. Image Review (select your preferred review time)

There are two default display modes that give you different amounts of information while reviewing your photos. The default view (**Figure 1.7**) simply displays your image along with the image filename, date, time, and image quality setting.

To get more visual feedback, press the Multi-selector up to display the second display view called Overview Data (**Figure 1.8**). This view mode not only displays the same information as the default view, but also includes camera settings such as aperture, shutter speed, lens length, white balance, exposure compensation, shooting mode, ISO, white balance setting, picture style, quality setting, any compensation settings, the active color space, picture control, and the D-Lighting setting. The other noticeable item will be the histogram, which gives you important feedback on the luminance values in your image.

FIGURE 1.7
This is the standard view when reviewing images on your camera's monitor.

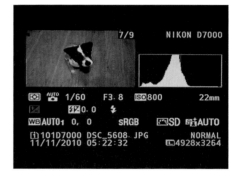

FIGURE 1.8
This display mode gives you much more information.

You probably won't want to use this display option as your default review setting because the image thumbnail is so small, but if you are trying to figure out what settings you used or if you want to review the histogram (see "The Value of the Histogram" sidebar), you now have all of this great information available.

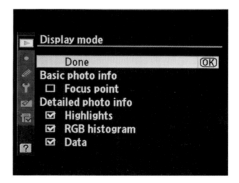

FIGURE 1.9
The Display mode options: Here's where you need to choose the image information you want displayed when reviewing an image during playback.

There are other display options that must be turned on using the camera menu. These can be found in the Playback menu under the Display mode option (**Figure 1.9**). With this menu option you can add display modes such as Highlights, RGB histograms

(**Figure 1.10**), and additional camera data (**Figure 1.11**). I personally don't use the RGB histogram and Data settings because they don't offer me any visual information that I find critical during a photo session. I do, however, always have the Highlights option turned on so that I can make sure I'm not clipping any information from my image highlights.

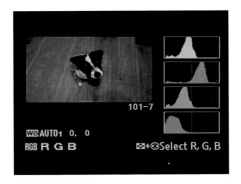

FIGURE 1.10
The RGB histogram display mode: If you're interested in monitoring the histogram of your images' color channels, select this option.

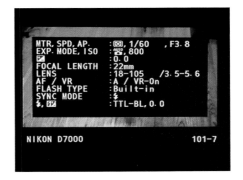

FIGURE 1.11
The Data display mode: Select this option if you wish to display focal length, exposure, lens info, and more.

DELETING IMAGES

Deleting or erasing images is a fairly simple process that is covered on page 47 of your manual. To quickly get on your way, simply press the Image Playback button and use the Multi-selector to find the picture that you want to delete. Then press the Trash button located on the back of the camera to the left of the eyepiece. When you see the confirmation screen, simply press the Trash button once again to complete the process.

Caution: Once you have deleted an image, it is gone for good. Make sure you don't want it before you drop it in the trash.

THE VALUE OF THE HISTOGRAM

Simply put, histograms are two-dimensional representations of your images in graph form. There are two histograms that you should be concerned with: the luminance and the color histograms. Luminance is referred to in your manual as "brightness" and is most valuable when evaluating your exposures. In **Figure 1.12**, you see what looks like a mountain range. The graph represents the entire tonal range that your camera can capture, from the whitest whites to the blackest blacks. The left side represents black, and all the way to the right side represents white. The peaks represent the number of pixels that contain those luminance levels (a tall peak in the middle means your image contains a large amount of medium-bright pixels).

Looking at this figure, it is hard to determine where all of the ranges of light and dark areas are and how much of each I have. If I look at the histogram, I can see that the largest peak of the graph is in the middle and trails off as it reaches the edges. In most cases, you would look for this type of histogram, indicating that you captured the entire range of tones, from dark to light, in your image. Knowing that is fine, but here is where the information really gets useful.

A histogram that has a spike or peak riding up the far left or right side of the graph means that you are clipping detail from your image. In essence, you are trying to record values that are either too dark or too light for your sensor to accurately record. This is usually an indication of over- or underexposure. It also means that you need to correct your exposure so that the important details will not record as solid black or white pixels (which is what happens when clipping occurs).

There are times, however, when some clipping is acceptable. If you are photographing a scene where the sun will be in the frame, you can expect to get some clipping because the sun is just too bright to hold any detail. Likewise, if you are shooting something that has true blacks in it—think coal in a mine shaft at

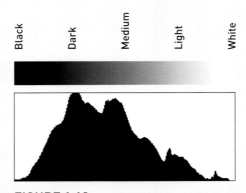

FIGURE 1.12
This is a typical histogram, where the dark to light tones run from left to right. The black to white gradient above the graph demonstrates where the tones lie on the graph and would not appear above your camera histogram display.

midnight—there are most certainly going to be some true blacks with no detail in your shot. The main goal is to ensure that you aren't clipping any "important" visual information, and that is achieved by keeping an eye on your histogram.

Take a look at **Figure 1.13**. The histogram displayed in the image shows a heavy skew toward the left with almost no part of the mountain touching the right side. This is a good example of what an underexposed image histogram looks like. Now look at **Figure 1.14** and compare the histogram for the image that was correctly exposed. Notice that even though there are distinct peaks on the graph, there is a fairly even distribution across the entire histogram.

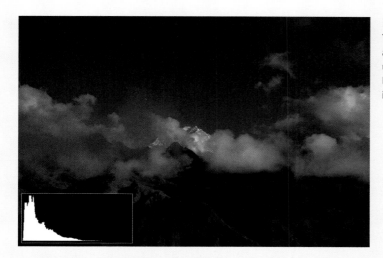

FIGURE 1.13
This image is about two stops underexposed. Notice the histogram is skewed to the left.

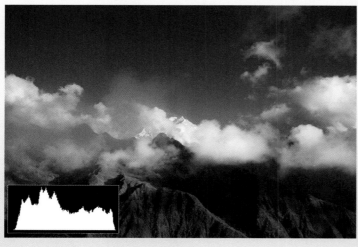

FIGURE 1.14
This histogram reflects a correctly exposed image.

7. WHERE'S THE BEEP? CUSTOM FOCUSING OPTIONS

The D7000 is known for being ultra quiet. When I received my camera from the factory, I noticed there was no beep when I focused in on an image. The camera had shipped to me with the focus confirmation beep turned off. Some of you will like having this feature off and some of you, like me, enjoy hearing that little confirmation beep telling us that the lens is in focus. Often I'm moving very quickly, and just hearing a beep that says everything is in focus is reassuring. Here's how you can turn the beep back on and select a volume.

1. Menu
2. Custom Setting Menu
3. D Shooting/Display
4. D1 Beep
 - Select Volume and Pitch
 - Click OK

Focus Point Wrap—Turn this feature on and you'll save your thumb from doing a lot of clicking when working from opposite ends of the AF points.

1. Menu
2. Custom Setting Menu
3. A Autofocus
4. A5 Focus Point Wrap Around
 - Select On

AF-Assist Illuminator—The D7000 is equipped with an autofocus illuminator. Basically, a light comes on when the camera is trying to focus in the dark. It's similar to a red-eye light but serves a totally different purpose. I am not a fan of this function, but you may like it. I don't recommend it for low-light portraits because the flashing light bothers some people's eyes. If you want to turn this function off, either all the time or only for low-light portraits, here is how you do that.

1. Menu
2. Custom Setting Menu
3. A Autofocus
4. A7 Built in AF-Assist Illuminator
 - Select Off
 - Press OK

8. CUSTOM DISPLAY OPTIONS

Viewfinder Grid—I love a viewfinder grid. I think it's super handy when composing images and lining things up. Those of you familiar with the rule of thirds will recognize this grid.

1. Menu
2. Custom Setting Menu
3. D Shooting/Display
4. D2 Viewfinder Grid Display
 - Select On
 - Press OK

ISO Display—If you want to view what your current ISO is instead of how many images you have left to shoot until your card is full, then you'll want to turn this feature on. When I'm shooting I worry more about my ISO setting than about how many more pictures I can take, so I prefer to turn this feature on.

1. Menu
2. Custom Setting Menu
3. D Shooting Display
4. D3 ISO Display and Adjustment
 - Show ISO Sensitivity
 - Press OK

9. SHUTTER DELAY OPTIONS

Exposure Delay mode—This is a landscape photographer's dream. It's a great feature to activate if you don't have a remote or cable release for your camera. We all know that movement is bad when taking long exposures. This feature delays the shutter for one second after the shutter release button has been pressed. But what makes it even cooler is that it only works when your camera is in Mirror Lock-up. I love this feature because otherwise I would need to use a self-timer, but the problem with a self-timer is that it's designed around getting people in front of the camera, so the shortest delay is still longer than I need when taking landscape shots. Exposure Delay is better than using the timer because there isn't such a long delay, but it achieves the same function as a cable release.

Exposure Delay mode *(continued)*	**Self-Timer Mode**
1. Menu	1. Menu
2. Custom Setting menu	2. Custom Setting Menu
3. D Shooting/Display	3. C Timers/AE Lock
4. D11 Exposure Delay Mode	4. C3 Self-Timer
• Select On	• Self-Timer Delay (select from 2 to 20 seconds)

10. HOLD YOUR CAMERA FOR PROPER SHOOTING

It's worth taking a few seconds to think about how you hold your camera. dSLR cameras are made to favor the right-handed individual. Grasp the camera body with the right hand. Most of the important camera controls are within easy reach. Create a stable base for your camera to rest on by placing the camera body on the up-facing palm of your left hand (**Figure 1.15**). Now you can curl your fingers around the lens barrel. By using the underhand grip, your elbows are close to your body. Pull them in to stabilize your shooting position. Also try to maintain proper upright posture. Leaning forward at the waist will begin to fatigue your back, neck, and arms. Finally, place your left foot in front of your right foot, and face your subject in a wide stance.

FIGURE 1.15
Here's the proper way to hold your camera to ensure sharp, blur-free images.

Chapter 1 Assignments

Let's begin our shooting assignments by setting up and using all of the elements of the Top Ten list. Even though I have yet to cover the professional shooting modes, you should set your camera to the P (Program) mode. This will allow you to interact with the various settings and menus that have been covered thus far.

Basic camera setup

Charge your battery to 100 percent to get it started on a life of dependable service. Next, using your newfound knowledge, set up your camera to address the following: Image Quality and Auto ISO.

Selecting the proper white balance

Take your camera outside into a daylight environment and then photograph the same scene using different white balance settings. Pay close attention to how each setting affects the overall color-cast of your images. Next, try moving inside and repeat the exercise while shooting in a tungsten lighting environment. Finally, find a fluorescent light source and repeat one more time.

Focusing with single point and AF-S

Change your camera setting so that you are focusing using the single-point focus mode. Try using all of the different focus points to see how they work in focusing your scene. Then set your focus mode to AF-S and practice focusing on a subject and then recomposing before actually taking the picture. Try doing this with subjects at varying distances. Remember to turn Focus Wrap Around on.

Evaluating your pictures with the monitor

Set up your image display properties and then review some of your previous assignment images using the different display modes. Review your shooting information for each image and take a look at the histograms to see how the content of your photo affects the shape of the histograms.

Discovering the manual focus mode

Change your focus mode from auto to manual and practice a little manual focus photography. Get familiar with where the focus ring is and how to use it to achieve sharp images.

Get a grip: proper camera holding

This final assignment is something that you should practice every time you shoot: proper grip and stance for shooting with your camera. Use the described technique and then shoot a series of images. Then try shooting some with improper technique to compare the stability of the grip and stance.

Share your results with the book's Flickr group!

Join the group here: flickr.com/groups/nikond7000_fromsnapshotstogreatshots

2

ISO 200
1/125 sec.
f/1.4
85mm lens

First Things First

A FEW THINGS TO KNOW AND DO BEFORE YOU BEGIN TAKING PICTURES

Now that we've covered the top ten tasks to get you up and shooting, we should probably take care of some other important details. You must become familiar with certain features of your camera before you can take full advantage of it. Additionally, we will take some steps to prepare the camera and memory card for use. So to get things moving, let's start off with something that you will definitely need before you can take a single picture: a memory card.

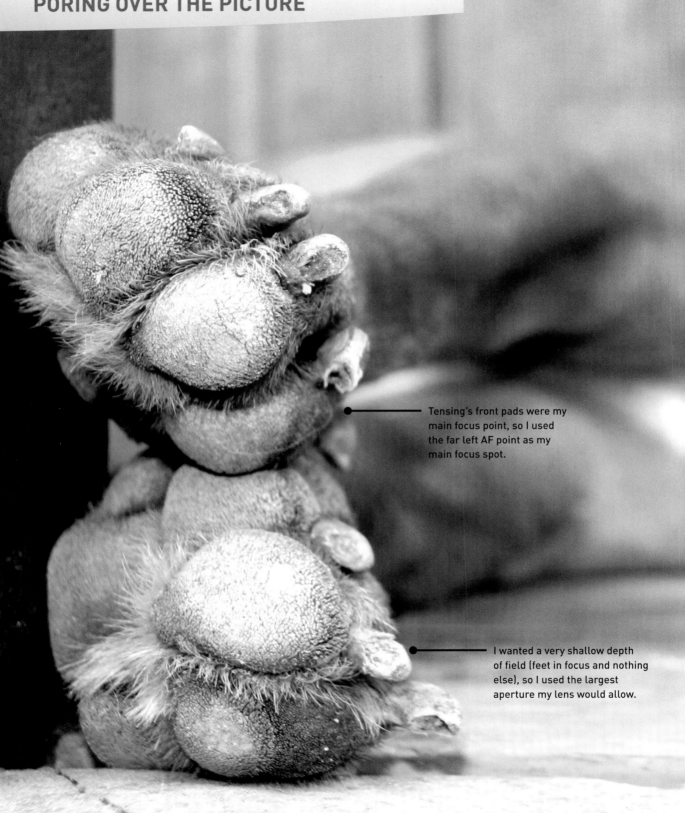

Tensing's front pads were my main focus point, so I used the far left AF point as my main focus spot.

I wanted a very shallow depth of field (feet in focus and nothing else), so I used the largest aperture my lens would allow.

I wanted the feet to look very far away from the body, and I was able to achieve this by using a wide-angle lens.

If you have a pet, chances are your hard drive is littered with hundreds of images just like this. This image of Tensing was photographed in Jamaica a few years back while he was chilling on his owner's porch. I don't know about you, but having a dog's life at times seems very appealing. I know my three dogs are proof of that. This dog's feet were perfectly placed at eye level, so it allowed me to capture an interesting perspective.

ISO 400
1/100 sec.
f/5.6
33mm lens

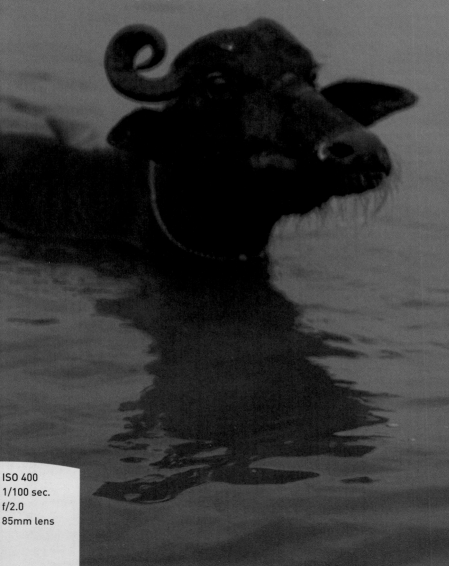

PORING OVER THE PICTURE

Composition was key to this photograph. I wanted to make sure the man and all the cows were in the image, while keeping the man in the bottom right of the frame. Since I was using a fixed focal length prime lens, all my zooming in and out was done via my own two feet.

Whenever I'm photographing at night I always take a fast prime lens with me so I'm not hindered by the low light and forced into flash or grainy images. This allows me to use lower ISO and maximize the available light. Ninety-five percent of my street photography is done in Aperture Priority mode, and that was the case here.

ISO 400
1/100 sec.
f/2.0
85mm lens

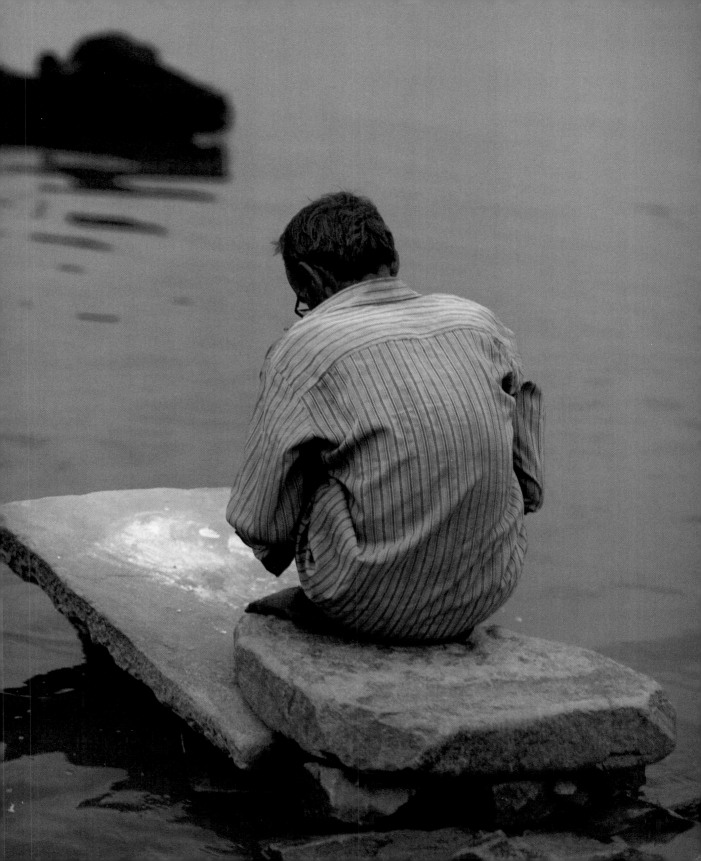

CHOOSING THE RIGHT MEMORY CARD

Selecting a memory card that is appropriate for your camera and your needs is a crucial step to avoiding problems in the future. Your new D7000 is equipped with two Secure Digital (SD) memory card slots (**Figure 2.1**).

If you have been using a point-and-shoot camera, chances are you already own an SD media card. Which brand of card you use is up to you, but here is some advice about choosing a memory card:

FIGURE 2.1

Make sure you select an SD card that has enough capacity to handle your photography needs.

- Capacity matters. At 16 megapixels, the D7000 will require a lot of storage space, especially if you shoot in the RAW or RAW+JPEG mode (more on this later in the chapter). You should definitely consider using a card with a storage capacity of at least 8 GB.

- Write speed is critical. Your Nikon D7000 can write to a card very quickly—that is, if the card is fast enough. Learn from my mistakes. You don't want to buy an inexpensive memory card that can't keep up with your camera's file write speed. Having a card that can't keep up can result in corrupted files as well as lost photo opportunities. Transfer speed is a key factor when shooting in Continuous mode (see Chapter 5) or when recording video. If your card is not rated fast enough or doesn't have enough capacity, then you will be left in the dust. Here are some of Nikon's recommendations for your D7000:

- If you shoot video, or plan on shooting in Continuous mode, choose an SDHC card with a class 6 or faster write speed. The D7000 also supports the newest and fastest card, the SDXC, which has a faster transfer speed and larger capacity than the standard SDHC.

- Buy more than one card. If you have already purchased a memory card, consider getting another. You can quickly ruin your day of shooting by filling your card and then having to either erase shots or choose a lower-quality image format so that you can keep on shooting. With the cost of memory cards what it is, keeping a spare just makes good sense. Plus, the D7000 has two memory card slots for storage—but more about that later.

FORMATTING YOUR MEMORY CARD

Now that you have your card, let's talk about formatting for a minute. When you purchase any new SD card, you can pop it into your camera and start shooting right away—and probably everything will work as it should. However, what you should do first is format the card in the camera. This process allows the camera to set up the card to record images from your camera. Just as a computer hard drive must be formatted, formatting your card ensures that it is properly initialized. The card may work in the camera without first being formatted, but chances of failure down the road are much higher.

As a general practice, I always format new cards or cards that have been used in different cameras. I also reformat cards after I have downloaded my images and want to start a new shooting session. Note that you should always format your card in the camera, not your computer. Using the computer could render the card useless. You should also pay attention to the card manufacturer's recommendations in respect to moisture, humidity, and proper handling procedures. It sounds a little clichéd, but when it comes to protecting your images, every little bit helps.

A

HOW TO FORMAT A MEMORY CARD

1. Insert your memory card into the camera.

2. Press the Menu button and navigate to the Setup menu screen.

3. Use the Multi-selector on the back of the camera to highlight the Format Memory Card option and press OK (**A**).

4. Next you will have the option of formatting Slot 1 or Slot 2. Pick the appropriate card slot to format and click OK (**B**).

5. The next screen will show you a warning, letting you know that formatting the card will delete images (**C**). Select Yes and press the OK button.

6. The card is now formatted and ready for use.

B

C

UPDATING THE D7000'S FIRMWARE

I know that you want to get shooting, but having the proper firmware can affect the way the camera operates. It can fix problems as well as improve operation, so you should probably check it sooner rather than later.

Updating your camera's firmware is something that the manual omits, yet it can change the entire behavior of your camera's operating systems and functions. The firmware of your camera is the set of computer operating instructions that control how your camera functions. Updating it is a great way to not only fix little bugs but also gain access to new functionality. You will need to check out the information on the Nikon Firmware update page (http://nikonusa.com/Service-And-Support/Download-Center.page) to see if a firmware update is available and how it will affect your camera, but it is always a good idea to be working with the most up-to-date firmware version available.

Keep in mind, it is not uncommon for a new camera model to see several firmware upgrades within the first six months after its release, so check back frequently at first, then every so often during the lifetime of the camera or if you experience any unexplained problems with the camera.

CHECKING THE CAMERA'S CURRENT FIRMWARE VERSION NUMBER

1. Press the Menu button and then navigate to the Setup menu.

2. Use the Multi-selector on the back of the camera to highlight the Firmware Version option and press OK (**A**).

3. Take note of the current version numbers (there are three of them) and then check the Nikon Web site to see if you are using the current versions (**B**).

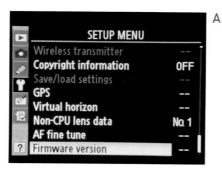

A

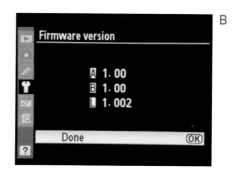

B

UPDATING THE FIRMWARE FROM YOUR SD CARD

1. Download the firmware update file from the Nikon Web site. (You can find the file by going to the Download section of the Nikon camera site and locating the firmware update for your camera and computer operating system.)

2. Once you have downloaded the firmware to your computer and extracted it, you will need to transfer it to your SD card. The card must be formatted in your camera prior to loading the firmware to it.

3. Make sure your camera battery is fully charged. With a freshly charged camera battery, insert the card into the camera and turn it on.

4. Follow the instructions for locating your firmware version listed above and you will now be able to update your firmware using the files located on the SD card.

At the time I finished writing this book, there were no firmware updates available for the D7000. After you check your camera firmware version and the Nikon site for updates, continue to check back periodically to see if updates become available.

CLEANING THE SENSOR

Cleaning camera sensors used to be a nerve-racking process that required leaving the sensor exposed to scratching and even more dust. Now cleaning the sensor is pretty much an automatic function. Every time you turn the camera on and off, you can instruct the sensor in the camera to vibrate to remove any dust particles that might have landed on it.

There are five choices for cleaning in the camera setup menu: Clean at Startup, Clean at Shutdown, Clean at Startup/Shutdown, Cleaning Off, and Clean Now. I'm kind of obsessive when it comes to cleaning my sensor, so I like to have it set to Clean at Startup/Shutdown. This works nicely, since I make a habit of turning my camera off whenever I change my lenses. There are many schools of thought on this practice, but for the few seconds it takes I would rather not run the risk of damaging any electronics in the lens or camera.

Removing or changing a lens will leave the camera body open and susceptible to dust sneaking in. If you never change lenses, you shouldn't have too many dust problems. But the more often you change lenses, the more chances you are giving dust to enter the body. The camera sensor is an electrically charged device. This means that when the camera is turned on, there is a current running through the sensor. This electric current can create static electricity, which will attract small dust particles to the sensor area. For this reason, it is always a good idea to turn off the camera prior to removing a lens.

You should also consider having the lens mount facing down when changing lenses so that there is less opportunity for dust to fall into the inner workings of the camera. As long as you are turning the camera off while changing your lenses, the camera will automatically clean the sensor when you turn it back on.

Every now and then, there will just be a dust spot that is impervious to the shaking of the Auto Cleaning feature. This will require manual cleaning of the sensor by raising the mirror and opening the camera shutter. When you activate this feature, it will move everything out of the way, giving you access to the sensor so that you can use a blower or other cleaning device to remove the stubborn dust speck. The camera will need to be turned off after cleaning to allow the mirror to reset.

If you choose to manually clean your sensor, use a device that has been made to clean sensors (not a cotton swab from your medicine cabinet). There are dozens of commercially available devices such as brushes, swabs, and blowers that will clean the sensor without damaging it. To keep the sensor clean, always store the camera with a body cap or lens attached.

1. Press the Menu button, then navigate to the Setup menu.

2. Use the Multi-selector on the back of the camera to highlight the Clean Image Sensor option and press OK (**A**).

3. Pick Clean Now to clean the camera immediately or pick Clean at Startup/ Shutdown to clean the camera whenever the camera is turned on or off (**B**). I prefer the latter setting. Once you've made your selection, press OK.

A

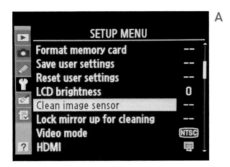

B

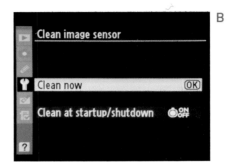

USING THE RIGHT FORMAT: RAW VS. JPEG

When shooting with your D7000, you have a choice of image formats that your camera will use to store the pictures on the memory card. JPEG is probably the format most familiar to anyone who has been using a digital camera.

There is nothing wrong with JPEG if you are taking casual shots. JPEG files are ready to use, right out of the camera. Why go through the process of adjusting RAW images of the kids opening presents when you are just going to e-mail them to Grandma? Also, for journalists and sports photographers who are shooting nine frames per second and who need to transmit their images across the wire, again, JPEG is just fine. So what is wrong with JPEG? Absolutely nothing—unless you care about having complete creative control over all of your image data.

JPEG is not actually an image format. It is a compression standard, and compression is where things go bad. When you have your camera set to JPEG—whether it is Fine, Normal, or Basic—you are telling the camera to process the image however it sees fit and then throw away enough image data to make it shrink into a smaller space. In doing so, you give up subtle image details that you will never get back in post-processing. That is an awfully simplified statement but still fairly accurate.

SO WHAT DOES RAW HAVE TO OFFER?

First and foremost, RAW images are like digital negatives and are typically not compressed. If they are compressed the camera uses lossless compression, which mean there is no loss of actual image data. Note that RAW image files will require you to perform post-processing on your photographs. This is not only necessary, it is the reason that most photographers use it. You can use the software that came with your camera to process the RAW images (**Figure 2.2**), or for more control you can use an application like Adobe Lightroom or Apple's Aperture. I do all my own post-production in Adobe Lightroom. RAW images have a greater dynamic range than JPEG-processed images. This means that you can recover image details that just aren't available in JPEG-processed images.

FIGURE 2.2
ViewNX 2 can be used to import, edit, and print RAW files.

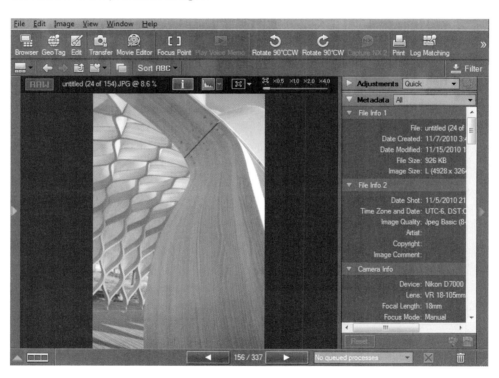

There is more color information in a RAW image because it is a 14-bit image, which means it contains more color information than a JPEG, which is almost always an 8-bit image. More color information means more to work with and smoother changes between tones. Regarding sharpening, a RAW image offers more control because you are the one who is applying the sharpening according to the effect you want to achieve. Once again, JPEG processing applies a standard amount of sharpening that you cannot change after the fact.

Finally, and most importantly, a RAW file is your negative. The file format is called nondestructive. Meaning, no matter what you do to it, you won't change it unless you save your file in a different format. This means that you can come back to that RAW file later and try different processing settings to achieve other results and never harm the original image. By comparison, if you make a change to your JPEG and accidentally save the file, guess what? You have a new original file, and you will never get back to that first image. That alone should make you sit up and take notice.

What I love about RAW is that, as technology changes, it allows me to go back and work the original file again and again without damaging or changing the "digital negative."

ADVICE FOR NEW RAW SHOOTERS

Don't give up on shooting RAW just because it means more work. Hey, if it takes up more space on your card, buy bigger cards or more smaller ones. Will it take more time to download? Yes, but good things come to those who wait. Don't worry about needing to purchase expensive software to work with your RAW files; you already own a program that will allow you to work with them. Nikon's ViewNX 2 software comes bundled in the box with your camera and gives you the ability to work directly on the RAW files and then output the enhanced results.

If you're unfamiliar with RAW format, my recommendation is to shoot in JPEG mode while you are using this book. This will allow you to quickly review your images and study the effects of the book's lessons. Once you have become comfortable with all of the camera features, you should switch to shooting in RAW mode so that you can start gaining more creative control over your image processing. After all, you took the photograph—shouldn't you be the one to decide how it looks in the end?

IMAGE RESOLUTION

When photographers are discussing digital cameras, the term *image resolution* is often used to describe pixel resolution or the number of pixels used to make an image. This can be displayed as a dimension such as 4928 x 3264. This is the physical number of pixels in width and height of the image sensor. Resolution can also be referred to in megapixels (MP) such as 19.4 MP for a RAW 14-bit lossless compression. This number represents the number of total pixels on the sensor and is commonly used to describe the amount of image data that a digital camera can capture.

SHOOTING DUAL FORMATS

Your camera has the added benefit of being able to write two files for each picture you take, one in RAW and one in JPEG. This can be useful if you need a quick version to e-mail but want a higher-quality version for more advanced processing. You will notice that there is a dash (—) option at the beginning of the RAW and JPEG settings. If you don't want to shoot in both RAW and JPEG together, you must set one of the formats to the dash. If you have a RAW and JPEG setting selected, your camera will save your images in both formats on your card.

Note that using both formats would require more space on the memory card. With the D7000 you have the option to record your RAW images on one memory card and the JPEGs on another. So if you have one large and one small memory card, you can designate the larger card to write the RAW files and the smaller card to write the JPEG files. This option will also give you a chance to experiment with RAW if you're unfamiliar with it and still have the security blanket of JPEG. You can also see the difference between the two and decide for yourself which file type you prefer. However, eventually I recommend that you use only one format or the other unless you have a specific need to shoot both.

SHOOTING IN RAW AND JPEG

1. Press and hold the Qual button on the back of the camera (**Figure 2.3**). While holding the Qual button, rotate the main Command dial with your right thumb until it shows RAW+Fine, RAW+Norm, or RAW+Basic (**Figure 2.4**).

2. You can then choose the size of the JPEG file by holding the Qual button and rotating the Sub-command dial with your right finger to choose S, M, or L for small, medium, or large JPEG (**Figure 2.5**).

3. Release the Qual button to make your final selection (see Chapter 1).

FIGURE 2.3
The screen will display your current settings.

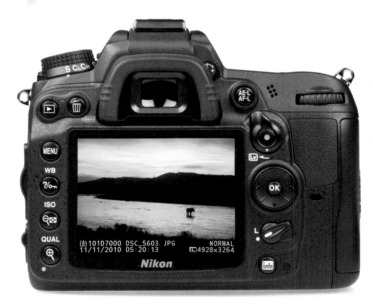

FIGURE 2.4
Press the Qual button to set your file format while rotating the Command dial.

FIGURE 2.5
Rotate the Sub-command dial to set your image size.

SAVING RAW/JPEG FILES TO SEPARATE CARDS

1. To choose one memory card to record JPEG and the other RAW, press the Menu button on the back of the camera.

2. Use the Multi-selector to choose the Shooting menu (**A**).

3. Select the option Role Played by Card in Slot 2 and press OK (**B**).

4. Using the Multi-selector, choose RAW Slot 1 – JPEG Slot 2, and press OK to finalize your selection (**C**).

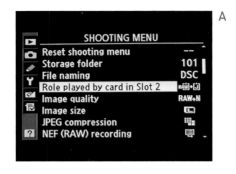

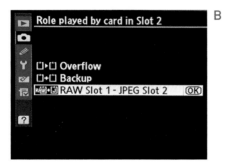

You will notice when you are in the selection screen on the top LCD of the camera that you will be able to see how much storage space each option will require on your SD card. This is the number to the right of the screen. The RAW+Fine L option, which is the one I use, will take up approximately 23 MB of space for each photograph you take.

LENSES AND FOCAL LENGTHS

If you ask most professional photographers what they believe to be their most critical piece of photographic equipment, they will undoubtedly tell you that it is their lens. The technology and engineering that goes into your camera is a marvel, but it isn't worth a darn if it can't get the light from the outside onto the sensor. The D7000, as a digital single lens reflex (dSLR) camera, uses the lens for a multitude of tasks, from focusing on a subject to metering a scene to delivering and focusing the light onto the camera sensor. The lens is also responsible for the amount of the scene that will

be captured (the frame). With all of this riding on the lens, let's take a more in-depth look at the camera's eye on the world.

Lenses are composed of optical glass that is both concave and convex in shape. The alignment of the glass elements is designed to focus the light coming in from the front of the lens onto the camera sensor. The amount of light that enters the camera is also controlled by the lens, the size of the glass elements, and the aperture mechanism within the lens housing. The quality of the glass used in the lens will have a direct effect on how well the lens can resolve details and the contrast of the image (the ability to deliver great highlights and shadows). Most lenses now routinely include things like the autofocus motor and, in some cases, a vibration reduction mechanism. If you bought the Nikon D7000 kit lens, then your 18–105mm lens is equipped with both autofocus as well as vibration reduction.

There is one other aspect of the camera lens that is often the first consideration of the photographer: lens length. Lenses are typically divided into three or four groups depending on the field of view they deliver.

Wide-angle lenses cover a field of view from around 110 degrees to about 60 degrees (**Figure 2.6**). There is also a tendency to get some distortion in your image when using extremely wide-angle lenses. This will be apparent toward the outer edges of the frame. As for which lenses would be considered wide angle, anything 35mm or smaller could be considered wide.

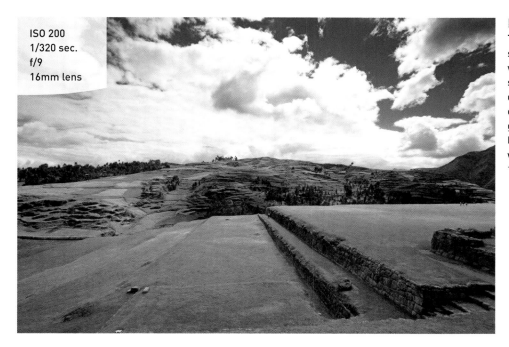

ISO 200
1/320 sec.
f/9
16mm lens

FIGURE 2.6
The 16mm lens setting provides a wide view of the scene but little detail in distant objects. I photograph most of my landscape images with a wide-angle 16–35mm lens.

Wide-angle lenses can display a large depth of field, which allows you to keep the foreground and background in sharp focus. This makes them very useful for landscape photography. They also work well in tight spaces, such as indoors, where there isn't much elbow room available. They can be handy for large group shots but aren't so great for close-up portrait work, due to the amount of distortion.

A *normal* lens has a field of view that is about 45 degrees and delivers approximately the same view as the human eye. The perspective feels very natural, and there is little distortion in objects. The normal lens for full-frame and 35mm cameras is the 50mm lens, but for the D7000 it is more in the neighborhood of a 35mm lens. Often I'll use a 50mm or an 85mm for street photography (**Figure 2.7**).

FIGURE 2.7
This image was photographed using an 85mm. I really enjoy observing people. I'm not sure why but this image just brings a smile to my face.

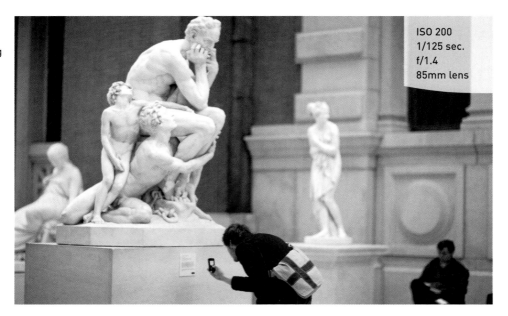

ISO 200
1/125 sec.
f/1.4
85mm lens

Long viewed as the "normal" lens for 35mm photography, the 50mm focal length can be considered somewhat of a telephoto lens on the D7000 because it has the same angle of view and magnification as an 80mm lens on a 35mm camera body. I find it to be the perfect lens to use for many portraits.

Normal focal length lenses are useful for photographing people and architecture and most other general photographic purposes. They have very little distortion and offer a moderate range of depth of field (**Figure 2.8**).

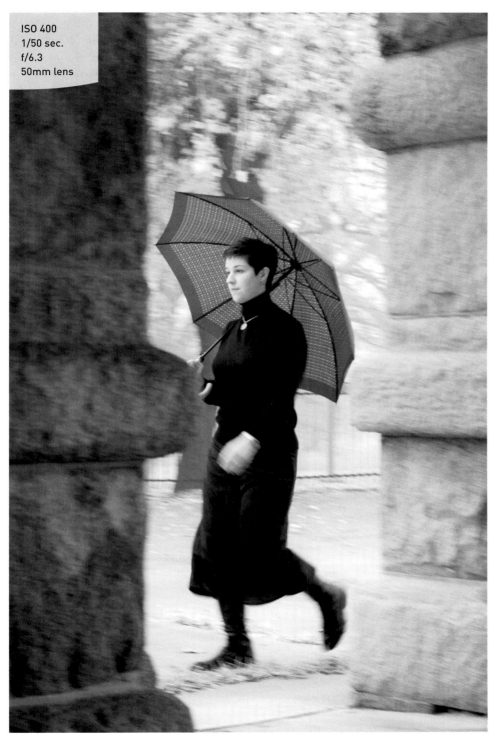

ISO 400
1/50 sec.
f/6.3
50mm lens

FIGURE 2.8
The 50mm is often considered a wonderful street photography lens because of its compact size combined with large aperture. Here I wanted to show some motion and also maintain some depth of field, so I used a slower speed and smaller f-stop.

Most longer focal length lenses are referred to as *telephoto* lenses. They can range in length from 135mm up to 800mm or longer and have a field of view that is about 35 degrees or smaller. These lenses have the ability to greatly magnify the scene, allowing you to capture details of distant objects, but the angle of view is sharply reduced. You will also find that you can achieve a much narrower depth of field. They suffer from something called distance compression, which means they make objects at different distances appear to be much closer together than they really are (**Figure 2.9**).

FIGURE 2.9
It would have been a little dangerous for me to get this close to a bull elk, so using a telephoto lens was key in getting this image in Yellowstone National Park.

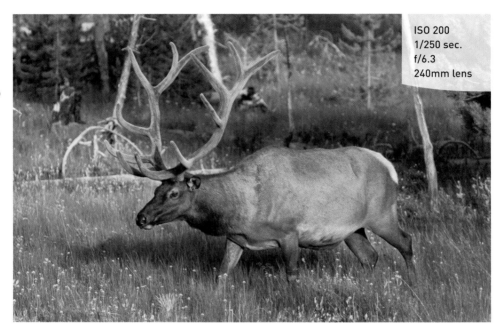

ISO 200
1/250 sec.
f/6.3
240mm lens

Telephoto lenses are most useful for wildlife and sports photography or any application where you just need to get closer to your subject. They can have a compressing effect—making objects look closer together than they actually are—and a very narrow depth of field when shot at their widest apertures.

A *zoom* lens is a great compromise to carrying a bunch of single focal-length lenses (also referred to as prime lenses). They can cover a wide range of focal lengths because of the configuration of their optics. However, because it takes more optical elements to capture a scene at different focal lengths, the light must pass through more glass on its way to the image sensor. The more glass, the lower the quality of the image sharpness. The other sacrifice that is made is in aperture. Zoom lenses typically have smaller maximum apertures than prime lenses, which means they cannot achieve a narrow depth of field or work in lower light levels without the assistance

of image stabilization, a tripod, or higher ISO settings. (We'll discuss all this in more detail in later chapters.)

The D7000 can be purchased with the body only, but many folks will purchase it with a kit lens. The most common kit lens is the 18–105mm VR f/3.5–5.6. Throughout the book, I will occasionally make reference to lenses that are wider or more telephoto than these, because I have a multitude of lenses that I use for my photography. This doesn't mean that you have to run out and purchase more lenses. It just means that if you do this long enough, you are sure to accumulate additional lenses that will expand your ability to be even more creative with your photography.

WHAT IS EXPOSURE?

In order for you to get the most out of this book, I need to briefly discuss the principles of exposure. Without this basic knowledge, it will be difficult for you to move forward in improving your photography. There are many excellent books that have been written on exposure. I highly recommend *Exposure: From Snapshots to Great Shots* (Peachpit Press) by Jeff Revell. However, for our purposes I will just cover some of the basics. This will give you the essential tools to make educated decisions in determining how best to photograph a subject (**Figure 2.10**).

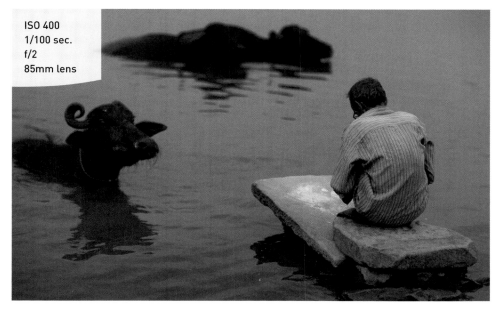

ISO 400
1/100 sec.
f/2
85mm lens

FIGURE 2.10
This image was taken at dusk and the light was changing very quickly. I needed to adjust ISO several times to get the proper exposure.

Exposure is the process whereby the light bouncing off a subject reflects through an opening in the camera lens for a defined period of time onto the camera sensor. The combination of the lens opening, shutter speed, and sensor sensitivity is used to achieve a proper exposure value (EV) for the scene. The EV is the sum of these components necessary to properly expose a scene. A relationship exists between these factors that is sometimes referred to as the exposure triangle.

At each point of the triangle lies one of the factors of exposure:

- **ISO:** Determines the sensitivity of the camera sensor. ISO stands for the International Organization for Standardization, but the acronym is used as a term to describe the sensitivity of the camera sensor to light. The higher the sensitivity, the less light is required for a good exposure. These values are a carryover from the days of traditional color and black-and-white films.

- **Aperture:** Also referred to as the f-stop, this determines how much light passes through the lens at once.

- **Shutter Speed:** Controls the length of time that light is allowed to hit the sensor.

Here's how it works. The camera sensor has a level of sensitivity that is determined by the ISO setting. To get a proper exposure—not too much, not too little—the lens needs to adjust the aperture diaphragm (the size of the lens opening) to control the volume of light entering the camera. Then the shutter is opened for a relatively short period of time to allow the light to hit the sensor long enough for it to record on the sensor.

ISO numbers for the D7000 start at 100 and then double in sensitivity as you double the number. So 200 is twice as sensitive as 100. The camera can be set to use 1/2- or 1/3-stop increments, but for ISO just remember that the base numbers double: 100, 200, 400, 800, and so on. You can also use a wide variety of shutter speeds. The speeds on the D7000 range from as long as 30 seconds to as short as 1/8000 of a second. When using the camera, you will not see the 1 over the number, so you will need to remember that anything shorter than a second will be a fraction.

Typically, you will be working with a shutter speed range from around 1/30 of a second to about 1/2000, but these numbers will change depending on your circumstances and the effect that you are trying to achieve. The lens apertures will vary slightly depending on which lens you are using. This is because different lenses have different maximum apertures. The typical apertures that are at your disposal are f/3.5, f/4, f/4.5, f/5.6, f/6.3, f/7.1, f/8, f/9, f/10, f/11, f/13, f/14, f/16, f/18, and f/22.

When it comes to exposure, a change to any one of these factors requires changing one or more of the other two. This is referred to as reciprocal change. If you let more light in the lens by choosing a larger aperture opening, you will need to shorten the amount of time the shutter is open. If the shutter is allowed to stay open for a longer period of time, the aperture needs to be smaller to restrict the amount of light coming in.

HOW IS EXPOSURE CALCULATED?

We now know about the exposure triangle—ISO, shutter speeds, and aperture—so it's time to put all three together to see how they relate to one another and how you can change them as needed.

STOP

You will hear the term *stop* thrown around all the time in photography. It relates back to the f-stop, which is a term used to describe the aperture opening of your lens. When you need to give some additional exposure, you might say that you are going to "add a stop." This doesn't just equate to the aperture; it could also be used to describe the shutter speed or even the ISO. So when your image is too light or dark or you have too much movement in your subject, you will probably be changing things by a "stop" or two.

When you point your camera at a scene, the light reflecting off your subject enters the lens and is allowed to pass through to the sensor for a period of time as dictated by the shutter speed. The amount and duration of the light needed for a proper exposure depends on how much light is being reflected and how sensitive the sensor is. To figure this out, your camera uses a built-in light meter that looks through the lens and measures the amount of light. That level is then calculated against the sensitivity of the ISO setting and an exposure value is rendered. Here is the tricky part: There is no single way to achieve a perfect exposure because the f-stop and shutter speed can be combined in different ways to allow the same amount of exposure. See, I told you it was tricky.

Here is a list of reciprocal settings that would all produce the same exposure result. Let's use the "sunny 16" rule, which states that, when using f/16 on a sunny day, you can use a shutter speed that is roughly equal to the ISO setting to achieve a proper exposure. For simplification purposes, we will use an ISO of 100.

RECIPROCAL EXPOSURES: ISO 100

F-STOP	2.8	4	5.6	8	11	16	22
SHUTTER SPEED	1/4000	1/2000	1/1000	1/500	1/250	1/125	1/60

If you were to use any one of these combinations, they would each have the same result in terms of the exposure (how much light hits the camera's sensor) but very different depth of field. Also take note that every time we cut the f-stop in half, we reciprocated by doubling our shutter speed. For those of you wondering why f/5.6 is half of f/8, it's because those numbers are actually fractions based on the opening of the lens in relation to its focal length. This means that a lot of math goes into merely figuring out what the total area of a lens opening is, so you just have to take it on faith that f/5.6 is half of f/8 but twice as much as f/4. A good way to remember which opening is larger is to think of your camera lens as a pipe that controls the flow of water. If you had a pipe that was 1/2 inch in diameter (f/2) and one that was 1/8 inch (f/8), which would allow more water to flow through? It would be the 1/2-inch pipe. The same idea works here with f-stops; f/2 is a larger opening than f/4 or f/8 or f/16.

Now that we know this, we can start using this information to make intelligent choices in terms of shutter speed and f-stops. Let's bring the third element into this by changing our ISO by one stop, from 100 to 200.

RECIPROCAL EXPOSURES: ISO 200

F-STOP	2.8	4	5.6	8	11	16	22
SHUTTER SPEED	1/8000	1/4000	1/2000	1/1000	1/500	1/250	1/125

Notice that, since we doubled the sensitivity of the sensor, we now require half as much exposure as before.

Let's use the exposure setting of f/16 at 1/250 of a second for a sunny day for purposes of our graph. Why bother with all of these reciprocal values when this one setting will give us a properly exposed image? The answer is that the f-stop and shutter speed also control two other important aspects of our image: motion and depth of field.

MOTION AND DEPTH OF FIELD

There are distinct characteristics that are related to changes in aperture and shutter speed. Shutter speed controls the length of time the light has to strike the sensor; consequently, it also controls the blurriness (or lack of blurriness) of the image. The less time light has to hit the sensor, the less time your subjects have to move around and become blurry. This lets you control things like freezing the motion of a fast-moving subject or intentionally blurring subjects to give the feel of energy and motion (**Figure 2.11**).

ISO 1600
.3 sec.
f/8
16mm lens

FIGURE 2.11
A slower shutter will convey motion when photographing moving vehicles. How much motion you want to show will depend on the shutter speed used. Here I wanted the image of the taxi to be very blurred, so I used a very slow shutter speed. If I had wanted the taxi to be less blurry I would have used a faster shutter speed.

The aperture controls the amount of light that comes through the lens, but also determines what areas of the image will be in focus. This is referred to as depth of field, and it is an extremely valuable creative tool. The smaller the opening (the larger the number, such as f/22), the greater the sharpness of objects from near to far. A large opening (or small number, like f/2.8) means more blurring of objects that are not at the same distance as the subject you are focusing on (**Figure 2.12**).

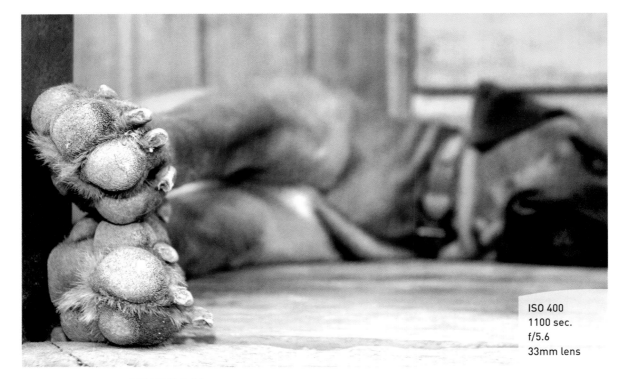

ISO 400
1100 sec.
f/5.6
33mm lens

FIGURE 2.12
Isolating a subject is accomplished by using a large aperture, which produces a narrow area of sharp focus. Here I was able to isolate Tensing's pads by using the largest available aperture.

As we further explore the features of the camera, we will learn not only how to use the elements of exposure to capture properly exposed photographs, but also how we can make adjustments to emphasize our subject. It is the manipulation of these elements—motion and focus—that will take your images to the next level.

Chapter 2 Assignments

Formatting your card

Even if you have already begun using your camera, make sure you are familiar with formatting the Secure Digital card. If you haven't done so already, follow the directions given earlier in the chapter and format as described (make sure you save any images that you may have already taken). Then perform the format function every time you have downloaded or saved your images or use a new card.

Checking your firmware version

Using the most up-to-date version of the camera firmware will ensure that your camera is functioning properly. Use the menu to find your current firmware version and then update as necessary using the steps listed in this chapter.

Cleaning your sensor

You probably noticed the sensor-cleaning message the first time you turned your camera on. Make sure to adjust the frequency of sensor cleaning to what works for you. Try setting it to Clean on Startup/Shutdown so that you don't have to remember to clean every time you change your lens.

Exploring your image formats

I want you to become familiar with all of the camera features before using the RAW format, but take a little time to explore the format menu so you can see what options are available to you.

Exploring your lens

If you are using a zoom lens, spend a little time shooting with all of the different focal lengths, from the widest to the longest. See just how much of an angle you can cover with your widest lens setting. How much magnification will you be able to get from the telephoto setting? Try shooting the same subject with a variety of focal lengths to note the differences in how the subject looks, and also the relationship between the subject and the other elements in the photo.

Share your results with the book's Flickr group!

Join the group here: flickr.com/groups/nikond7000_fromsnapshotstogreatshots

3

ISO 100
.6 sec.
f/22
80mm lens

The Auto Modes

GET SHOOTING WITH THE AUTOMATIC CAMERA MODES

Every digital photographer I know has taken photographs using what I call the green zone, or auto zone, and I'm not ashamed to admit that I still hang out there from time to time. The Nikon D7000 has done an incredible job of simplifying some of the most complex camera settings and creating an excellent baseline for many shots. In this chapter we're going to focus on how to use the built-in scene modes and the advantages even some of the more experienced photographers can gain from using these presets. Let's take a look at the different modes and how and when to use them.

I positioned the tree to the left of the frame, creating a more dynamic photograph.

ISO 100
1/250 sec.
f/9.5
44mm lens

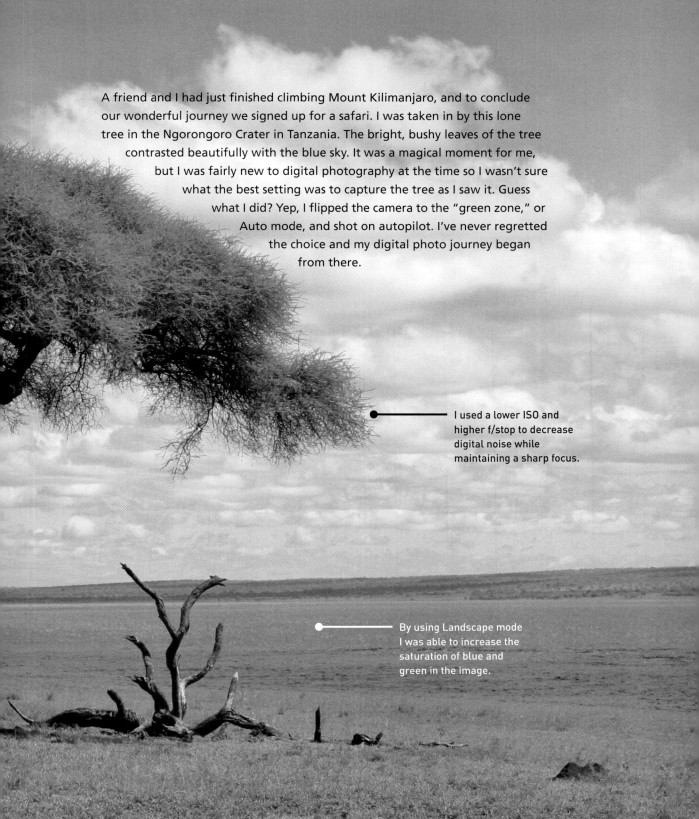

A friend and I had just finished climbing Mount Kilimanjaro, and to conclude our wonderful journey we signed up for a safari. I was taken in by this lone tree in the Ngorongoro Crater in Tanzania. The bright, bushy leaves of the tree contrasted beautifully with the blue sky. It was a magical moment for me, but I was fairly new to digital photography at the time so I wasn't sure what the best setting was to capture the tree as I saw it. Guess what I did? Yep, I flipped the camera to the "green zone," or Auto mode, and shot on autopilot. I've never regretted the choice and my digital photo journey began from there.

I used a lower ISO and higher f/stop to decrease digital noise while maintaining a sharp focus.

By using Landscape mode I was able to increase the saturation of blue and green in the image.

AUTO MODE

 Auto mode is all about thought-free photography (**Figure 3.1**). There is little to nothing for you to do in this mode except point and shoot. Your biggest concern when using Auto mode is focusing. The camera will use the automatic focusing modes to achieve the best possible focus for your picture. Naturally, the camera is going to assume that the object that is closest to the camera is the one that you want to have the sharpest focus. Simply press the shutter button down halfway while looking through the viewfinder and you should see one of the focus points light up over the subject. Of course, you know that putting your subject in the middle of the picture is not the best way to compose your shot. So wait for the chirp to confirm that the focus has been set, and then, while still holding down the button, recompose your shot. Now just press down the shutter button the rest of the way to take the photo. It's that easy (**Figure 3.2**). The camera will take care of all your exposure decisions, including when to use flash.

FIGURE 3.1
To shoot in Auto mode, all you need to do is move the Mode dial so that the green camera icon lines up with the white line. It's as simple as that!

I always tell my workshop students, if you're not sure of what setting to use or if exposure, aperture, and speed are confusing, then start by using Auto mode. This mode can be an excellent learning tool. Take a photograph using Auto mode and note the ISO, aperture, and speed the camera uses. This is a great way to become familiar with settings. Then, as you become more familiar with the settings, you can begin to change them to better create your vision.

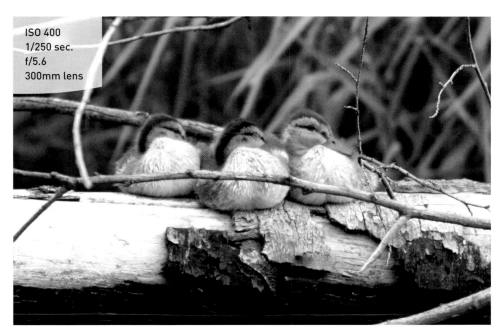

FIGURE 3.2
Auto mode works great a large percentage of the time, so don't hesitate to use it. This photograph was taken while I was fly-fishing on the Deschutes River in Oregon. I had little time to think about my settings, so I put the camera on green, or Auto mode, and captured a very cute moment.

ISO 400
1/250 sec.
f/5.6
300mm lens

FLASH OFF MODE

 Sometimes you will be in a situation where the light levels are low but you don't want to use the flash. It could be that you are shooting in a place that restricts flash photography, such as a museum, or maybe you want to take advantage of the available light, as when shooting candles on a birthday cake. This is where Flash Off mode comes into play (**Figure 3.3**).

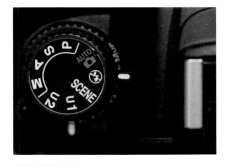

FIGURE 3.3
To shoot in Flash off mode, turn the mode dial to the Flash off symbol. This will prevent your flash from firing.

By keeping the flash from firing, you will be able to use just the available ambient light while the camera automatically modifies the ISO setting to assist you in getting a good exposure (**Figure 3.4**). If the camera estimates that the shutter speed is going to be slow enough to introduce camera shake, it will give a warning on the information screen that reads "Subject is too dark." It will also list the shutter speed as "Lo" so that you know to check the camera settings. Fortunately, most of the new Vibration Reduction (VR) lenses being sold today allow you to hand-hold the camera at much slower shutter speeds and still get great results. The two downfalls to this mode are the Auto ISO setting, which will quickly take your ISO setting up as high as 3200, and the possibility of getting blur from subject movement.

FIGURE 3.4
Flash would have ruined this shot of this Indian woman at a festival in Northern India. The flame was lighting her face beautifully, and the flash would have created a harsh, unwanted light.

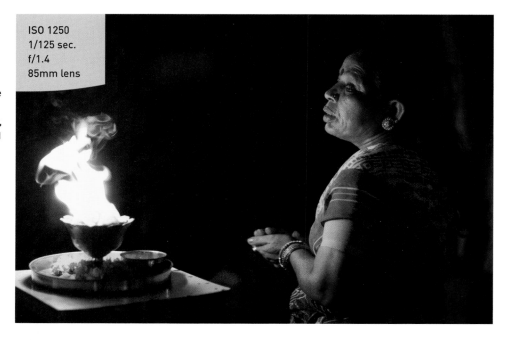

ISO 1250
1/125 sec.
f/1.4
85mm lens

SCENE MODES

 Most digital SLR cameras will only have about seven or eight automatic modes at their disposal, but the D7000 takes things to a whole new level with 19 additional scene modes to choose from (**Figure 3.5**). Nikon has anticipated many of the typical shooting scenarios that you will encounter and created scene modes that are optimized for those situations. We're going to focus on a few of the most popular modes in detail, but first, here's how to find them.

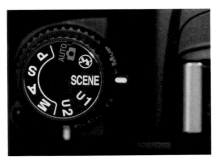

FIGURE 3.5
Remember you have over 19 preset modes to choose from, so have fun and experiment a little.

USING SCENE MODES

1. Set the Mode dial to the Scene setting.
2. Press the *i* or Info button to turn on the information screen on the back of the camera.
3. Rotate the Command dial until the appropriate scene appears on the information screen.

PORTRAIT MODE

As mentioned before, Auto mode is accurate much of the time, but one of the problems with Full Auto mode is that it has no idea what type of subject you are photographing and, therefore, uses the same settings for each situation. Shooting portraits is a perfect example. Typically, when you are taking a photograph of someone, you want the emphasis of the picture to be on the person, not necessarily the stuff going on in the background.

FIGURE 3.6
Portrait mode will create soft and natural-looking skin tones.

This is what Portrait mode is all about (**Figure 3.6**). When you set your camera to this mode, you are telling the camera to select a larger aperture so that the depth of field is much narrower and will make objects

in the background blurrier. This blurry background places the attention on your subject (**Figure 3.7**). The other feature of this mode is the automatic selection of the D7000's built-in Portrait picture control (we'll go into more detail about picture controls in later chapters). This feature is optimized for skin tones and will also be a little softer to improve the look of skin.

FIGURE 3.7
Portrait mode will help isolate your subject from the background, making her the main focus of the image. In this image the subject was placed to the side of the frame to make the composition a little more interesting.

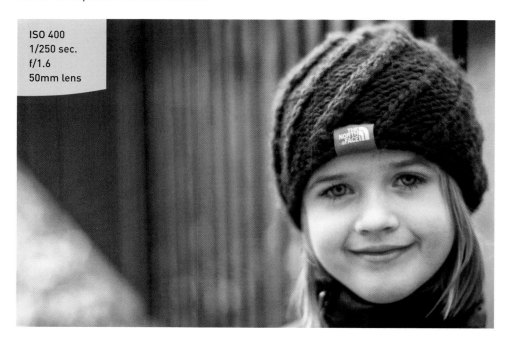

ISO 400
1/250 sec.
f/1.6
50mm lens

USING THE BEST LENS FOR GREAT PORTRAITS

When using Portrait mode, use a lens length that is 50mm or longer. The longer lens will give you a natural view of the subject, as well as aid in keeping the depth of field narrow.

LANDSCAPE MODE

As you might have guessed, Landscape mode has been optimized for shooting landscape images (**Figure 3.8**). Particular emphasis is placed on the picture control, with the camera trying to boost the greens and blues in the image (**Figure 3.9**). This makes sense, since the typical landscape would be out-doors where grass, trees, and skies should look more colorful. This picture control also boosts the sharpness that is applied during processing. The camera uses the lowest ISO settings possible in order to keep digital noise to a minimum.

FIGURE 3.8
Landscape mode will increase color saturation and turn the AF-assist illuminator off.

The downfall to this setting is that, once again, there is little control over the camera settings. The focus mode can be changed—but only from AF-A to Manual. This means that either the camera will decide what to focus on for you, or you will need to use the manual focus feature in order to override the auto focus. Other changeable functions include Image Quality, ISO, and AF-area mode. Note that the flash cannot be used while in Landscape mode.

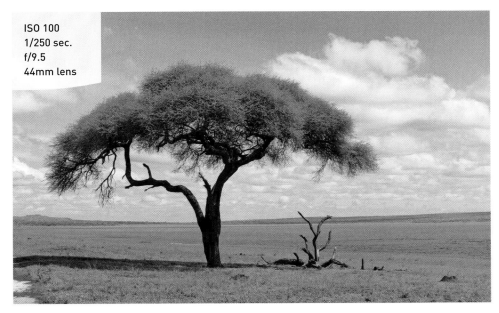

ISO 100
1/250 sec.
f/9.5
44mm lens

FIGURE 3.9
A low ISO was used to reduce digital noise while the blue skies and red rocks benefited by the increased saturation.

CLOSE UP MODE

Although most zoom lenses don't support true "macro" settings, that doesn't mean you can't shoot some great close-up photos. The key is to use your camera-to-subject distance to fill the frame while still being able to achieve sharp focus. This means that you move yourself as close as possible to your subject while still being able to get a good sharp focus. Often, your lens will be marked with the minimum focusing distance. On my 18–105mm zoom, it is about 8 inches with the lens set to 75mm. To help get the best focus in the picture, Close Up mode will use the smallest aperture it can while keeping the shutter speed fast enough to get a sharp shot (**Figures 3.10** and **3.11**). It does this by raising the ISO or turning on the built-in flash—or a combination of the two.

FIGURE 3.10

Close Up mode is best used for flowers, small objects, and insects. If you're into macro photography, then this is the mode to use.

Fortunately, there are several other settings that you can change in this mode. The flash will be set to Auto by default, but you can also change it to Auto-redeye and Off, depending on your need. The ISO can be changed from the Auto setting to one of your own choosing. This probably only needs to be done in low-light settings when Auto ISO starts to move up to maintain exposure values. Other settings that can be changed are Image Quality, Release mode, Focus mode (AF-A or Manual), and AF-area mode.

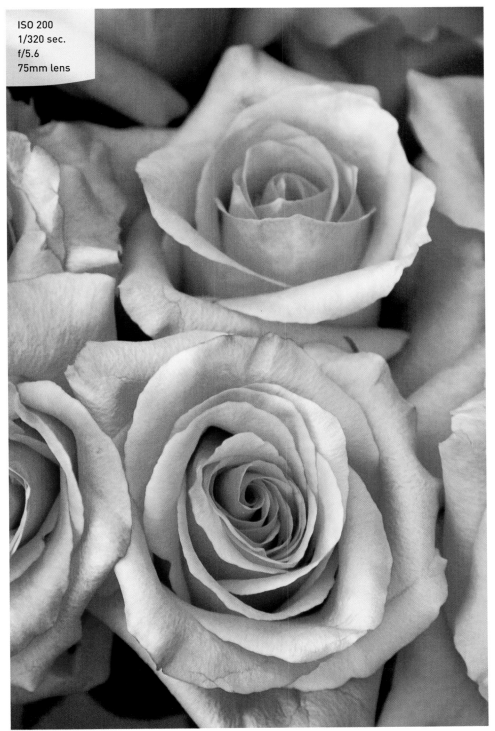

ISO 200
1/320 sec.
f/5.6
75mm lens

FIGURE 3.11
Close Up mode
provided the
proper exposure
to capture the
smallest of details.

SPORTS MODE

While this is called Sports mode, you can use it for any moving subject that you are photographing (**Figure 3.12**). The mode is built on the principles of sports photography: continuous focusing, large apertures, and fast shutter speeds (**Figure 3.13**). To handle these requirements, the camera sets the focus mode to Dynamic, the aperture to a very large opening, and the ISO to Auto. Overall, these are sound settings that will capture most moving subjects well. We will take an in-depth look at all of these features, like Continuous Drive mode, in Chapter 5.

FIGURE 3.12
Sports mode is best used for when you want to freeze motion. When in this mode the built-in flash and AF-assist illuminator will be turned off.

You can, however, run the risk of too much digital noise in your picture if the camera decides that you need a very high ISO (such as 3200). This is why you have the ability to change some options within Sports mode such as ISO and Release mode (single and continuous). Also, when using Sports mode, you can change the focus mode from AF-A to Manual. This is especially handy if you know when and where the action will take place and want to prefocus the camera on a spot and wait for the right moment to take the photo.

FIGURE 3.13
This is the type of shot that was made for Sports mode, where action-freezing shutter speeds and continuous focusing capture the moment.

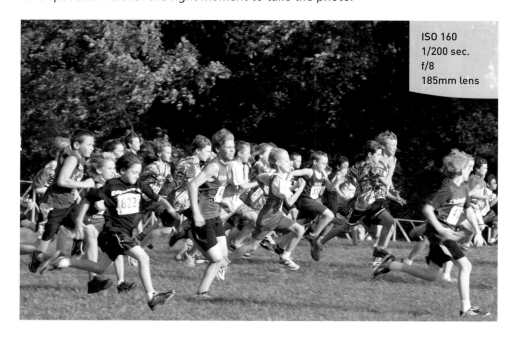

ISO 160
1/200 sec.
f/8
185mm lens

SUNSET MODE

Here's a dirty secret—every photographer I know, whether professional or amateur, has taken his fair share of sunset photos. Sunset mode is a great way to capture a beautiful scene at dusk. What I love about this setting is that most sunsets are fairly predictable, so the automatic mode works great (**Figure 3.14**). This setting will increase the saturation and optimize the colors present in a sunset. If you're on vacation or just want to enjoy the moment, the last thing you need to worry about is fumbling around with camera settings. Just move the dial to Sunset mode, sit back, relax, and let your camera do the work (**Figure 3.15**). One word of advice—this mode will use a longer exposure, so to avoid blurry photos try to use a tripod or steady your camera on a solid level surface. You do have the option to change your ISO in this mode. If you're unable to steady your camera on a tripod or solid surface, I recommend increasing your ISO so that your speed is equal to or greater than the focal length of your lens. By doing this, you reduce your chances of camera shake (blurry photos).

FIGURE 3.14
Sunset mode creates deeper hues during sunset and sunrise. A tripod is recommended with this mode.

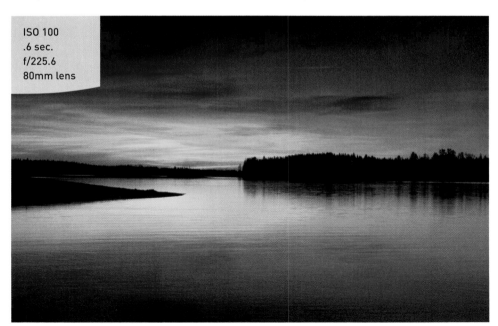

ISO 100
.6 sec.
f/225.6
80mm lens

FIGURE 3.15
The key to taking great sunset photos is being patient. It's better to be early than late and stick with the shot until the sun goes all the way down. Often the reflection of the sunset can be as beautiful as the sunset itself.

CHILD MODE

Photographing children can be tough. Those little stinkers are fast and if you've ever tried to photograph a two-year-old, you know the challenge of getting him or her to sit still. Child mode tries to solve this problem by blending the Sports and Portrait modes (**Figures 3.16** and **3.17**). Understanding that children are seldom still, the camera will try to use a slightly faster shutter speed to freeze any movement. The picture control feature has also been optimized to render bright, vivid colors that one normally associates with pictures of children. It's a great mode to use for those kids on the go, or to capture a very brief moment that you don't want to miss.

FIGURE 3.16
The Child mode is best used for snapshots of children on the go.

FIGURE 3.17
Child mode tries to use a fast shutter speed, as well as make colors more bright and vivid. I didn't have a lot of time to capture this shot before she was going to pull off her mustache. I'm so glad that I was able to get the shot of my good friend John and his granddaughter.

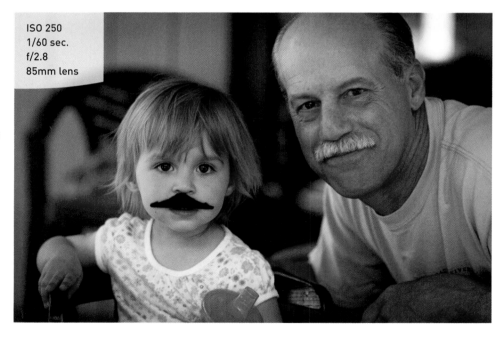

ISO 250
1/60 sec.
f/2.8
85mm lens

DUSK/DAWN

There are some great photo opportunities that take place both before the sun rises and after it sets. The only problem is that the typical camera settings don't truly capture the vibrancy of the colors. The Dusk/Dawn camera setting is optimized for low-light photography and helps boost colors and eliminate noise from longer exposures (**Figure 3.18**).

NIGHT PORTRAIT

Use this setting to help expose the background of your subject. For instance, if I'm taking a night portrait of a friend in front of Christmas lights, then I would use this setting. It tells your camera to use a slower than normal shutter speed so that the background has more time to be properly exposed (**Figure 3.19**).

BEACH/SNOW

Shooting in a bright environment like the beach or a ski resort can have a bad effect on your images. The problem is that beaches and snow often reflect a lot of light and can fool the camera's light meter into underexposing. This means that the snow would come out looking darker than it should. To solve this problem, you can use the Beach/Snow scene mode (**Figure 3.20**), which will overexpose slightly, giving you much more accurate tones.

FIGURE 3.18
The Dusk/Dawn scene mode maintains the muted colors of early morning and evening. The flash and AF-assist illuminator turn off in this mode. A tripod is recommended for this mode due to potentially longer shutter speeds.

FIGURE 3.19
The Night Portrait mode helps balance the subject and the background in low light. A tripod is recommended for low-light situations.

FIGURE 3.20
The Beach/Snow scene mode helps you capture vacations by the water or in winter, when the brightness of the sand or snow could otherwise trick the camera into underexposing. The built-in flash and AF-assist illuminator are turned off in this mode.

PARTY/INDOOR

This mode is very much like the Night Portrait mode except it is optimized for indoor use (**Figure 3.21**). The flash is automatically set to Auto-redeye and will use the redeye reduction lamp to help eliminate the redeye problem that often occurs when using the flash indoors.

FIGURE 3.21
The Party/Indoor scene mode is great for birthday parties or weddings when you want to capture a special moment.

NIGHT LANDSCAPE

A tripod or stable shooting surface is definitely recommended for Night Landscape mode (**Figure 3.22**). By using low ISOs, longer shutter speeds, and noise reduction, you can capture great cityscapes with more accurate colors. The flash and focus-assist functions are turned off for this mode, so focusing might be a little difficult. If so, try moving your focus point to a different location.

LOW KEY

Low-key photos are typically meant to have an overall dark look. Much like the beach/snow scenario in reverse, your camera's light meter will usually try to add some exposure when shooting a low-key scene to make everything brighter. If you want to keep things on the dark side, use Low Key mode (**Figure 3.23**), which will keep the flash turned off and underexpose things just a little bit.

HIGH KEY

If Low Key mode means dark, then it's probably pretty easy to guess what High Key is for (**Figure 3.24**). Images that are bright throughout can present a different sort of challenge, with the bright environment tending to fool the camera into making an image that is darker than desired. Using the High Key setting forces the camera to overexpose a little and really lighten up those bright objects in your image.

SILHOUETTE

Using the Silhouette mode (**Figure 3.25**) does things like adjust the exposure for the brightest area of the scene as well as turn off the D-Lighting feature (see Chapter 10 for more on D-Lighting). This is necessary, since D-Lighting tries to boost exposure in shadow areas, which is the opposite effect you want when trying to get a nice silhouette.

FIGURE 3.22

The Night Landscape scene mode helps reduce noise and unnatural colors. This mode is great for capturing a city skyline at night. A tripod is recommended so that the lights don't get blurred with a slow shutter speed.

FIGURE 3.23

The Low Key scene mode is best for times when you want to create a dark image or subdued image. It will turn off the flash and is best used with a tripod.

FIGURE 3.24

The High Key scene mode creates very light and bright images; as with the Low Key mode the flash is turned off.

FIGURE 3.25

The Silhouette scene mode creates a silhouette of the subject against brighter backgrounds. A tripod is recommended for this mode.

FOOD

Food photography is very popular of late, and Nikon has provided you with a scene mode that is perfect for this type of work (**Figure 3.26**). When you select this mode, the camera will use large apertures for fairly narrow depth of field, slightly overexposed settings to keep things bright, and a picture control that makes colors slightly more vivid.

FIGURE 3.26

The Food scene mode creates vivid colors. A tripod is advised with this mode; you will have use of the flash if needed.

AUTUMN COLORS

If you live in an area that has great fall color (like I do), you will want to give this mode a try (**Figure 3.27**). The big advantage to this scene mode is that it is optimized for the red and yellow hues that are present in autumn, and it really makes them pop. It also turns off the flash, since the light from a flash can wash out the color in the leaves. Try using this mode when the leaves have turned and the skies are overcast. You will get some amazing color in your images.

BLOSSOM

This mode is very similar to the Landscape setting but with a few slight adjustments. The color settings for Blossom have been optimized for use outdoors where there are many flowers in full bloom (**Figure 3.28**).

CANDLELIGHT

Sometimes it's pretty easy to know when to use a particular mode. This mode is similar to the Flash Off mode, but it is tweaked for the color of candlelight and will give you much more pleasing results (**Figure 3.29**). If you are photographing people in candlelight, try using a tripod and have them hold fairly still to reduce image blur.

PET PORTRAIT

This mode is similar to the Portrait mode in that it uses larger apertures and faster shutter speeds (**Figure 3.30**). The difference is that Portrait mode is optimized for human skin, with adjustments to the hues and color values. Pets don't normally have any skin showing, so the sharpness and hues are adjusted accordingly.

FIGURE 3.27

The Autumn Colors scene mode creates bright yellows and reds in autumn leaves. A tripod is recommended; flash is unavailable in this mode.

FIGURE 3.28

The Blossom scene mode is best used when photographing a field of flowers. A tripod is recommended to avoid blur, and flash will be unavailable.

FIGURE 3.29

The Candlelight scene mode helps in low-light conditions. The built-in flash is disabled, and a tripod is recommended.

FIGURE 3.30

The Pet Portrait scene mode works well when you're photographing a pet and don't want to scare it off with the AF-assist illuminator.

WHEN YOU MAY NOT WANT TO USE AUTO MODE

With so many easy-to-use camera modes, why would anyone ever want to use anything else? Well, the first thing that comes to my mind is control. It is the number one benefit of using a digital SLR camera. The ability to control every aspect of your photography will open up creative avenues that just aren't available in the automatic scene modes. Let's face it: There is a reason that the Mode dial is split into two different categories. Let's look at what we are giving up when we work in the scene modes.

- **White balance.** There is no choice available for white balance. You are simply stuck with the Auto setting. This isn't necessarily a bad thing, but your camera doesn't always get it right. And in the scene modes there is just no way to change it.

- **Picture control.** All of the automatic modes have specifically tuned picture controls. Some of them use the control presets such as Landscape or Vivid, but there is no way to change the characteristics of the controls while in the auto modes.

- **Metering.** All of the auto scene modes use the Matrix metering mode to establish the proper exposure. This is generally not a downside, but there are specific scenarios that would benefit from a center or spot metering solution, which we will cover in later chapters.

- **Exposure Compensation.** You will notice that in each and every automatic scene mode, the ability to adjust the exposure through the use of the exposure compensation feature has been completely turned off. This makes it very difficult to make slight adjustments to exposure that are often needed.

- **Active D-Lighting.** This is another feature that is unavailable for changing in all of the auto modes. There are default settings for this feature that change from scene to scene, but there is no way for you to override the effect.

LIVE VIEW

Live View is the feature on your D7000 that allows you to see a real-time view of what the camera is looking at via the rear LCD display. Using Live View can be helpful when you want to see or shoot from an angle that doesn't let you put your eye up to the viewfinder. It is also an excellent way of previewing any changes to white balance or the picture style because their effects will be visible on the screen. You'll find more on Live View in Chapters 6 and 7.

- **Flash Compensation.** Just like exposure compensation, there is no way to make any adjustments to the power output of the flash. This means that you are stuck with whatever the camera feels is correct, even if it is too weak or too strong for your particular subject.

- **Exposure Bracketing.** One way to make sure that you have at least one good exposure is to use the bracketing feature of the camera, which takes images at varying exposures so you can get just the right look for your image. Unfortunately, this feature is also unavailable when using the scene modes.

Another thing you will find when using any of the automatic modes is that there are fewer choices in the camera menus for you to adjust. Each scene mode presents its own set of restrictions for the available menu items. These aren't the only restrictions to using the automatic scene modes, but they should be enough to make you want to explore the other side of the Mode dial, which I like to call the professional modes.

FOCUS MODES ON THE NIKON D7000

Three focus modes are available on the D7000. Depending on the type of photography you are doing, you can easily select the mode that will be most beneficial. The standard mode is called AF-S, which allows you to focus on one spot and hold the focus until you take the picture or release the shutter button. The AF-C mode will constantly refocus the camera on your subject the entire time you are depressing the shutter release button. This is great for sports and action photography. The AF-A mode is a combination of both of the previous modes, using AF-S mode unless it senses that the subject is moving, when it will switch to AF-C mode.

Chapter 3 Assignments

These assignments will have you shooting in the various automatic scene modes so that you can experience the advantages and disadvantages of using them in your daily photography.

Shooting in Auto mode

It's time to give up complete control and just concentrate on what you see in the viewfinder. Set your camera to Auto and practice shooting in a variety of conditions, both indoors and outside. Take notice of the camera settings when you are reviewing your pictures. Try using the AF-S focus point to pick a spot to focus on and then recompose before taking the picture.

Checking out Portrait mode

Grab your favorite photogenic person and start shooting in Portrait mode. Try switching between Auto and Portrait mode while photographing the same person in the same setting. You should see a difference in the sharpness of the background as well as the skin tones. If you are using a zoom lens, set it to about 55mm if available.

Capturing the scenery with Landscape and Close Up modes

Take your camera outside for some landscape and macro work. First, find a nice scene and then, with your widest available lens, take some pictures using Landscape mode. Then switch back to Auto so that you can compare the settings used for each image as well as the changes to colors and sharpness. Now, while you are still outside, find something in the foreground—a leaf or a flower—and switch the camera to Close Up mode. See how close you can get and take note of the f-stop that the mode uses. Then switch to Auto and shoot the same subject.

Stopping the action with Sports mode

This assignment will require that you find a subject that is in motion. That could be the traffic in front of your home or your child at play. The only real requirement is that the subject be moving. This will be your opportunity to test out Sports mode. There isn't a lot to worry about here. Just point and shoot. Try shooting a few frames one at a time and then go ahead and hold down the shutter button and shoot a burst of about five or six frames. It will help if your subject is in good available light to start with so that the camera won't be forced to use high ISOs.

Let your camera do the mentoring

How many times have you wondered what settings you should use for a particular shot? Here's what I tell my students—if you're in doubt, place your camera on the auto settings and take note of what your camera thinks is the best ISO, aperture, and speed. Your camera won't always be right, but it's going to give you a great baseline. Then adjust one element at a time and retake the shot to see what happens. This will help you understand how each of the settings affects the shot.

Share your results with the book's Flickr group!

Join the group here: flickr.com/groups/nikond7000_fromsnapshotstogreatshots

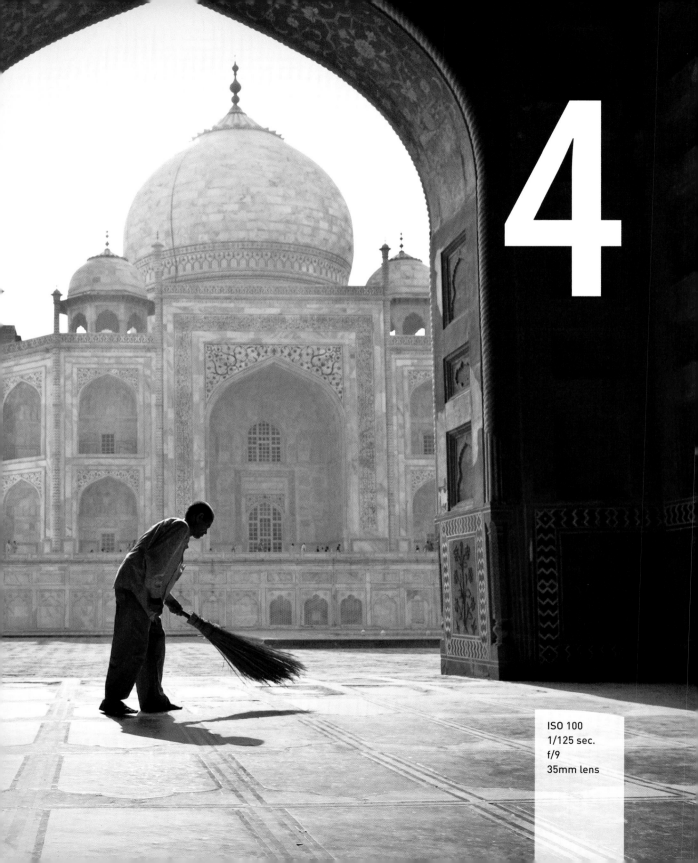

4

ISO 100
1/125 sec.
f/9
35mm lens

The Professional Modes

TAKING YOUR PHOTOGRAPHY TO THE NEXT LEVEL

If you talk to professional photographers, you will find that the majority of them use a few selective modes that offer the greatest amount of control over their photography. To anyone who has been involved with photography for any period of time, these modes are the backbones of the art. They allow you to influence two of the most important factors in taking great photographs: *aperture* and *shutter speed.* To access these modes, you simply turn the Mode dial to one of the letter-designated modes and begin shooting. But wouldn't it be nice to know exactly what those modes control and how to make them do our bidding? Well, if you really want to take that next step in controlling your photography, it is essential that you understand not only how to control these modes but why you are controlling them. So let's move that Mode dial to the first of our professional modes: Program mode.

PORING OVER THE PICTURE

I love wandering the streets of Chicago in the late evening when the crowds die down and you feel as though you're the city's sole inhabitant. I took this image on one of my many strolls through the city. It was a cold winter evening, and the face in the fountain made it feel as though Big Brother was watching. I knew immediately that I wanted to create a strong black-and-white image. The lighting was tricky, given that it was very dark out and I was photographing a bright image. I needed the correct exposure to avoid blowing out the face. I took several test shots (that's a fancy way of saying garbage shots) and finally landed on this image.

Killer tip—If you're not sure what settings to use, then consider placing your camera in Auto mode and referencing the settings the camera wants to use. This is a great way to create a baseline to start from.

Manual mode was a must here since I needed control over the speed as well as the aperture.

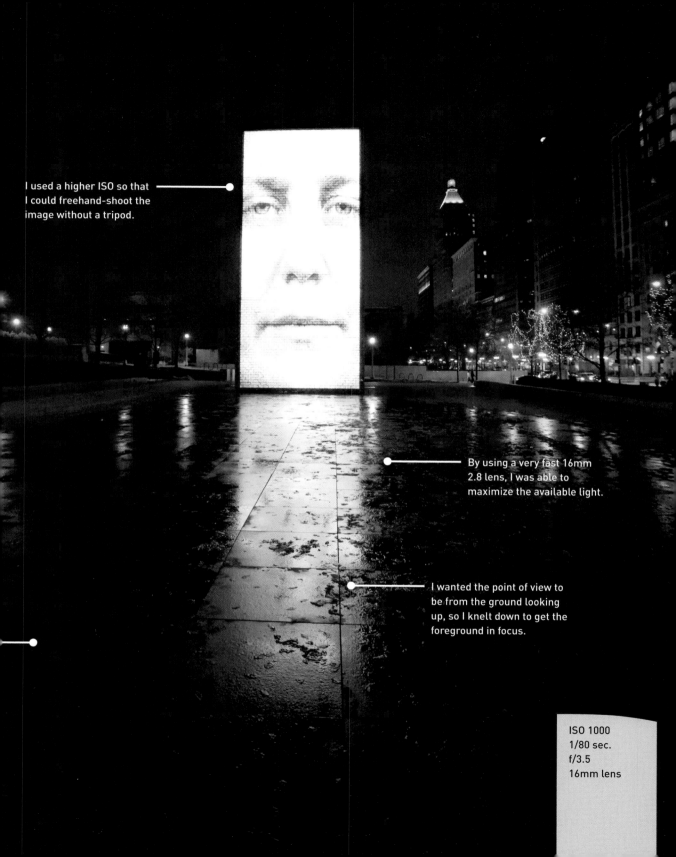

I used a higher ISO so that I could freehand-shoot the image without a tripod.

By using a very fast 16mm 2.8 lens, I was able to maximize the available light.

I wanted the point of view to be from the ground looking up, so I knelt down to get the foreground in focus.

ISO 1000
1/80 sec.
f/3.5
16mm lens

I had my tripod but no cable release, so I used the Exposure Delay mode to engage the shutter and minimize camera shake.

I framed this image trying to balance the pillars to the left and the skyline straight ahead, with the couple to the right.

ISO 100
1/50 sec.
f/10
80mm lens

This might end up being known as the Chicago chapter. I live in Chicago during the winter and in Montana in the summer. I tend to love extremes, and Chicago is a wonderful city for a midwestern guy like me. Everyone knows the famous Chicago skyline, and if you're ever visiting I strongly recommend wandering about the lakeshore as the sun sets. I was out taking photos with a friend when I noticed couples gathering to enjoy the beautiful spring evening and the same gorgeous scene I was seeking out. I decided to pause, setup my tripod, and capture the moment.

I always recommend placing your mirror in lockup to avoid mirror shake so you get a super-sharp image.

Composition is a balancing act. The people add another element of interest to the image; be careful not to crop too much of the environment out of the frame. My rule is leave in enough information so that your photo tells a good story and crop out any distractions.

P: PROGRAM MODE

 I think of Program mode as a good place to begin for those graduating from the automatic or scene modes (**Figure 4.1**). There is a reason that Program mode is only one click away from the automatic modes: With respect to apertures and shutter speeds, the camera is doing most of the thinking for you. So if that is the case, why even bother with Program mode?

First, let me say that I rarely use Program mode because it just doesn't give as much control over the image-making process as the other professional modes. There are occasions, however, when it comes in handy, like when I am shooting in widely changing lighting conditions and I don't have the time to think through all of my options, or I'm not very concerned with having ultimate control of the scene. Think of a picnic outdoors in a partial shade/sun environment. I want great-looking pictures, but I'm not looking for anything to hang in a museum. If that's the scenario, why choose Program over one of the scene modes? Because it gives me choices and control that none of the scene modes can deliver.

FIGURE 4.1
Use Program mode for flexible control and as a great place to start learning professional modes.

Manual Callout

To see available settings for each mode, check out the table on pages 292–294 of your owner's manual.

WHEN TO USE PROGRAM (P) MODE INSTEAD OF THE AUTOMATIC SCENE MODES

It's graduation time and you're ready to move on to a more advanced mode but not quite ready to jump in with both feet. When does Program mode come in handy?

• When shooting in a casual environment where quick adjustments are needed

• When you want more control over the ISO

• If you want to make corrections to the white balance

• When you want to change shutter speeds or the aperture to achieve a specific result

Let's go back to our picnic scenario. As I said, the light is moving from deep shadow to bright sunlight, which means that the camera is trying to balance our three photo factors (ISO, aperture, and shutter speed) to make a good exposure. From Chapter 1, we know that Auto ISO is generally not what we want except when in shooting in Auto mode, so we have already turned that feature off (you did turn it off, didn't you?). Well, in Program mode, you can choose which ISO you would like the camera to base its exposure on. The lower the ISO number, the better the quality of photographs, but the less light sensitive the camera becomes. It's a balancing act, with the main goal always being to keep the ISO as low as possible—too low an ISO, and we will get camera shake in our images from a long shutter speed; too high an ISO, and we will have an unacceptable amount of digital noise (**Figures 4.2** and **4.3**). For now, let's go ahead and select ISO 400 so that we provide enough sensitivity for those shadows while allowing the camera to use shutter speeds that are fast enough to stop motion.

FIGURE 4.2
Look closely and you'll notice the image is grainy or has small pixels. That's digital noise. Now, look at the same image taken at a lower 100 ISO.

FIGURE 4.3
Notice the detail in the black plastic and how little noise is in the image.

STARTING POINTS FOR ISO SELECTION

Many years ago camera manufacturers were racing to create cameras with more megapixels. Today the digital race is all about higher ISO. Photographers want to be able to shoot in lower light conditions without the risk of digital noise. There is a lot of discussion concerning ISO in this and other chapters, but it might be helpful if you know where your starting points should be for your ISO settings. The first thing you should always try to do is use the lowest possible ISO setting. Your D7000 has a good working range of 100–6400. That being said, here are good starting points for your ISO settings:

- 100: Bright, sunny day
- 200: Hazy or outdoor shade on a sunny day
- 400: Indoor lighting at night or cloudy conditions outside
- 800: Late night, low-light conditions or sports arenas at night
- 1600: Very low light; possibly candlelight or events where no flash is allowed
- 3200-6400: Extreme low light (some digital noise will be present; however, less than ever before)

These are just suggestions; you'll have to adjust as necessary. Your ISO selection will depend on a number of factors that will be discussed later in the book.

With the ISO selected, we can now make use of the other controls built into Program mode. By rotating the Command dial, we now have the ability to shift the program settings. Remember, your camera is using the internal meter to pick what it deems suitable exposure values, but sometimes it doesn't know what it's looking at and how you want those values applied (**Figures 4.4** and **4.5**). With the program shift, you can influence what the shot will look like. Do you need faster shutter speeds in order to stop the action? Just turn the Command dial to the right. Do you want a smaller aperture so that you get a narrow depth of field? Turn the dial to the left until you get the desired aperture. The camera shifts the shutter speed and aperture accordingly to get a proper exposure.

You will also notice that a small star will appear above the letter P in the viewfinder and the rear display if you rotate the Command dial. This star is an indication that you modified the exposure from the one the camera chose. To go back to the default Program exposure, simply turn the dial until the star goes away or switch to a different mode and then back to Program mode again.

ISO 200
1/800 sec.
f/5.6
58mm lens

FIGURE 4.4
This image was shot using the Program mode. What's key here is how the speed of the shutter changes between the two images. In this image the shutter was faster because the image is lighter than the image in Figure 4.5. Since the image is lighter, the camera needs less time to expose the image, so the shutter opens and closes very quickly—in this case, 1/160 of a second quicker.

ISO 200
1/640 sec.
f/5.6
105mm lens

FIGURE 4.5
By zooming in on the bronze statue, our image now becomes darker than in Figure 4.4 because there is less of the bright blue sky. The camera needs more light to properly expose the image, so the shutter is left open longer.

Let's set up the camera for Program mode and see how we can make all of this come together.

1. Turn your camera on and then turn the Command dial to align the P with the indicator line.

2. Select your ISO by pressing and holding the ISO button on the back left of the camera while rotating the main Command dial with your thumb.

3. The ISO will appear on the top display. Choose your desired ISO, and release the ISO button on the left to lock in the change.

4. Point the camera at your subject and then activate the camera meter by depressing the shutter button halfway.

5. View the exposure information in the bottom of the viewfinder or by looking at the display panel on the back of the camera.

6. While the meter is activated, use your thumb to roll the Command dial left and right to see the changed exposure values.

7. Select the exposure that is right for you and start clicking. (Don't worry if you aren't sure what the right exposure is yet. We will work on making the right choices for those great shots beginning with the next chapter.)

S: SHUTTER PRIORITY MODE

 S mode is what we photographers commonly refer to as Shutter Priority mode. Just as the name implies, it is the mode that prioritizes or places major emphasis on the shutter speed above all other camera settings (**Figure 4.6**).

Just as with Program mode, Shutter Priority mode gives us more freedom to control certain aspects of our photography. In this case, we are talking about shutter speed. The selected shutter speed determines just how long you expose your camera's sensor to light. The longer it remains open, the more time your sensor has to gather light.

FIGURE 4.6
Shutter Priority mode is great for freezing or showing motion. Use this mode when your shutter speed is of utmost importance.

The shutter speed also, to a large degree, determines how sharp your photographs are. Even though an image may appear sharply in focus, any movement by the subject or the camera while the shutter is open can blur the image. If you think about it, when you are trying to show motion, you want a slower shutter speed because it blurs the image.

A good rule of thumb for avoiding blurry images is to always use a shutter speed as fast as your focal length. For instance, if I'm out photographing my daughter with an 80mm lens, then I'll want to make sure my shutter speed is at least 1/120 of a second, taking into account that the camera is not full frame, so the actual focal length is greater than the focal length of the lens. Anything less than that might cause camera shake (even if you're equipped with biceps as big as Popeye's). The D7000 has a 1.5x magnification, so if your focal length is 100mm, you shouldn't shoot less than 1/150 of a second.

SHUTTER SPEEDS

A *slow* shutter speed refers to leaving the shutter open for a long period of time—like 1/30 of a second or less. A *fast* shutter speed means that the shutter is open for a very short period of time—like 1/250 of a second or more. The faster the shutter, the less information your sensor can gather, so you will get less detail in your image.

WHEN TO USE SHUTTER PRIORITY (S) MODE

- When working with fast-moving subjects where you want to freeze the action (**Figure 4.7**); much more on this is in Chapter 5

- When you want to emphasize movement in your subject with motion blur (**Figure 4.8**)

- When you want to use a long exposure to gather light over a long period of time (**Figure 4.9**); more on this is in Chapter 8

- When you want to create that smooth-looking water in a waterfall (**Figure 4.10**)

FIGURE 4.7
Whenever I'm planning on freezing motion I always make sure I'm shooting with a fast shutter speed. I knew the rodeo would be giving me lots of opportunity for that kind of action, so I set my speed to be very fast so that I could capture every movement of the horse and the rider.

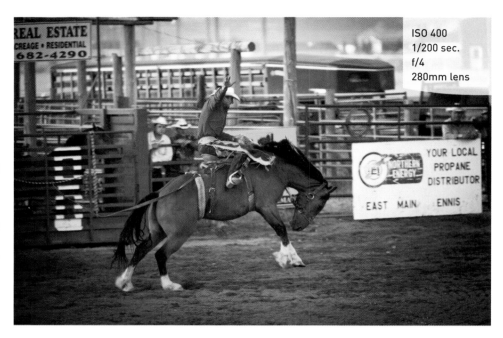

ISO 400
1/200 sec.
f/4
280mm lens

FIGURE 4.8
If you're photographing a fast-moving subject and wish to convey a sense of motion, always use a slower shutter. In this image I wanted to blur the background while freezing the subject, so it required me to use a slower shutter while following or "panning" with subject in focus.

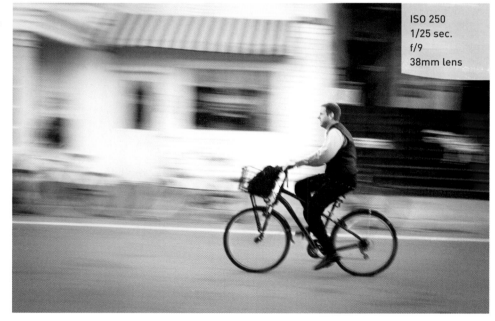

ISO 250
1/25 sec.
f/9
38mm lens

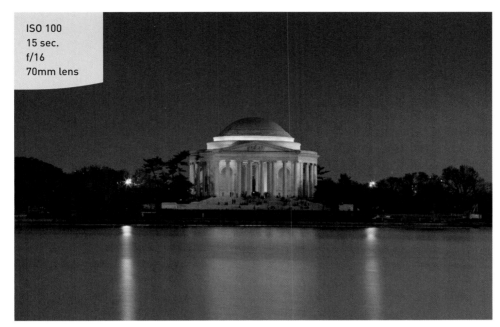

ISO 100
15 sec.
f/16
70mm lens

FIGURE 4.9
I took this very long exposure of the Jefferson Monument in D.C. using a tripod and a cable release. There's no way I could have held the camera steady for 15 seconds! A tripod is a must for these super-long exposures.

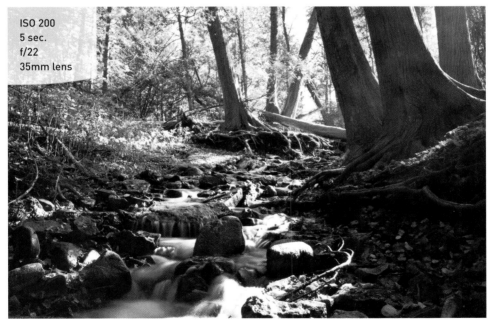

ISO 200
5 sec.
f/22
35mm lens

FIGURE 4.10
I used a cable release and tripod to photograph this small creek on Mackinac Island, Michigan. I was able to create a smooth look to the water by increasing the length of the exposure using Shutter Priority Mode.

As you can see, the subject of your photo usually determines whether or not you will use Shutter Priority mode. It is important that you be able to previsualize the result of using a particular shutter speed. The great thing about shooting with digital cameras is that you get instant feedback by viewing your shot on the LCD screen. But what if your subject won't give you a do-over? Such is often the case when shooting sporting events. It's not like you can go ask your daughter to score another goal in her soccer game because your photograph was blurry from a slow shutter speed. This is why it's important to know what those speeds represent in terms of their capabilities to stop the action and deliver a blur-free shot.

First, let's examine just how much control you have over the shutter speeds. The D7000 has a shutter speed range from 1/8000 of a second all the way down to 30 seconds. With that much latitude, you should have enough control to capture almost any subject. The other thing to think about is that Shutter Priority mode is considered a semiautomatic mode. This means that you are taking control over one aspect of the total exposure while the camera handles the other. In this instance, you are controlling the shutter speed and the camera is controlling the aperture. This is important, because there will be times that you want to use a particular shutter speed but your lens won't be able to accommodate your request.

For example, you might encounter this problem when shooting in low-light situations: If you are shooting a fast-moving subject that will blur at a shutter speed slower than 1/125 of a second but your lens's largest aperture is f/3.5, you might find your aperture display in your viewfinder and the rear LCD panel will display the word "Lo." This is your warning that there won't be enough light available for the shot—due to the limitations of the lens—so your picture will be underexposed.

Another case where you might run into this situation is when you are shooting moving water. To get that look of smooth, flowing water, it's usually necessary to use a shutter speed of at least 1/15 of a second. If your waterfall is in full sunlight, you may get a message that reads "Hi" because the lens you are using only stops down to f/22 at its smallest opening. In this instance, your camera is warning you that you will be overexposing your image. There are workarounds for these problems, which we will discuss later, but it is important to know that there can be limitations when using Shutter Priority mode.

SETTING UP AND SHOOTING IN SHUTTER PRIORITY MODE

1. Turn your camera on and then turn the Mode dial to align the S with the indicator line.

2. Select your ISO by pressing and holding the ISO button on the back left of the camera while rotating the main Command dial with your thumb.

3. The ISO will appear on the top display. Choose your desired ISO, and release the ISO button on the left to lock in the change.

4. Point the camera at your subject and then activate the camera meter by depressing the shutter button halfway.

5. View the exposure information in the bottom area of the viewfinder or by looking at the rear LCD panel.

6. While the meter is activated, use your thumb to roll the Command dial left and right to see the changed exposure values. Roll the dial to the right for faster shutter speeds and to the left for slower speeds.

A: APERTURE PRIORITY MODE

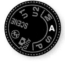 Probably the mode most widely used by professional photographers, Aperture Priority is one of my personal favorites, and I believe that it will quickly become one of yours. Aperture Priority mode is also deemed a semiautomatic mode because it allows you to once again control one factor of exposure while the camera adjusts for the other (**Figure 4.11**).

Why is this one of my favorite modes? It's because the aperture of your lens dictates depth of field. Depth of field, along with composition, is a major factor in how you

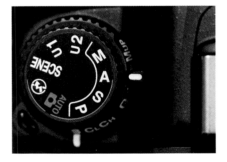

FIGURE 4.11
Use Aperture Priority mode when you need to control depth of field. This is my favorite shooting mode.

direct attention to what matters in your image. It is the controlling factor of how much area in your image is sharp. If you want to isolate a subject from the background, such as when shooting a portrait, you can use a large aperture to keep the focus on your subject and make both the foreground and background blurry. If you want to keep the entire scene sharply focused, as with a landscape scene, then using a small aperture will render the greatest amount of depth of field possible.

WHEN TO USE APERTURE PRIORITY (A) MODE

- When shooting portraits or wildlife (**Figure 4.12**)
- When shooting most landscape photography (**Figure 4.13**)
- When shooting macro, or close-up, photography (**Figure 4.14**)
- When shooting architectural photography, which often benefits from a large depth of field (**Figure 4.15**)

FIGURE 4.12
The lizard was very still so I was able to use a tripod and zoom in tightly. The large aperture helped create a smooth, blurry background also known as bokeh.

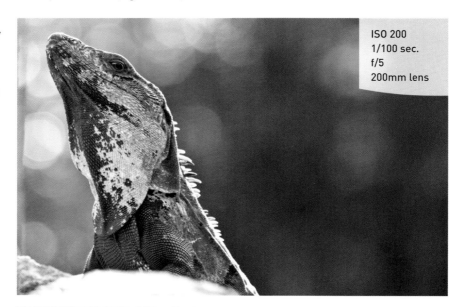

ISO 200
1/100 sec.
f/5
200mm lens

FIGURE 4.13
The smaller aperture setting brings sharpness to near and far objects.

ISO 200
1/200 sec.
f/10
27mm lens

ISO 160
1/640 sec.
f/22
27mm lens

FIGURE 4.14
Using a very small aperture on a clear blue day, I was able to create this sunburst. Typically f/16 or higher will do the trick! Give it a try. The key ingredient is a clear sky, since clouds will diffuse the sun.

ISO 100
1/50 sec.
f/10
80mm lens

FIGURE 4.15
I wanted the foreground as well as the background in focus, so I used a wide-angle lens combined with a small aperture to maintain focus throughout the image. This is called a deep depth of field.

F-STOPS AND APERTURE

As discussed earlier, the numeric value of your lens aperture is described as an *f-stop*. The f-stop is one of those old photography terms that, technically, relates to the focal length of the lens (e.g., 200mm) divided by the effective aperture diameter. These measurements are defined as "stops" and work incrementally with your shutter speed to determine proper exposure. Older camera lenses used one-stop increments to assist in exposure adjustments, such as 1.4, 2, 2.8, 4, 5.6, 8, 11, 16, and 22. Each stop represents about half the amount of light entering the lens iris as the larger stop before it. Today, most lenses don't have f-stop markings, since all adjustments to this setting are performed via the camera's electronics. The stops are also now typically divided into 1/3-stop increments to allow much finer adjustments to exposures, as well as to match the incremental values of your camera's ISO settings, which are also adjusted in 1/3-stop increments.

I strongly recommend knowing your lens's aperture rating. Every lens has a marking on it with a number; f/1.4, f/2.8, or f/5.6 are all very common maximum aperture sizes. This number simply means the largest aperture your lens supports is f/1.4, f/2.8, or f/5.6, respectively. The D7000 kit ships with a standard 18–105mm lens with an f/3.5–f/5.6 variable maximum aperture (see note below).

Knowing the limits of your lens aperture is crucial when using Aperture Priority. As a general rule, the lower the number on the lens, the "faster" it is (because it allows more light in to expose the image, thus reducing the amount of shutter time) and the sharper the image is. Typically, fast lenses are heavier and more expensive, but well worth the investment if you find yourself shooting in low light conditions. The larger the aperture is, the better the exposure without having to increase ISO and introduce digital noise.

See page 269 in your Nikon D7000 owner's manual to determine the maximum aperture of your lens.

On the other hand, bright scenes require the use of a small aperture (such as f/16 or f/22), especially if you want to use a slower shutter speed. That small opening reduces the amount of incoming light, and this reduction of light requires that the shutter stay open longer.

1. Turn your camera on and then turn the Mode dial to align the A with the indicator line.

2. Select your ISO by pressing and holding the ISO button on the back left of the camera while rotating the main Command dial with your thumb.

3. The ISO will appear on the top display. Choose your desired ISO, and release the ISO button on the left to lock in the change.

4. Point the camera at your subject and then activate the camera meter by depressing the shutter button halfway.

5. View the exposure information in the bottom area of the viewfinder or by looking at the rear display panel.

6. While the meter is activated, use your thumb to roll the Command dial left and right to see the changed exposure values. Roll the dial to the right for a smaller aperture (higher f-stop number) and to the left for a larger aperture (lower f-stop number).

ZOOM LENSES AND MAXIMUM APERTURES

Some zoom lenses (like the 18–105mm kit lens) have a variable maximum aperture. This means that the largest opening will change depending on the zoom setting. In the example of the 18–105mm zoom, the lens has a maximum aperture of f/3.5 at 18mm and only f/5.6 when the lens is zoomed out to 105mm.

M: MANUAL MODE

 Manual mode is all about control. Keep in mind, this mode was not designed for those of us who want to go on autopilot and shoot to our heart's content. This mode was designed to allow the photographer to take complete control of shutter speed and aperture (**Figure 4.16**). The camera doesn't do any of the work for you.

When you have your camera set to Manual (M) mode, the camera meter will give you a reading of the scene you are photographing.

FIGURE 4.16
For ultimate control of shutter speed and aperture, use Manual mode.

It's your job, though, to set both the f-stop (aperture) and the shutter speed to achieve a correct exposure. If you need a faster shutter speed, you will have to make the reciprocal change to your f-stop. Using any other mode, such as Shutter Priority or Aperture Priority, would mean that you just have to worry about one of these changes, but Manual mode means you have to do it all yourself. This can be a little challenging at first, but after a while you will have a complete understanding of how each change affects your exposure, which will, in turn, improve the way that you use the other modes.

WHEN TO USE MANUAL (M) MODE

- When lighting and exposure get tricky (**Figure 4.17**)
- When your environment is fooling your light meter and you need to maintain a certain exposure setting (**Figure 4.18**)
- When shooting silhouetted subjects, which requires overriding the camera's meter readings (**Figure 4.19**)

FIGURE 4.17
Shooting indoors can be tricky. The wonderful thing about your D7000 is that it has an incredible ISO range with relatively low digital noise. I took this image behind glass and wanted to avoid having my flash trigger because that would have left a nasty reflection. I decided to bump up my ISO and use a large aperture to get this shot.

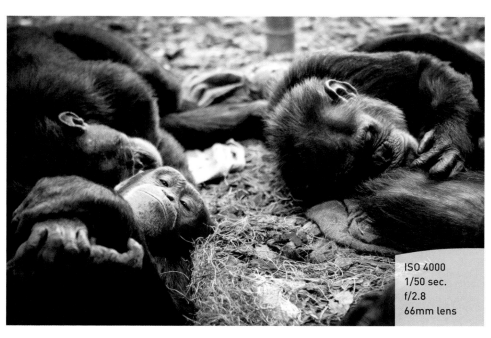

ISO 4000
1/50 sec.
f/2.8
66mm lens

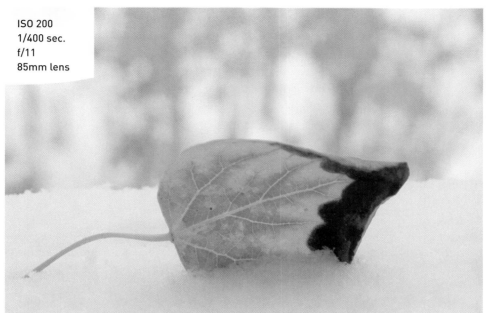

ISO 200
1/400 sec.
f/11
85mm lens

FIGURE 4.18
Beaches and snow are always a challenge for light meters. Whenever I'm shooting something in snow I find myself switching over to manual mode. A good rule of thumb in snow is to bump your exposure up +1 or to +2 if it's really sunny. That should get you closer to the correct exposure.

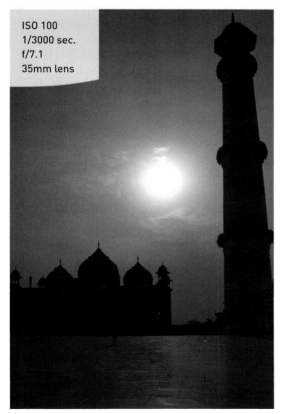

ISO 100
1/3000 sec.
f/7.1
35mm lens

FIGURE 4.19
The camera's meter will do a great job most of the time, but when you want to get creative sometimes you need to use the Manual mode. Using Manual mode allowed me to silhouette the buildings while maintaining the warm glow of the sun.

SETTING UP AND SHOOTING IN MANUAL MODE

1. Turn your camera on and then turn the Mode dial to align the M with the indicator line.

2. Select your ISO by pressing and holding the ISO button on the back left of the camera while rotating the main Command dial with your thumb.

3. The ISO will appear on the top display. Choose your desired ISO, and release the ISO button on the left to lock in the change.

4. Point the camera at your subject and then activate the camera meter by depressing the shutter button halfway.

5. View the exposure information in the bottom area of the viewfinder or by looking at the display panel on the rear of the camera.

6. While the meter is activated, use your thumb to roll the Command dial left and right to change your shutter speed value until the exposure mark is lined up with the zero mark. The exposure information is displayed by a scale with marks that run from –2 to +2 stops. A proper exposure will line up with the arrow mark in the middle. As the indicator moves to the left, it is a sign that you will be underexposing (there is not enough light on the sensor to provide adequate exposure). Move the indicator to the right and you will be providing more exposure than the camera meter calls for. This is overexposure.

7. To set your exposure using the aperture, depress the shutter release button until the meter is activated. Then, while holding down the Exposure Compensation/Aperture button (located behind and to the right of the shutter release button), rotate the Command dial to change the aperture. Rotate right for a smaller aperture (large f-stop number) and left for a larger aperture (small f-stop number).

USER SETTINGS MODE—SAVING YOUR FAVORITE SETTINGS TO THE MODE DIAL

 In 2010, Nikon introduced user settings to your D7000. This is a great feature if you're looking to have your favorite settings at the touch of a dial. These are located on the dial as U1 and U2. If you have a favorite group of settings that you find you are using often and want to have them close at hand, then these modes are handy for you.

• First, set the camera to your favorite settings, under any of the semiautomatic modes or Manual mode, adjusting aperture, shutter speed, ISO, flash, focus point, metering, and/or bracketing.

- Go to the setup menu, and click on Save User Settings (**A**), (**B**).

- Highlight U1 or U2, then click OK to save your settings (**C**).

- When you want to use those settings again, just rotate the top dial to U1 or U2, and the camera will choose your saved settings so that you're ready to go (**D**).

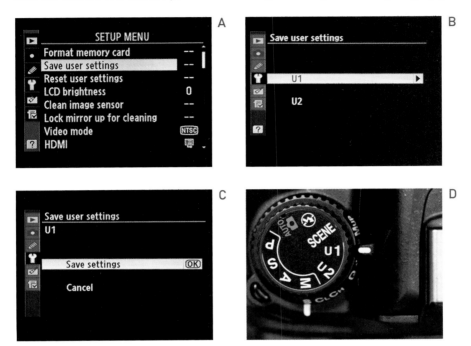

For more on setting up user modes, see page 75 of your owner's manual.

HOW I SHOOT: MY FAVORITE CAMERA SETTINGS

I'm generally a landscape and travel photographer, but like many of you, I enjoy photographing everything. There's very little that doesn't interest me. I have found throughout the years that I primarily use the Aperture Priority mode. Why? Often when I'm traveling and photographing streetscapes I don't have time to worry about every single variable, and I've found focusing on aperture has given me the control I need for 75 percent of my photography. If I want an image to have a shallow depth of field, then I'll use a large aperture such as f/2.8, or if I'm shooting a landscape and I need a greater depth of field I'll use a smaller aperture such as f/16.

However, sometimes Aperture Priority just doesn't work. Maybe the lighting is tricky or it's close but not quite right. In those cases I'll switch over to Manual mode. Almost

all of my landscape photography that I've shot during the golden hours was done in Manual mode because the light changes very quickly.

Each photographer has a different way of doing things. No one approach is necessarily better than the other. In the end, it's about creating your own system so that you're consistent. When you're consistent, you can measure results and then make changes accordingly.

When I first started out photographing in Aperture Priority, the biggest mistake I made was shooting with much too slow of a shutter speed. I would get blurry pictures and I would ask myself, "How did this happen? They looked super sharp when I took them." I would then look at the metadata (image information) and see that I shot the blurry image at 1/30 of a second, way too slow for hand-holding. So I learned my lesson and started shooting a little faster, and my results improved immensely.

Doing things consistently and measuring results is a great way to improve your photography. Don't ignore the metadata; it's very helpful in understanding why an image looks a certain way and learning how to change your setting the next time to make the image stronger.

While the other camera modes have their place, I think you will find that most professional photographers use the Aperture Priority and Shutter Priority modes for 90 percent of their shooting.

The other concern that I have when I am setting up my camera is just how low I can keep my ISO. This is always a priority for me because a low ISO will deliver the cleanest image. I raise the ISO only as a last resort because each increase in sensitivity is an opportunity for more digital noise to enter my image. To that end, I always have the High ISO Noise Reduction feature turned on (see Chapter 7).

To make quick changes while I shoot, I often use the Exposure Compensation feature (covered in Chapter 7) so that I can make small over- and underexposure changes. This is different than changing the aperture or shutter; it is more like fooling the camera meter into thinking the scene is brighter or darker than it actually is. To get to this function quickly, I simply press the Exposure Compensation button, right next to the shutter button, then dial in the desired amount of compensation using the Command dial. If you can't get the exact exposure you want with aperture and speed alone, make little adjustments to the exposure compensation.

Moving Target

HOW TO SHOOT WHEN YOUR SUBJECT IS IN MOTION

Now that you have learned about the professional modes, it's time to put your newfound knowledge to good use. Whether you are shooting the action at a professional sporting event or a child on a merry-go-round, you'll learn techniques that will help you bring out the best in your photography when your subject is in motion.

The number one thing to know when trying to capture a moving target is that speed is king! I'm not talking about how fast your subject is moving but rather how fast your shutter is opening and closing. Shutter speed is the key to freezing the moment in time—but also to conveying movement. It's all in how you turn the dial. There are some other considerations for taking your shot to the next level, too: composition, lens selection, and a few more items that we will explore in this chapter. So strap on your seat belt and hit the gas, because here we go!

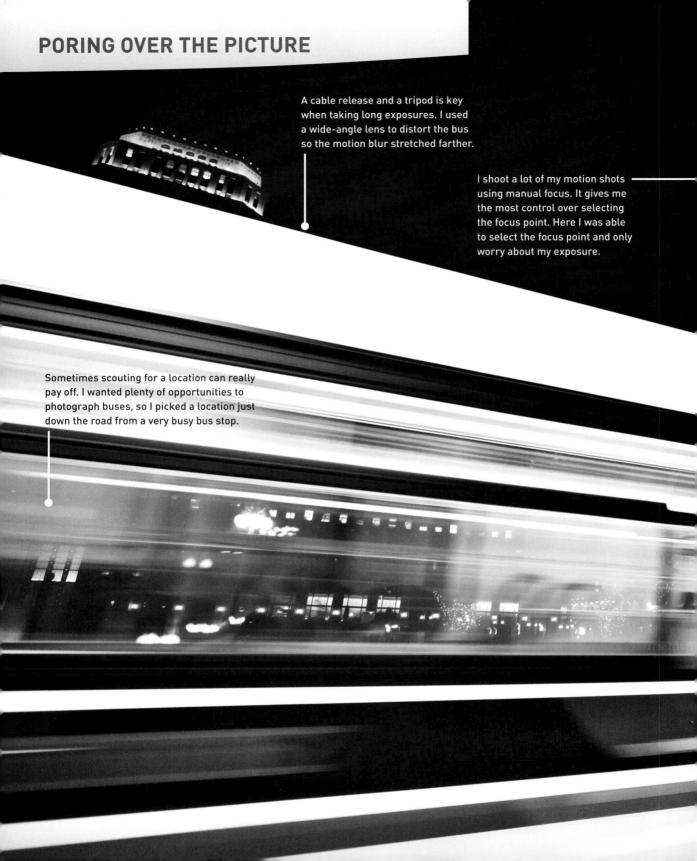

PORING OVER THE PICTURE

A cable release and a tripod is key when taking long exposures. I used a wide-angle lens to distort the bus so the motion blur stretched farther.

I shoot a lot of my motion shots using manual focus. It gives me the most control over selecting the focus point. Here I was able to select the focus point and only worry about my exposure.

Sometimes scouting for a location can really pay off. I wanted plenty of opportunities to photograph buses, so I picked a location just down the road from a very busy bus stop.

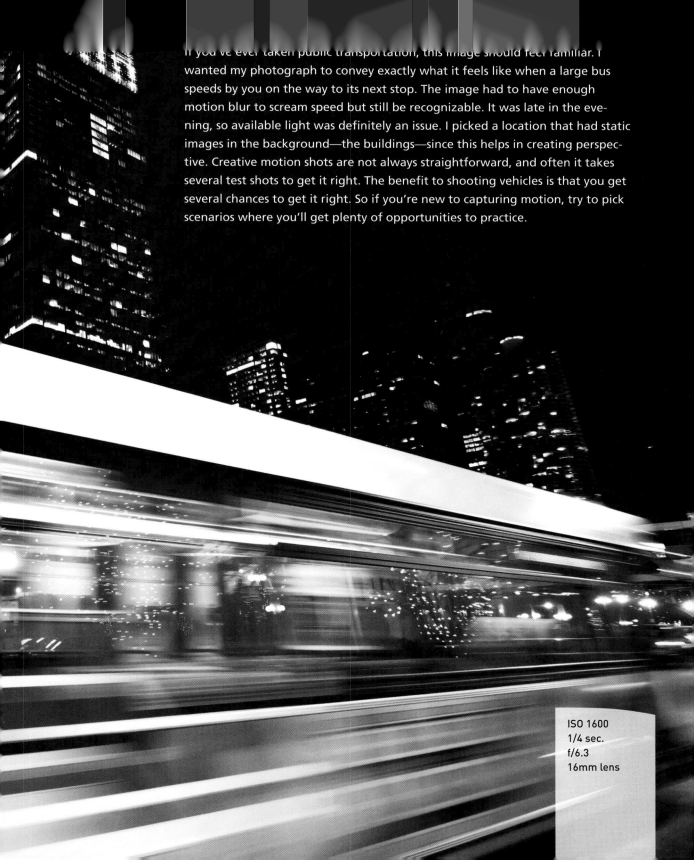

If you've ever taken public transportation, this image should feel familiar. I wanted my photograph to convey exactly what it feels like when a large bus speeds by you on the way to its next stop. The image had to have enough motion blur to scream speed but still be recognizable. It was late in the evening, so available light was definitely an issue. I picked a location that had static images in the background—the buildings—since this helps in creating perspective. Creative motion shots are not always straightforward, and often it takes several test shots to get it right. The benefit to shooting vehicles is that you get several chances to get it right. So if you're new to capturing motion, try to pick scenarios where you'll get plenty of opportunities to practice.

ISO 1600
1/4 sec.
f/6.3
16mm lens

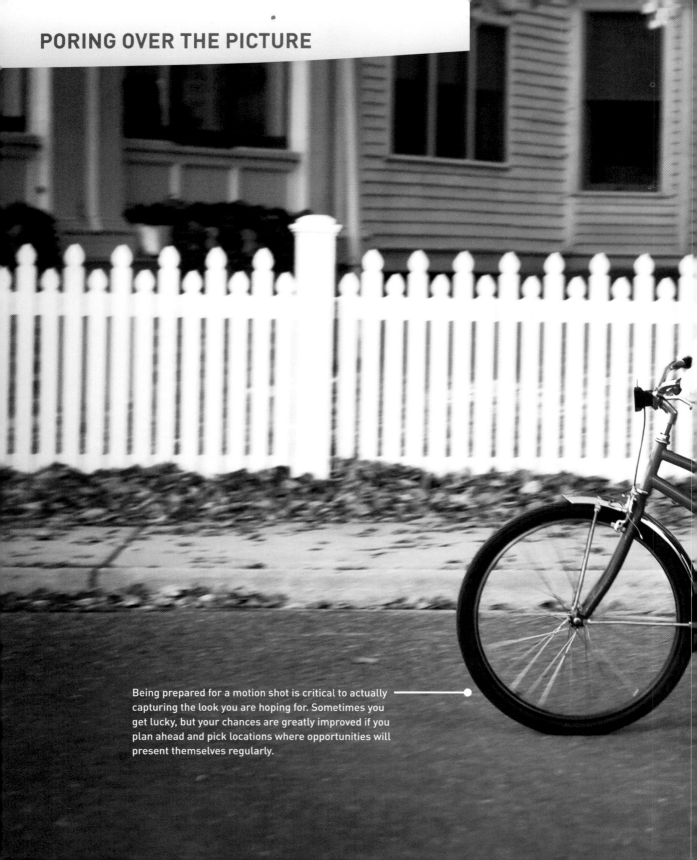

Being prepared for a motion shot is critical to actually capturing the look you are hoping for. Sometimes you get lucky, but your chances are greatly improved if you plan ahead and pick locations where opportunities will present themselves regularly.

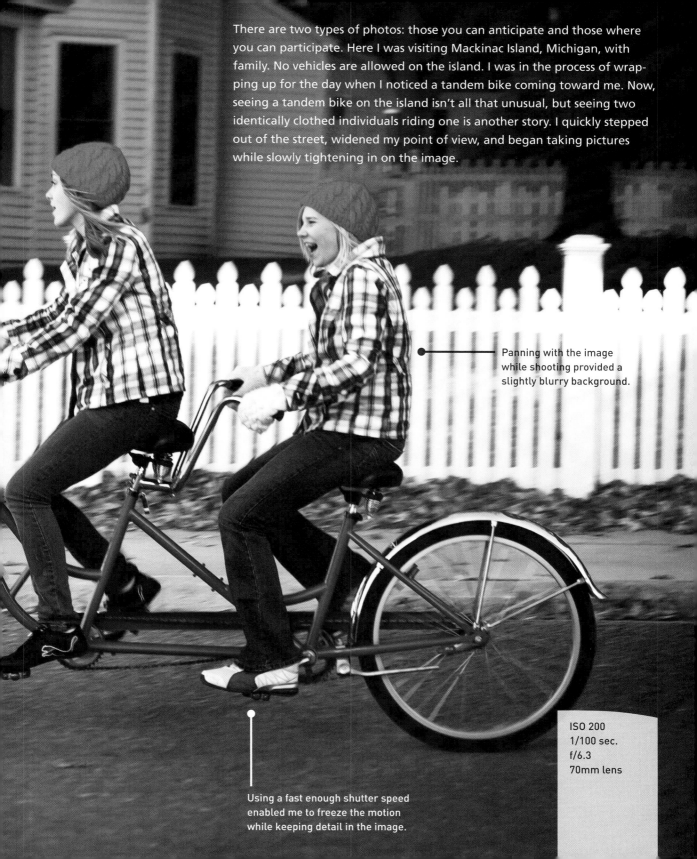

There are two types of photos: those you can anticipate and those where you can participate. Here I was visiting Mackinac Island, Michigan, with family. No vehicles are allowed on the island. I was in the process of wrapping up for the day when I noticed a tandem bike coming toward me. Now, seeing a tandem bike on the island isn't all that unusual, but seeing two identically clothed individuals riding one is another story. I quickly stepped out of the street, widened my point of view, and began taking pictures while slowly tightening in on the image.

Panning with the image while shooting provided a slightly blurry background.

ISO 200
1/100 sec.
f/6.3
70mm lens

Using a fast enough shutter speed enabled me to freeze the motion while keeping detail in the image.

STOP RIGHT THERE!

Shutter speed is the main tool in the photographer's arsenal for capturing great action shots. The ability to freeze a moment in time often makes the difference between a good shot and a great one. To take advantage of this concept, you should have a good grasp of the relationship between shutter speed and movement. When you press the shutter release button, your camera goes into action by opening the shutter curtain and then closing it after a predetermined length of time. The longer you leave your shutter open, the more your subject will move across the frame, so common sense dictates that the first thing to consider is just how fast your subject is moving.

Typically, you will be working in fractions of a second. How many fractions depends on several factors. Subject movement, while simple in concept, is actually based on three factors. The first is the direction of travel. Is the subject moving across your field of view (left to right) or traveling toward or away from you? The second consideration is the actual speed at which the subject is moving. There is a big difference between a moving sports car and a child on a bicycle. Finally, the distance from you to the subject has a direct bearing on how fast the action seems to be taking place. Let's take a brief look at each of these factors to see how they might affect your shooting.

DIRECTION OF TRAVEL

Typically, the first thing people think about when taking an action shot is how fast the subject is moving, but the first consideration should actually be the direction of travel. Where you are positioned in relation to the subject's direction of travel is critical in selecting the proper shutter speed. When you open your shutter, the lens gathers light from your subject and records it on the camera sensor. If the subject is moving across your viewfinder, you need a faster shutter speed to keep that lateral movement from being recorded as a streak across your image. Subjects that are moving perpendicular to your shooting location do not move across your viewfinder and appear to be more stationary. This allows you to use a slightly slower shutter speed (**Figure 5.1**). A subject that is moving in a diagonal direction—both across the frame and toward or away from you—requires a shutter speed in between the two.

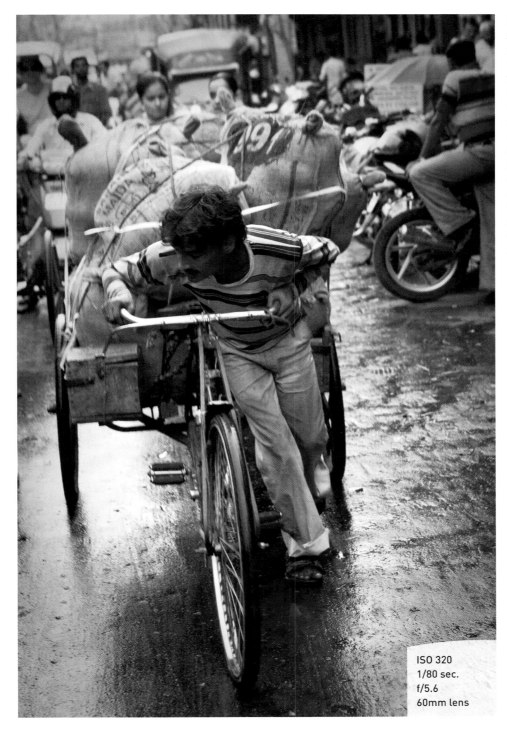

FIGURE 5.1
Action coming toward the camera can be captured with slower shutter speeds. This Indian man was pushing his bicycle right at me. By capturing him head on, I not only caught the movement but the look on his face that showed how much work it required to push the heavy load.

ISO 320
1/80 sec.
f/5.6
60mm lens

SUBJECT SPEED

Once the angle of motion has been determined, you can then assess the speed at which the subject is traveling. The faster your subject moves, the faster your shutter speed needs to be in order to "freeze" that subject (**Figure 5.2**). A person walking across your frame might only require a shutter speed of 1/60 of a second, while a cyclist traveling in the same direction would call for 1/500 of a second. That same cyclist traveling toward you at the same rate of speed, rather than across the frame, might only require a shutter speed of 1/125 of a second. You can start to see how the relationship of speed and direction comes into play in your decision-making process.

FIGURE 5.2
Everyone loves a parade, and the key to getting good shots is shooting at a fast enough shutter speed to capture your favorite moments. Here I needed to increase my shutter speed to catch this young girl riding her bike across the frame.

ISO 200
1/1000 sec.
f/5.6
140mm lens

SUBJECT-TO-CAMERA DISTANCE

So now we know both the direction and the speed of your subject. The final factor to address is the distance between you and the action. Picture yourself looking at a highway full of cars from up in a tall building a quarter of a mile from the road. As you stare down at the traffic moving along at 55 miles per hour, the cars and trucks seem to be slowly moving along the roadway. Now picture yourself standing in the median of that same road as the traffic flies by at the same rate of speed; it appears to be moving much faster.

Although the traffic is moving at the same speed, the shorter distance between you and the traffic makes the cars look like they are moving much faster. This is because your field of view is much narrower; therefore, the subjects are not going to present themselves within the frame for the same length of time. The concept of distance applies to the length of your lens as well (**Figure 5.3**). If you are using a wide-angle lens, you can probably get away with a slower shutter speed than if you were using a telephoto, which puts you in the heart of the action. It all has to do with your field of view. That telephoto gets you "closer" to the action—and the closer you are, the faster your subject will be moving across your viewfinder.

ISO 6400
1/250 sec.
f/2.8
160mm lens

FIGURE 5.3
Due to the distance from the camera, a slower shutter speed could be used to capture this action. For this dance recital, I was seated in the back of the auditorium. Although I had a zoom lens on, I was still at a distance from the movement. This is a great example of where I had to use a high ISO to get a workable shutter speed.

USING SHUTTER PRIORITY (S) MODE TO STOP MOTION

In Chapter 4, you were introduced to the professional shooting modes. As discussed there, the mode that gives you ultimate control over shutter speed is Shutter Priority, or S, mode, where you are responsible for selecting the shutter speed while handing over the aperture selection to the camera. The ability to concentrate on just one exposure factor helps you quickly make changes on the fly while staying glued to your viewfinder and your subject.

There are a couple of things to consider when using Shutter Priority mode, both of which have to do with the amount of light that is available when shooting. While you have control over which shutter speed you select in Shutter Priority mode, the range of shutter speeds that is available to you depends largely on how well your subject is lit.

Typically, when shooting fast-paced action, you will be working with very fast shutter speeds. This means that your lens will probably be set to a large aperture. If the light is not sufficient for the shutter speed selected, you will need to do one of two things: Select a lens that offers a larger working aperture, or raise the ISO of the camera.

ZOOM IN TO BE SURE

When reviewing your shots on the LCD, don't be fooled by the display. The smaller your image is, the sharper it will look. To ensure that you are getting sharp, blur-free images, make sure that you zoom in on your LCD display.

To zoom in on your images, press the Playback button located below the mode dial on the left and then press the Zoom In button to zoom (**Figure 5.4**). Continue pressing the Zoom In button to increase the zoom ratio.

To zoom back out, simply press the Zoom Out button (the magnifying glass with the minus sign on it) or press the Playback button again.

FIGURE 5.4
Zooming in on your image helps you confirm that the image is really sharp.

Playback

Zoom In

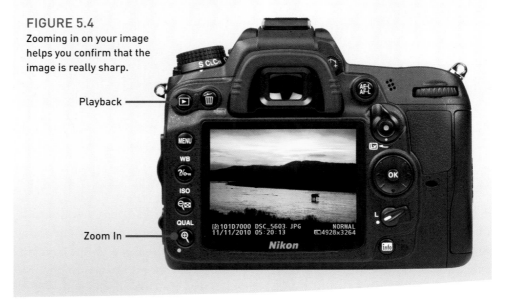

Working off the assumption that you have only one lens available, let's concentrate on balancing your exposure using the ISO.

Let's say that you are shooting a baseball game at night, and you want to get some great action shots. You set your camera to Shutter Priority mode and, after testing out some shutter speeds, determine that you need to shoot at 1/500 of a second to freeze the action on the field. When you place the viewfinder to your eye and press the shutter button halfway, you notice that the f-stop has been replaced by the word "Lo." This is your camera's way of telling you that the lens has now reached its maximum aperture and you are going to be underexposed if you shoot your pictures at the currently selected shutter speed. You could slow your shutter speed down until the Lo indicator goes away, but then you would get images with too much motion blur.

The alternative is to raise your ISO to a level that is fast enough for a proper exposure. The key here is to always use the lowest ISO that you can get away with. That might mean ISO 100 in bright sunny conditions or ISO 3200 for an indoor or night situation (**Figure 5.5**).

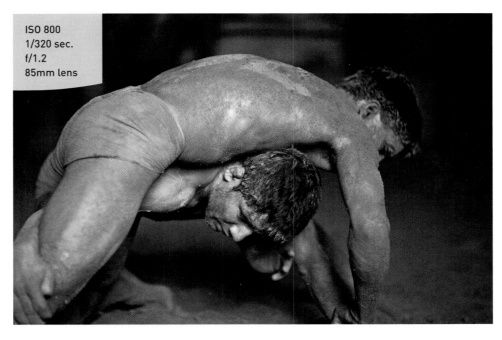

ISO 800
1/320 sec.
f/1.2
85mm lens

FIGURE 5.5
While in India I had a chance to photograph a Kushti wrestling match, which is a traditional style of wrestling performed in a dirt ring. This particular match was being performed in a poorly lit room, so I increased my ISO to 800 and shot wide open at an f/1.2 aperture in hopes of freezing the fast movements of the wrestlers.

Just remember that the higher the ISO, the greater the amount of noise in your image. This is the reason that you see professional sports photographers using those mammoth lenses perched atop a monopod: They could use a smaller lens, but to get those very large apertures they need a huge piece of glass on the front of the lens.

The larger the glass on the front of the lens, the more light it gathers, and the larger the aperture for shooting. For the working pro, the large aperture translates into low ISO (and thus low noise), fast shutter speeds, and razor-sharp action.

ADJUSTING YOUR ISO ON THE FLY

1. Look at the exposure values (the shutter speed and aperture settings) in the lower portion of your viewfinder.

2. If the word "Lo" appears where the aperture normally is, then it's time to increase the ISO (**A**).

3. Select the higher ISO by observing the control panel while pressing and holding the ISO button on the back of the camera and rotating the Command dial to the right. Once the desired ISO is selected, simply release the ISO button (**B**).

4. If you now see an aperture setting in the display, shoot away. If you still see the word "Lo," repeat steps 2 through 4 until it is set correctly.

 A

 B

USING APERTURE PRIORITY (A) MODE TO ISOLATE YOUR SUBJECT

One of the benefits of working in Shutter Priority mode with fast shutter speeds is that, more often than not, you will be shooting with the largest aperture available on your lens. Shooting with a large aperture allows you to use faster shutter speeds, but it also narrows your depth of field.

To isolate your subject in order to focus your viewer's attention on it, a larger aperture is required. The larger aperture reduces the foreground and background sharpness: the larger the aperture, the more blurred they will be.

The reason that I bring this up here is that when you are shooting most sporting events, the idea is to isolate your main subject by having it in focus while the rest of the image has some amount of blur. This sharp focus draws your viewer right to the subject. Studies have shown that the eye is drawn to sharp areas before moving on to the blurry ones. Also, depending on what your subject matter is, a busy background can be distracting if everything in the photo is equally sharp. Without a narrow depth of field, it might be difficult for the viewer to establish exactly what the main subject is in your picture.

Let's look at how to use depth of field to bring focus to your subject. In the previous section, I told you that you should use Shutter Priority mode for getting those really fast shutter speeds to stop action. Generally speaking, Shutter Priority mode will be the mode you most often use for shooting sports and other action, but there will be times when you want to ensure that you are getting the narrowest depth of field possible in your image. The way to do this is by using Aperture Priority mode, or A.

So how do you know when you should use Aperture Priority mode as opposed to Shutter Priority mode? There's no simple answer, but your LCD screen can help you make this determination. The best scenario for using Aperture Priority mode is a brightly lit scene where maximum apertures will still give you plenty of shutter speed to stop the action.

Let's say that you are shooting a soccer game in the midday sun. If you have determined that you need something between 1/500 and 1/1250 of a second for stopping the action, you could just set your camera to a high shutter speed in Shutter Priority mode and start shooting. But you also want to be using an aperture of, say, f/4.5 to *aperture* get that narrow depth of field. Here's the problem: If you set your camera to Shutter Priority mode and select 1/1000 of a second as a nice compromise, you might get that desired f-stop—but you might not. As the meter is trained on your moving subject, the light levels could rise or fall, which might actually change that desired f-stop to something higher like f/5.6 or even f/8. Now the depth of field is extended, and you will no longer get that nice isolation and separation that you wanted.

To rectify this, switch the camera to Aperture Priority mode and select f/4.5 as your aperture. Now, as you begin shooting, the camera holds that aperture and makes exposure adjustments with the shutter speed. As I said before, this works well when you have lots of light—enough light so that you can have a high-enough shutter speed without introducing motion blur.

THE ISO SENSITIVITY AUTO CONTROL TRICK

There is a very cool trick that can get you the best of both worlds and that won't sacrifice your shutter speed or aperture. With the ISO Sensitivity auto control feature, you can set the camera to automatically select an ISO that keeps you at your preferred shutter speed, while using the largest aperture and lowest ISO possible. It will also put an upper limit on the ISO to keep you from getting too much noise in your images.

Here's the way it works. If I am shooting an activity that requires a shutter speed of 1/250 of a second, I set that as the minimum in the auto control settings. Then I decide that I can deal with the noise that is produced with an ISO up to 1600, so I set that as my maximum sensitivity. Since I would always like to use the lowest ISO, I set the low ISO sensitivity to 200. Once everything is set, the camera will now adjust my ISO without any interaction from me, letting me shoot at my desired shutter speed at the lowest possible ISO and largest aperture setting possible.

SETTING UP THE ISO SENSITIVITY AUTO CONTROL FEATURE

1. Press the Menu button and then use the Multi-selector to get to the Shooting menu.

2. Press the Multi-selector to the right to enter the menu and then locate the ISO Sensitivity Settings feature (A).

3. Press the Multi-selector to the right to enter the setup screen.

4. Press the Multi-selector to the right and select the lowest ISO that you wish to use (ISO Sensitivity) and press the OK button (B).

5. Press the Multi-selector down to highlight Auto ISO Sensitivity Control and then move the selector to the right and select On to activate the feature (C).

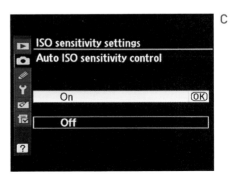

6. Use the Multi-selector to choose Maximum Sensitivity (**D**). This will be the upper limit of your ISO.

7. Finally, select the Minimum shutter speed that you want to use while shooting (**E**). This will be completely dependent on the speed necessary to stop the action you are shooting.

D

E

With everything set up, you can begin shooting without fear of constantly having to change the ISO. This technique is also quite helpful when working in varying light conditions. As you are shooting, you will notice the ISO Auto warning in the lower portion of the viewfinder along with the adjusted ISO setting.

KEEP THEM IN FOCUS WITH CONTINUOUS-SERVO FOCUS AND AF FOCUS POINT SELECTION

With the exposure issue handled for the moment, let's move on to something equally important: focusing. If you have browsed your manual, you know that there are several focus modes to choose from in the D7000. To get the greatest benefit from each of them, it is important to understand how they work and the situations where each mode will give you the best opportunity to grab a great shot. Because we are discussing subject movement, our first choice is going to be Continuous-servo AF mode (AF-C). AF-C mode uses all of the focus points in the camera to find a moving subject and then lock in the focus when the shutter button is completely depressed.

SELECTING AND SHOOTING IN CONTINUOUS-SERVO AF FOCUS MODE

1. Press and hold the AF button while observing the control panel (**A**).

2. Now rotate the Command dial while continuing to hold the AF button. Once you have selected AF-C, release the AF button (**B**).

3. The camera will maintain the subject's focus as long as it remains within one of the focus points in the viewfinder or until you release the shutter button or take a picture.

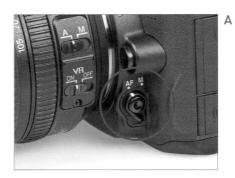
A

B

Note that holding down the shutter button for long periods of time will cause your battery to drain much faster because the camera will be constantly focusing on the subject.

When using the AF-C mode, you can use the AF point mode set to Dynamic Area, which makes a focus point of your choosing the primary focus but uses information from the surrounding points if your subject happens to move away from the point.

SETTING THE AF-AREA MODE TO DYNAMIC

1. To set the AF-area mode, press and hold the AF button on the front of the camera while observing the control panel (**A**).

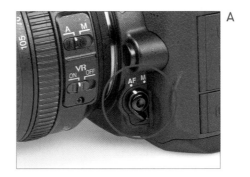
A

2. Now rotate the Sub-command dial while holding the AF button (**B**). As you turn the dial, your AF modes will be displayed on the control panel. Select from one of three dynamic modes and release the AF button when you have made your selection (**C–E**).

C

D

E

Note that the AF mode is used to select the method with which the camera will focus the lens. This is different from the AF point, which is a cluster of small points that are visible in the viewfinder and are used to determine where you want the lens to focus.

STOP AND GO WITH 3D-TRACKING AF

If you are going to be changing between a moving target and one that is still, you should consider using the 3D-tracking AF mode. This mode mixes both the AF-S and dynamic modes for shooting a subject that goes from stationary to moving without having to adjust your focus mode.

When you have a stationary subject, simply place your selected focus point on your subject and the camera will focus on it. If your subject begins to move out of focus, the camera will track the movement, keeping a sharp focus.

For example, suppose you are shooting a football game. The quarterback has brought the team to the line and he is standing behind the center, waiting for the ball to be hiked. If you are using the 3D-tracking AF mode, you can place your focus point on the quarterback and start taking pictures of him as he stands at the line. As soon as the ball is hiked and the action starts, the camera will switch to tracking mode and follow his movement within the frame. This can be a little tricky at first, but once you master it, it will make your action shooting effortless.

To select 3D-tracking, simply follow the same
steps listed for selecting dynamic modes but
instead select the 3D-tracking mode. It is impor-
tant to know that the 3D-tracking AF mode uses
color and contrast to locate and then follow
the subject, so this mode might be less effective
when everything is similar in tone or color.

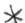 CHOOSING A FOCUS MODE

Selecting the proper focus mode depends largely on what type of subject you are
photographing. Single Point is typically best for stationary subjects. It allows you to
determine exactly where you want your focus to be and then recompose your image while
holding the focus in place. If you are taking pictures of an active subject who is moving
quickly, trying to set a focus point with Single Point can be difficult, if not impossible.
This is when you will want to rely on the Dynamic Area and 3D-tracking modes to quickly
assess the subject distance and set your lens focus. This can be especially helpful if the
subject distance is varying constantly.

MANUAL FOCUS FOR ANTICIPATED ACTION

While I use the automatic focus modes for the majority of my shooting, there are
times when I like to fall back on manual focus. This is usually when I know when and
where the action will occur and I want to capture the subject as it crosses a certain
plane of focus. This is useful in sports like motocross or auto racing, where the sub-
jects are on a defined track and I know exactly where I want to capture the action.
I could try tracking the subject, but sometimes the view can be obscured by a curve.
By prefocusing the camera, all I have to do is wait for the subject to approach my
point of focus (**Figure 5.6**) and then start firing the camera.

It is also a good idea to decide how much of the environment you want to show in
your image. With these twins riding the tandem bicycle, I wanted to show the old-
fashioned buildings in the background to give a sense of Mackinac Island. I could
have cropped in tighter, but I would have lost the essential background information
(**Figure 5.7**).

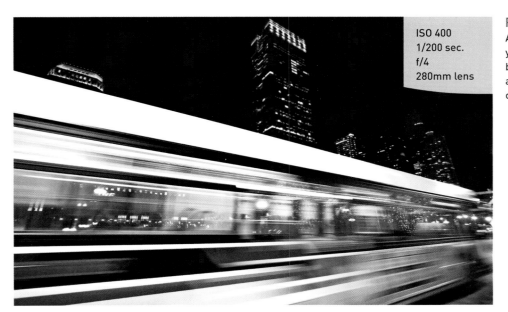

ISO 400
1/200 sec.
f/4
280mm lens

FIGURE 5.6
Anticipating where your subject will be is a major advantage when capturing motion.

ISO 200
1/100 sec.
f/6.3
70mm lens

FIGURE 5.7
You don't always need to crop in tight on a motion shot. By showing more of the environment I was able to give the viewer a sense of time and place.

The drive mode determines how fast your camera will take pictures. Single Frame is for taking one photograph at a time. With every full press of the shutter release button, the camera will take a single image. The continuous modes allow for a more rapid capture rate. Think of it like a machine gun. When you are using one of the continuous modes, the camera will continue to take pictures as long as the shutter release button is held down.

KEEPING UP WITH THE CONTINUOUS SHOOTING MODES

Getting great focus is one thing, but capturing the best moment on the sensor can be difficult if you are shooting just one frame at a time. In the world of sports, and in life in general, things move pretty fast. If you blink, you might miss it. The same can be said for shooting in Single Frame mode. Fortunately, your D7000 comes equipped with a Continuous High (CH) shooting—or "burst"—mode that lets you capture a series of images at up to six frames a second. You can also select Continuous Low (CL), which allows the user to customize the desired frames per second by using the Custom Settings (**Figure 5.8**).

SETTING UP AND SHOOTING IN CONTINUOUS SHOOTING MODE

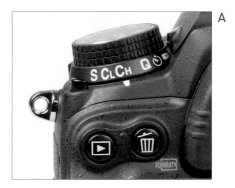

A

1. Press the Mode dial lock at the top left corner of your camera (**A**).

2. While pressing the dial lock release, simply turn the Release Mode dial to either CL or CH. CH will provide up to six frames per second and CL will provide one to five frames per second, based upon the user's preference. To set up CL, go to D6 in your Custom Settings menu. (For more on this, refer to page 217 of your user manual.)

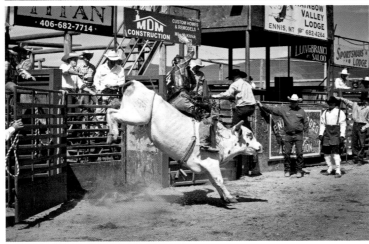

ISO 125
1/800 sec.
f/5.6
70mm lens

FIGURE 5.8
Using continuous mode means that you are sure to capture the peak of the action. Using the continuous shooting mode causes the camera to keep taking images for as long as you hold down the shutter release button. In Single Frame mode, you have to release the button and then press it again to take another picture.

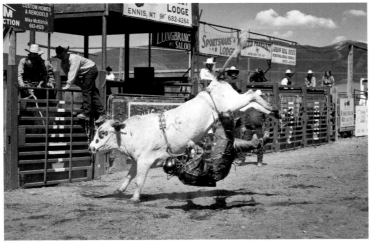

Your camera has an internal memory, called a "buffer," where images are stored while they are being processed prior to being moved to your memory card. Depending on the image format you are using, the buffer might fill up, and the camera will stop shooting until space is made in the buffer for new images. The camera readout in the viewfinder tells you how many frames you have available in burst mode. Just look in the viewfinder at the bottom right to see the maximum number of images for burst shooting. As you shoot, the number will go down and then back up as the images are written to the memory card.

A SENSE OF MOTION

Shooting action isn't always about freezing the action. There are times when you want to convey a sense of motion so that the viewer can get a feel for the movement and flow of an event. Two techniques you can use to achieve this effect are panning and motion blur.

PANNING

Panning has been used for decades to capture the speed of a moving object as it moves across the frame. It doesn't work well for subjects that are moving toward or away from you. Panning is achieved by following your subject across your frame, moving your camera along with the subject, and using a slower-than-normal shutter speed so that the background (and sometimes even a bit of the subject) has a sideways blur but the main portion of your subject is sharp and blur-free.

The key to a great panning shot is selecting the right shutter speed: too fast and you won't get the desired blurring of the background; too slow and the subject will have too much blur and will not be recognizable. Practice the technique until you can achieve a smooth motion with your camera that follows along with your subject. The other thing to remember when panning is to follow through even after the shutter has closed. This will keep the motion smooth and give you better images.

Panning can take a lot of practice before you stumble upon the correct shutter speed. During the Chicago Marathon I was able to take several practice shots of the wheel-chair division as they crossed my path. The speeds achieved by the athletes were incredibly fast, so it took several test shots before I was able to dial in the appropriate shutter speed. Aided by continuous mode and Shutter Priority, I was able to achieve the perfect shot (**Figure 5.9**), albeit through trial and error.

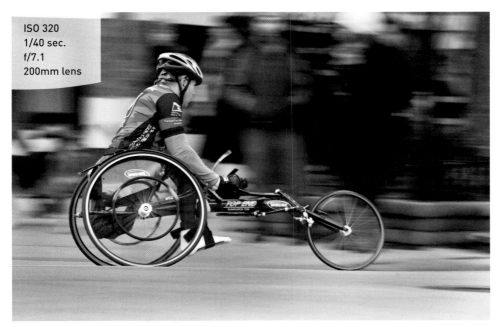

ISO 320
1/40 sec.
f/7.1
200mm lens

FIGURE 5.9
Following the subject as it moves across your field of view allows for a slower shutter speed and adds a sense of motion. Panning takes practice, so it's helpful to seek out plenty of opportunities to hone your skills.

MOTION BLUR

Another way to let the viewer in on the feel of the action is to simply include some blur in the image (**Figure 5.10**). This isn't accidental blur from choosing the wrong shutter speed. This blur is more exaggerated, and it tells a story (**Figure 5.11**). In Figure 5.10, I wanted to capture the strumming of the guitar player's hand. I felt that the motion of the hand told a better story than simply freezing the motion.

FIGURE 5.10
The movement of the hand strumming the guitar coupled with a slower shutter speed conveys a sense of motion.

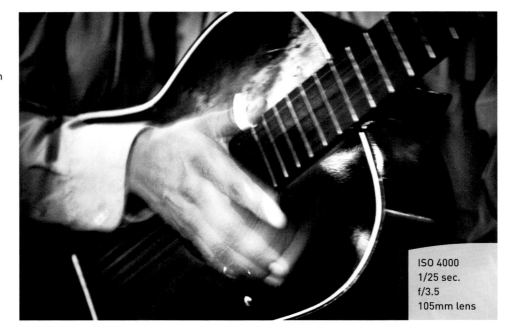

ISO 4000
1/25 sec.
f/3.5
105mm lens

FIGURE 5.11
You haven't seen traffic until you've been to India. Here a couple is trying to cross a busy intersection. The speed at which the couple was moving contrasted well against the speed of the passing traffic.

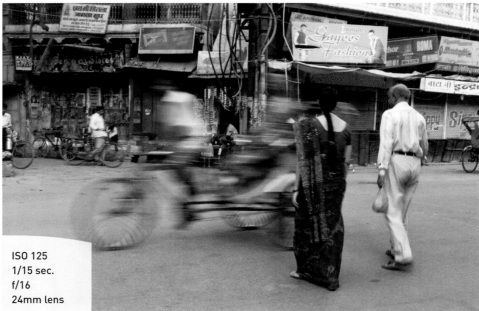

ISO 125
1/15 sec.
f/16
24mm lens

Just as in panning, there is no preordained shutter speed to use for this effect. It is simply a matter of trial and error until you have a look that conveys the action. I try to show an area of the frame that is frozen—for instance, in the shot of the musician above the guitar may be frozen, or still, but the hand is moving. In the shot of the couple in **Figure 5.12**, the couple had paused momentarily. This helps lend visual contrast and adds to the story of the photo. The key to this technique is the correct shutter speed combined with keeping the camera still during the exposure. You are trying to capture the motion of the subject, not the photographer or the camera, so use a good shooting stance or even a tripod.

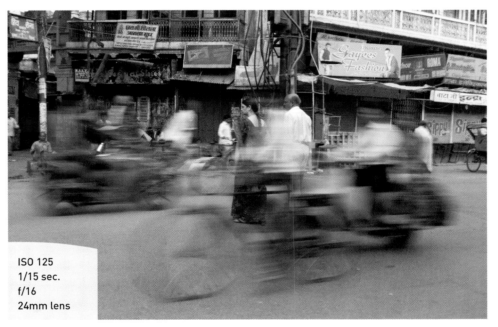

ISO 125
1/15 sec.
f/16
24mm lens

FIGURE 5.12
Due to the very slow shutter speed I was able to capture the motion of the bikes on both sides of the couple. What made this shot work is the fact that the couple had to pause before continuing to cross.

TIPS FOR SHOOTING ACTION

GIVE THEM SOMEWHERE TO GO

Framing your image is as important as how well you expose the image. A poorly composed shot can ruin a great moment by not holding the viewer's attention.

One common mistake in action photography is not using the frame properly. If you are dealing with a subject moving horizontally across your field of view, give the subject somewhere to go by placing it to the side of the frame, with its motion leading toward the middle of the frame (**Figure 5.13**). This offsetting of the subject will introduce a sense of direction and anticipation for the viewer. Unless you are going to completely fill the image with the action, try to avoid placing your subject in the middle of the frame.

Here I was photographing the demolition of the famous Cabrini Green housing projects in Chicago. The debris was flying off the building every time the wrecking ball hit the structure. By framing the image this way, it shows you how far the debris was flying and guides your eye through the movement.

FIGURE 5.13
Try to leave space in front of your subject to lead the action in a direction. In this case, the bright blue sky provided the negative space to show the directionality of the flying debris.

ISO 125
1/250 sec.
f/11
80mm lens

GET IN FRONT OF THE ACTION

Here's another one. When shooting action, show the action coming toward you (**Figure 5.14**) rather than going away from you. People want to see faces. Faces convey the action, the drive, the sense of urgency, and the emotion of the moment. So if you are shooting action involving people, always position yourself so that the action is either coming at you or is at least perpendicular to your position.

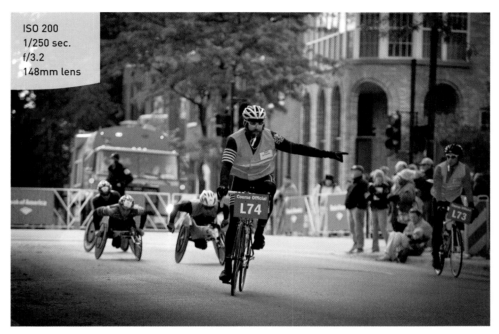

ISO 200
1/250 sec.
f/3.2
148mm lens

FIGURE 5.14
Shooting from the front with a telephoto gives a feeling that the action is coming right at you. You can see the cyclist blowing his whistle, which draws you in to the feeling of the scene. You also get a real perspective of the wheelchair athletes and their determination as they are rounding this corner in the Chicago Marathon.

PUT YOUR CAMERA IN A DIFFERENT PLACE

Changing your vantage point is a great way to find new angles. Shooting from above with a wide-angle lens might let you incorporate some depth into the image. Shooting from farther away with a telephoto lens will compress the elements in a scene and allow you to crop in tighter on the action. Don't be afraid to experiment and try new things.

The image in **Figure 5.15** was a different view of the Kushti wrestlers. Instead of viewing them straight on, the higher vantage point showed a new take on their exercise routine.

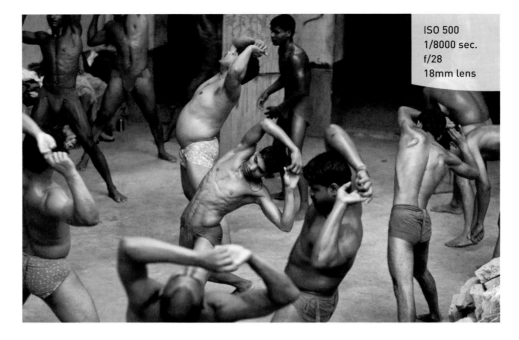

ISO 500
1/8000 sec.
f/28
18mm lens

I could not have achieved this viewpoint if I had not climbed up to this higher vantage point. I wanted to get a shot that showed all of the wrestlers warming up, so I climbed up on top of a cement embankment. If I had stayed below, the image would have been at eye level and the depth of the shot would have been missing. I also would not have been able to capture as many wrestlers in the frame with an eye-level vantage point. Sometimes a low perspective works fine, but also look up to see if you can get to high ground for a better view.

Chapter 5 Assignments

The mechanics of motion

For this first assignment, you need to find some action. Explore the relationship between the speed of an object and its direction of travel. Use the same shutter speed to record your subject moving toward you and across your view. Try using the same shutter speed for both to compare the difference made by the direction of travel.

Wide vs. telephoto

Just as with the first assignment, photograph a subject moving in different directions, but this time, use a wide-angle lens and then a telephoto. Check out how the telephoto setting on the zoom lens will require faster shutter speeds than the lens at its wide-angle setting.

Getting a feel for focusing modes

We discussed two different ways to autofocus for action: Dynamic Area and 3D-tracking. Starting with Dynamic Area mode, find a moving subject and use the mode to get familiar with the way the mode works.

Now repeat the process using the 3D-tracking AF mode. The point of the exercise is to become familiar enough with the two modes to decide which one to use for the situation you are photographing.

Anticipating the spot using manual focus

For this assignment, you will need to find a subject that you know will cross a specific line that you can prefocus on. A street with moderate traffic works well for this. Focus on a spot on the street that the cars will travel across (don't forget to set your lens for manual focus). To do this right, you need to set the drive mode on the camera to continuous mode. Now, when a car approaches the spot, start shooting. Try shooting in three- or four-frame bursts.

Following the action

Panning is a great way to show motion. To begin, find a subject that will move across your path at a steady speed and practice following it in your viewfinder from side to side. Now, with the camera in Shutter Priority mode, set your shutter speed to 1/30 of a second and the focus mode to Dynamic Area. Now pan along with the subject and shoot as it moves across your view. Experiment with different shutter speeds and focal lengths. Panning is one of those skills that takes some time to get a feel for, so try it with different types of subjects moving at different speeds.

Feeling the movement

Instead of panning with the motion, use a stationary camera position and adjust the shutter speed until you get a blurred effect that gives the sense of motion while still being able to identify the subject. There is a big difference between a slightly blurred photo that looks like you just picked the wrong shutter speed and one that looks intentional for the purpose of showing motion. As with panning, it will take some experimentation to find just the right shutter speed to achieve the desired effect.

Share your results with the book's Flickr group!

Join the group here: flickr.com/groups/nikond7000_fromsnapshotstogreatshots

6

ISO 100
1/320 sec.
f/8
85mm lens

Perfect Portraits

SETTINGS AND FEATURES TO MAKE GREAT PORTRAITS

One of my favorite things to do while traveling is take portraits. I find that people are very approachable if you are sincere and respect their wishes. Taking pictures of people is one of the great joys of photography. You will experience a tremendous sense of accomplishment when you capture the spirit and personality of someone in a photograph. In this chapter, we will explore some camera features and techniques that can help you create great portraits.

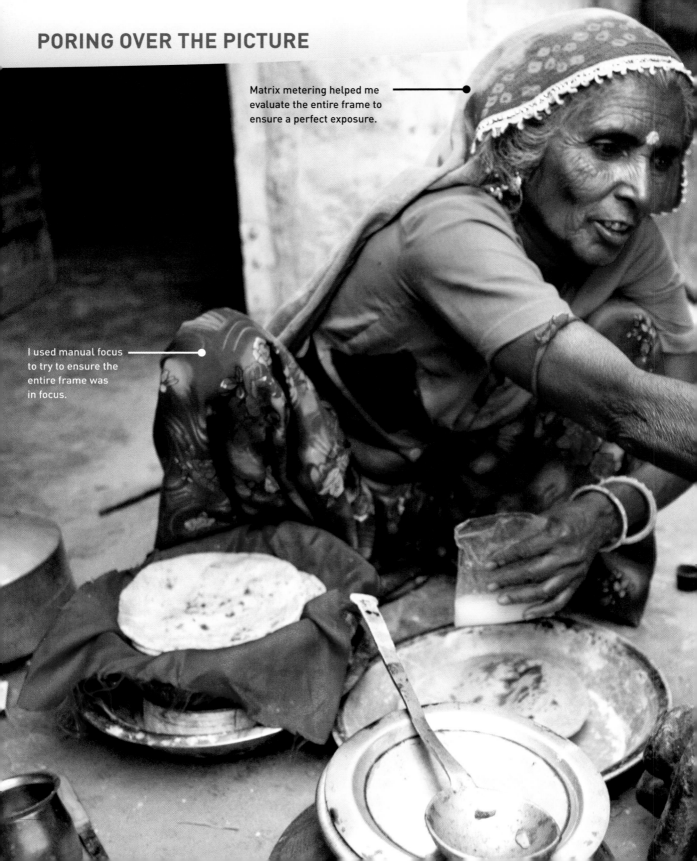

PORING OVER THE PICTURE

Matrix metering helped me evaluate the entire frame to ensure a perfect exposure.

I used manual focus to try to ensure the entire frame was in focus.

I was walking through the streets of Jaipur, India, when my nose led me down a backstreet to this woman's house. She was cooking dinner for her family, and I politely asked if she would mind if I took a few photos. She agreed, so I started off with a wide-angle shot to show more of the environment and then tightened in on her face. I loved the bright colors and the setup of her outdoor kitchen.

The wide-angle lens allowed me to show more of the environment.

A higher ISO coupled with a large aperture allowed me to make the most of the available light.

ISO 800
1/60 sec.
f/2.8
24mm lens

This image was shot in the "golden hour" of the early evening when the angle of the sun is low. You can even see the glow of the flames under the naan that's cooking.

PORING OVER THE PICTURE

I was on my way to hike Machu Picchu when we stopped by a road stand to check out a local market where this young girl was selling rugs. What drew me in was her eyes. As my mother used to say, "The story is in their eyes." I politely asked if I could take her photograph and she graciously agreed. I stood back and took a wide shot to include her environment, then zoomed in and focused in on her eyes.

A common mistake photographers make is rushing to get the shot and missing the bigger picture. If someone has given you his or her permission, then take your time and get the shot. Remember, especially when traveling, you won't get that exact opportunity again. Balance efficiency with quality. I like to take between five to six images in less than 30 seconds.

I used a smaller aperture to guarantee sharper focus while I zoomed in on her face. The 70–200mm lens allowed me to get a wide environmental image as well as a close-up portrait. Be very conscious of your backgrounds, and try to avoid taking images where the background is distracting.

When traveling, do not be afraid to ask permission to take a portrait. Just remember to be polite and above all else respectful of the subject's wishes. A smile can go a long way in getting a great shot!

I used Aperture Priority so that I could quickly get the right exposure just by adjusting the aperture.

ISO 160
1/125 sec.
f/8
140mm lens

AUTOMATIC PORTRAIT MODE

In Chapter 3, we reviewed all of the automatic scene modes. One of them, Portrait mode, is dedicated to shooting portraits. While this is not my preferred camera setting, it is a great jumping-off point for those who are just starting out. The key to using this mode is to understand what is going on with the camera so that when you venture further into portrait photography, you can expand on the settings and get the most from your camera and, more importantly, your subject.

Whether you are photographing an individual or a group, the emphasis should always be on the subject. Portrait mode uses a larger aperture setting to keep the depth of field very narrow, which means that the background will appear slightly blurred or out of focus. To take full advantage of this effect, use a medium- to telephoto-length lens. Also, keep a pretty close distance to your subject. If you shoot from too far away, the narrow depth of field will not be as effective.

USING APERTURE PRIORITY MODE

If you took a poll of portrait photographers to see which shooting mode was most often used for portraits, the answer would certainly be Aperture Priority (A, for short) mode. Selecting the right aperture is important for placing the most critically sharp area of the photo on your subject while simultaneously blurring all of the distracting background clutter (**Figure 6.1**). Not only will a large aperture give the narrowest depth of field, it will also allow you to shoot in lower light levels at lower ISO settings.

This isn't to say that you have to use the largest aperture on your lens. An aperture of f/1.2 may be too large, thus creating a shallow depth of field. A good place to begin is f/5.6. This will give you enough depth of field to keep the entire face in focus, while providing enough blur to eliminate distractions in the background. Remember, a portrait is all about the eyes, so focus first on the eyes and recompose the frame if needed (**Figure 6.2**). This isn't a hard-and-fast setting; it's just a good, all-around number to start with. Your aperture might change depending on the focal length of the lens you are using and on the amount of blur that you want for your foreground and background elements.

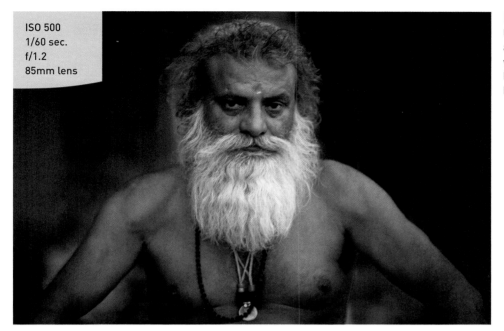

ISO 500
1/60 sec.
f/1.2
85mm lens

FIGURE 6.1
Using a wide
aperture, especially
with a longer lens,
blurs distracting
background details.

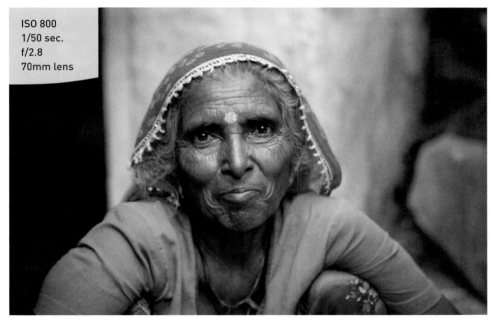

ISO 800
1/50 sec.
f/2.8
70mm lens

FIGURE 6.2
Try to connect
with the person
when you're taking
her photograph.
You don't want her
looking away; you
want to maintain
a good focus on
the eyes.

GO WIDE FOR ENVIRONMENTAL PORTRAITS

There will be times when your subject's environment is of great significance to the story you want to tell. This might mean using a smaller aperture to get more detail in the background or foreground. Once again, by using Aperture Priority mode, you can set your aperture to a higher f-stop, such as f/8 or f/11, and include the important details of the scene that surrounds your subject.

Using a wider-than-normal lens can also assist in getting more depth of field as well as showing the surrounding area. A wide-angle lens requires less stopping down of the aperture (making the aperture smaller) to achieve an acceptable depth of field. This is because wide-angle lenses cover a greater area, so the depth of field appears to cover a greater percentage of the scene.

A wider lens might also be necessary to relay more information about the scenery (**Figure 6.3**). Select a lens length that is wide enough to tell the story but not so wide that you distort the subject. Few things in the world of portraiture are quite as unflattering as giving someone a big, distorted nose (unless you are going for that sort of look). When shooting a portrait with a wide-angle lens, keep the subject away from the edge of the frame. This will reduce the distortion, especially in very wide focal lengths. As the lens length increases, distortion will be reduced.

FIGURE 6.3
Remember to tell the whole story. I like to take two shots whenever I'm photographing a scene where the environment is key, a wide shot and a tight close-up. A wide-angle lens allows you to capture more of the environment in the scene without having to increase the distance between you and the subject.

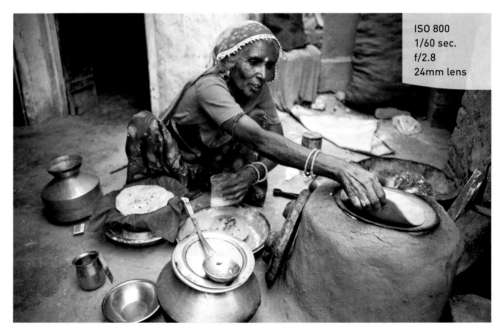

ISO 800
1/60 sec.
f/2.8
24mm lens

There are multiple metering modes in your camera, but the way they work is very similar. A light meter measures the amount of light being reflected off your subject and then renders a suggested exposure value based on the brightness of the subject and the ISO setting of the sensor. To establish this value, the meter averages all of the brightness values to come up with a middle tone, sometimes referred to as 18 percent gray. The exposure value is then rendered based on this middle gray value. This means that a white wall would be underexposed and a black wall would be overexposed in an effort to make each one appear gray. To assist with special lighting situations, the D7000 has three metering modes: Matrix (**Figure 6.4**), which uses the entire frame; Spot (**Figure 6.5**), which takes specific readings from small areas (often used with a gray card); and Center-weighted (**Figure 6.6**), which looks at the entire frame but places most of the exposure emphasis on the center of the frame.

FIGURE 6.4
The Matrix Metering mode uses the entire frame.

FIGURE 6.5
The Spot Metering mode uses a very small area of the frame.

FIGURE 6.6
The Center-weighted Metering mode looks at the entire frame but emphasizes the center of it.

METERING MODES FOR PORTRAITS

For most portrait situations, the Matrix Metering mode is ideal. (For more on how metering works, see the "Metering Basics" sidebar.) This mode measures light values from all portions of the viewfinder and then establishes a proper exposure for the scene. The only problem that you might encounter when using this metering mode is when you have very light or dark backgrounds in your portrait shots.

In these instances, the meter might be fooled into using the wrong exposure information because it will be trying to lighten or darken the entire scene based on the prominence of dark or light areas (**Figure 6.7**). You can deal with this in one of two ways. You can use the Exposure Compensation feature, which we cover in Chapter 7, to dial in adjustments for over- and underexposure. Or you can change the metering mode to Center-weighted Metering. The Center-weighted Metering mode uses only

the center area of the viewfinder (about 9 percent) to get its exposure information. This is the best way to achieve proper exposure for most portraits; metering off skin tones, averaged with hair and clothing, will often give a more accurate exposure (**Figure 6.8**). This metering mode is also great to use when the subject is strongly backlit.

FIGURE 6.7
[left] The light background color and clothing fooled the meter into choosing a slightly underexposed setting for the photo.

FIGURE 6.8
[right] When I switched to the Center-weighted Metering mode, my camera was able to ignore much of the background and add a little more time to the exposure.

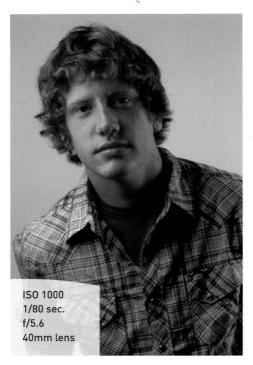

ISO 1000
1/80 sec.
f/5.6
40mm lens

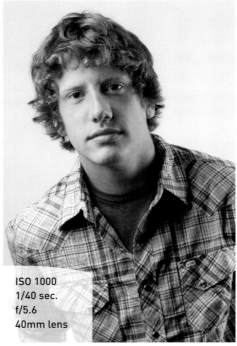

ISO 1000
1/40 sec.
f/5.6
40mm lens

SETTING YOUR METERING MODE TO CENTER-WEIGHTED METERING

1. Press and hold the meter button located at the top right side of your camera.

2. While holding the meter button, rotate the Command dial to locate the Center-weighted Metering icon and release the meter button once selected.

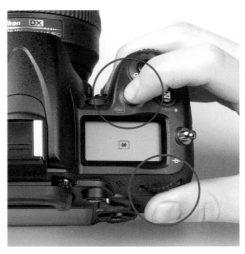

USING THE AE LOCK (AUTO EXPOSURE LOCK) FEATURE

There will often be times when your subject is not in the center of the frame but you still want to use the Center-weighted Metering mode. So how can you get an accurate reading if the subject isn't in the center? Try using the Auto Exposure Lock feature to hold the exposure setting while you recompose.

AE Lock lets you use the exposure setting from any portion of the scene that you think is appropriate, and then lock that setting in regardless of how the scene looks when you recompose. An example of this would be when you're shooting a photograph of someone and a large amount of blue sky appears in the picture. Normally, the meter might be fooled by all that bright sky and try to reduce the exposure. Using AE Lock, you can establish the correct metering by zooming in on the subject (or even pointing the camera toward the ground), taking the meter reading and locking it in with AE Lock feature, and then recomposing and taking your photo with the locked-in exposure.

Manual Callout

There is a way to lock in your AE Lock reading so that you can continue shooting without having to hold the AE-L button. This involves changing the button function in the custom menu, but I prefer to leave this feature turned off because I would, more often than not, forget that it is on and end up using the wrong metering for a new subject. If you want to learn more about this feature, check out pages 97 and 106 of your manual.

SHOOTING WITH THE AE LOCK FEATURE

1. Find the AE-L/AF-L button (which we'll call AE-L for short) on the back of the camera and place your thumb on it.

2. While looking through the viewfinder, place the focus point on your subject and press the shutter release button halfway to get a meter reading, and focus the camera.

3. Press and hold the AE-L button to lock in the meter reading. You should see the AE-L indicator in the viewfinder.

4. While pressing in the AE-L button, recompose your shot and take the photo.

5. To take more than one photo without having to take another meter reading, just hold down the AE-L button until you are done using the meter setting.

FOCUSING: THE EYES HAVE IT

It has been said that the eyes are the windows to the soul, and nothing could be truer when you are photographing someone (**Figure 6.9**). You could have the perfect composition and exposure, but if the eyes aren't sharp the entire image suffers. While there are many focusing modes to choose from on your D7000 for portrait work, you can't beat AF-S (Single-servo AF) mode using a single focusing point. AF-S focusing will establish a single focus for the lens and then hold it until you take the photograph; the other focusing modes continue focusing until the photograph is taken. The single-point selection lets you place the focusing point right on your subject's eye and set that spot as the critical focus spot. Using AF-S mode lets you get that focus and recompose all in one motion.

FIGURE 6.9
When photograph-ing people, you should almost always place the emphasis on the eyes.

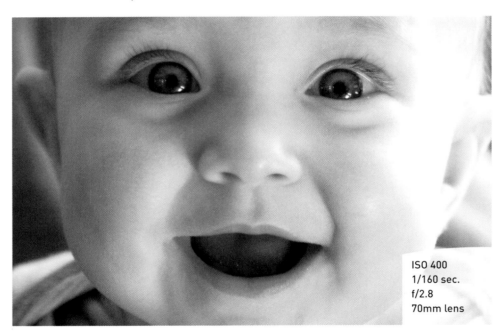

ISO 400
1/160 sec.
f/2.8
70mm lens

SETTING YOUR FOCUS TO A SINGLE POINT

1. Press and hold the Focus Mode selector, near the lens on the front of the camera.

2. While holding the button, rotate the Sub-command dial with your index finger (**A**).

3. Select the Single Point icon on the control panel and release the Focus Mode selector button (**B**).

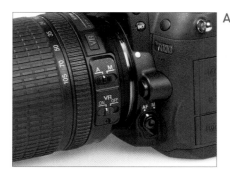

A
B

SETTING UP FOR AF-S FOCUS MODE

1. Press and hold the Focus Mode selector, near the lens on the front of the camera.

2. While holding the button, rotate the Command dial with your thumb.

3. Release the Focus Mode selector when AF-S is displayed in the control panel (**B**, above).

4. When you are back in shooting mode, use the Multi-selector to move the focus point to one of the 39 available positions. This is visible while looking through the viewfinder but also on the information screen.

Now, to shoot using this focus point, place that point on one of your subject's eyes, and press the shutter button halfway until you hear or see the focus indicator chirp. While still holding the shutter button down halfway, recompose if necessary and take your shot.

KEEPING FOCUS ON WHERE IT COUNTS

A common mistake is to focus on the center of the face or the nose. As a result you will get a portrait in which the nose is in focus but not the eyes, especially with a large aperture and shallow depth of field. Try to get in the habit of focusing in on the eyes and then recomposing the image.

I typically use the center point for focus selection. I find it easier to place that point directly on the location where my critical focus should be established and then recompose the shot. Even though the single point can be selected from any of the focus points, it typically takes longer to figure out where that point should be in relation to my subject. By using the center point, I can quickly establish focus and get on with my shooting.

CLASSIC BLACK-AND-WHITE PORTRAITS

There is something timeless about a black-and-white portrait. It eliminates the distraction of color and puts all the emphasis on the subject. To get great black-and-whites without having to resort to any image-processing software, set your picture control to Monochrome (**Figure 6.10**).

The picture controls are automatically applied when shooting with the JPEG file format. If you are shooting in RAW, the picture that shows up on your rear LCD display will look black and white, but it will appear as a color image when you open it in your software. You can use the software to apply Monochrome, or any other picture control, to your RAW image within the image-editing software.

The real key to using the Monochrome picture control is to customize it for your portrait subject. The control can be changed to alter the sharpness and contrast. For women, children, puppies, or anyone else you want to look somewhat soft, set the Sharpness setting to 0 or 1. For old cowboys, longshoremen, and anyone else who you want to look really detailed, including the wrinkles, try a setting of 6 or 7. I typically like to leave Contrast at a setting of around –1 or –2. This gives me a nice range of tones throughout the image.

The other adjustment that you should try is to change the picture control's Filter effect from None to one of the four available settings (Yellow, Orange, Red, and Green). Using the filters will have the effect of either lightening or darkening the skin tones. The Red and Yellow filters usually lighten skin, while the Green filter can make skin appear a bit darker. Experiment to see which one works best for your subject.

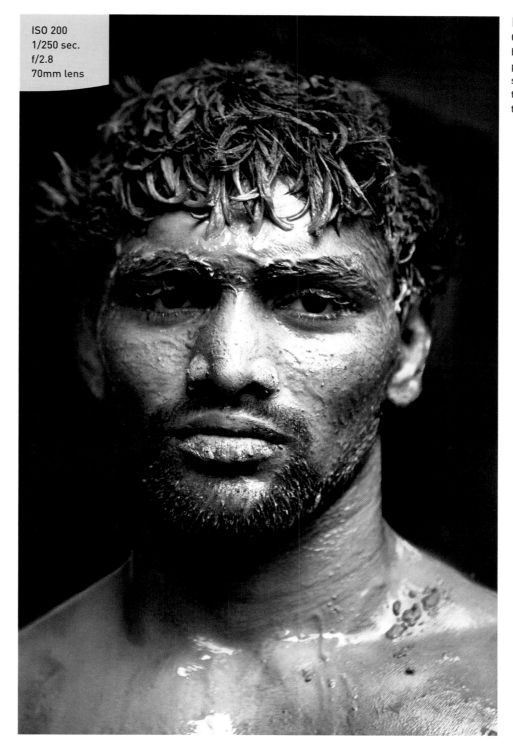

ISO 200
1/250 sec.
f/2.8
70mm lens

FIGURE 6.10
Getting high-quality
black-and-white
portraits is as
simple as setting
the picture control
to Monochrome.

THE PORTRAIT PICTURE CONTROL FOR BETTER SKIN TONES

As long as we are talking about picture controls for portraits, there is another control on your D7000 that has been tuned specifically for this type of shooting. Oddly enough, it's called Portrait. To set this control on your camera, simply follow the same directions as earlier, except this time, select the Portrait control (PT) instead of Monochrome. There are also individual options for the Portrait control that, like the Monochrome control, include sharpness and contrast. You can also change the saturation (how intense the colors will be) and hue, which lets you change the skin tones from more reddish to more yellowish. I prefer brighter colors, so I like to boost the Saturation setting to +2 and leave everything else at the defaults. You won't be able to use the same adjustments for everyone, especially when it comes to color tone, so do some experimenting to see what works best.

DETECT FACES WITH LIVE VIEW

Face detection is becoming commonplace in digital cameras. Your D7000 has four autofocus modes for Live View: Wide Area, Normal Area, Subject Tracking, and Face Priority. These modes are different from the standard modes like AF-S, AF-C, and AF-A. Face Priority mode is probably the slowest of the Live View focusing modes, so use it with a tripod or when your subjects are going to remain fairly still. When you turn on Live View with Face Priority focusing, the camera does an amazing thing: It zeroes in on any face appearing on the LCD and places a box around it. I'm not sure how it works; it just does.

There is a complete chapter in your manual that is dedicated to using Live View mode. It can be found on pages 49–56.

1. Press the Menu button and use the Multi-selector to navigate to the Custom Setting menu, then select the menu item A Autofocus (**A**).

2. Select A8 Live View/Movie AF and press the OK button (**B**).

3. Select AF-area mode and press OK (**C**).

4. Select Face-priority AF (**D**). Press the shutter release button to exit the Menu mode and get ready for shooting.

5. Activate the Live View function by pressing the Live View button located above the Multi-selector on the back of the camera.

6. Point your camera at a person and watch as the yellow frame appears over the face in the LCD.

7. Depress and hold the shutter release button halfway to focus on the face and wait until you hear the confirmation chirp.

8. Press the shutter button fully to take the photograph.

USE FILL FLASH FOR REDUCING SHADOWS

A common problem when taking pictures of people outside, especially during the midday hours, is that the overhead sun can create dark shadows under the eyes and chin. You could have your subject turn his or her face to the sun, but that is usually considered cruel and unusual punishment. So how can you have your subject's back to the sun and still get a decent exposure of the face? Try turning on your flash to fill in the shadows.

This also works well when you are photographing someone wearing a cap (**Figure 6.11**). The bill of the hat tends to create heavy shadows over the eyes, and the fill flash will lighten up those areas while providing a really nice catchlight in the eyes.

FIGURE 6.11
I used fill flash here to fill in the shadows created by the bull rider's cowboy hat. The flash does not completely remove the shadow, because that would look unnatural and be an overexposed image, but it helps fill in the darkest shadows. Here I wanted the bull rider to have his back to the fence, so instead of repositioning him, I just used fill flash.

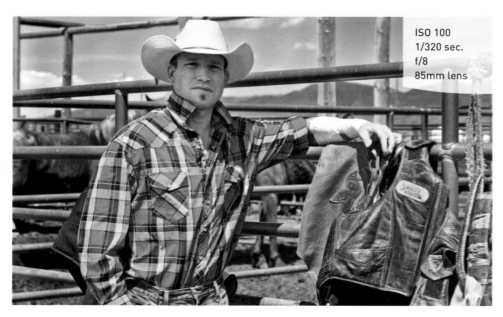

ISO 100
1/320 sec.
f/8
85mm lens

The key to using the flash as a fill is to not use it on full power. If you do, the camera will try to balance the flash with the daylight, and you will get a very flat and feature-less face.

CATCHLIGHT

A *catchlight* is that little sparkle that adds life to the eyes and brings attention to them. When you are photographing a person with a light source in front of them, you will usually get a reflection of that light in the eye, be it your flash, the sun, or something else brightly reflecting off the surface of the eye.

SETTING UP AND SHOOTING WITH FILL FLASH

1. Press the pop-up flash button to raise your pop-up flash into the ready position (**A**).

2. Press and hold the flash button while rotating the Sub-command dial until it reads -0.3 on the control panel (**B**).

3. Release the flash button.

4. Take a photograph and check your playback LCD to see if it looks good. If not, try reducing power in one-third stop increments.

One problem that can quickly surface when using the on-camera flash is red-eye. Not to worry, though—we will talk about how to remedy that in Chapter 8.

A

B

PORTRAITS ON THE MOVE

Not all portraits are shot with the subject sitting in a chair, posed and ready for the picture. Sometimes you might want to get an action shot that says something about the person, similar to an environmental portrait. Children, especially, just like to move. Why fight it? Set up an action portrait instead.

For the photo in **Figure 6.12**, I used the Portrait picture control and set my camera to Shutter Priority mode. I knew that there would be a good deal of movement involved, and I wanted to make sure that I had a fairly high shutter speed to freeze the action, so I set it to 1/320 of a second. I set the focus mode to AF-C, the drive mode to Continuous, and just let it rip. There were quite a few throwaway shots, but I was able to capture one that conveyed the energy and action.

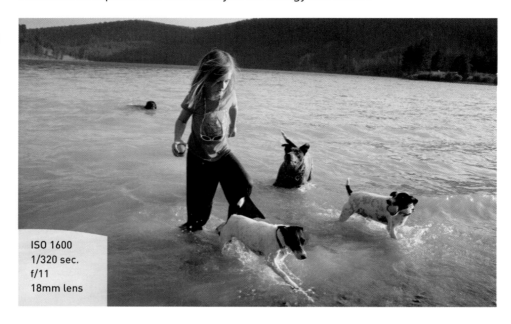

ISO 1600
1/320 sec.
f/11
18mm lens

TIPS FOR SHOOTING BETTER PORTRAITS

Before we get to the assignments for this chapter, I thought it might be a good idea to leave you with a few extra pointers on shooting portraits that don't necessarily have anything specific to do with your camera. There are entire books that cover things like portrait lighting, posing, and so on. But here are a few pointers that will make your people pics look a lot better.

AVOID THE CENTER OF THE FRAME

This falls under the category of composition. Instead of plunking your subject smack-dab in the middle for what I like to call the "mugshot" pose (**Figure 6.13**), position her toward the side of the frame (**Figure 6.14**)—it just looks more interesting.

ISO 400
1/50 sec
f/4.5
35mm lens

FIGURE 6.13
This is what I call "the mugshot." It's when you frame your subject dead center against a solid surface or background with empty space on both sides. Notice how unhappy she looks (dramatized for effect!).

ISO 400
1/50 sec.
f/4.5
35mm lens

FIGURE 6.14
Create a more interesting portrait by placing your subject off to the side. Notice how happy she became when I improved my framing.

CHOOSE THE RIGHT LENS

Choosing the correct lens can make a huge impact on your portraits. A wide-angle lens can distort features of your subject, which can lead to an unflattering portrait (**Figure 6.15**). Select a longer focal length if you will be close to your subject (**Figure 6.16**).

FIGURE 6.15
At this close distance, the 20mm lens is distorting the subject's face.

ISO 160
1/200 sec.
f/6.3
20mm lens

FIGURE 6.16
By zooming out to 50mm, the subject looks natural.

ISO 160
1/200 sec.
f/6.30
50mm lens

USE THE FRAME

Have you ever noticed that most people are taller than they are wide? Turn your camera vertically for a more pleasing composition (**Figure 6.17**).

ISO 125
1/80 sec.
f/7.1
70mm lens

FIGURE 6.17
Get in the habit of turning your camera to a vertical position when shooting portraits. This is also referred to as portrait orientation.

SUNBLOCK FOR PORTRAITS

The midday sun can be harsh and can do unflattering things to people's faces. If you can, find a shady spot out of the direct sunlight. You will get softer shadows, smoother skin tones, and better detail. This holds true for overcast skies as well (**Figure 6.18**). Just be sure to adjust your white balance accordingly.

GIVE THEM A HEALTHY GLOW

Nearly everyone looks better with a warm, healthy glow. Some of the best light of the day happens just a little before sundown, so shoot at that time if you can (**Figure 6.19**).

FIGURE 6.18
An overcast sky provided a soft, even light source for this picture of traditionally dressed girls in Cusco, Peru. The gentle light helps soften the faces, as well as make the most of their colorful clothing.

ISO 250
1/250 sec.
f/2.8
48mm lens

FIGURE 6.19
You just can't beat the glow of the late afternoon sun for adding warmth to your portraits.

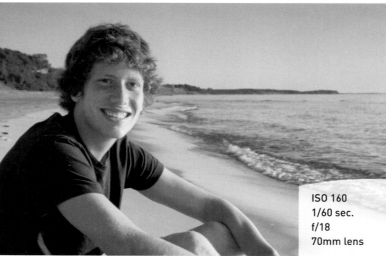

ISO 160
1/60 sec.
f/18
70mm lens

KEEP AN EYE ON YOUR BACKGROUND

Sometimes it's so easy to get caught up in taking a great shot that you forget about the smaller details. Try to keep an eye on what is going on behind your subjects so they don't end up with things popping out of their heads (**Figures 6.20** and **6.21**).

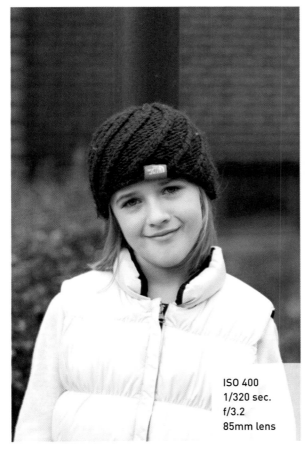

ISO 400
1/320 sec.
f/3.2
85mm lens

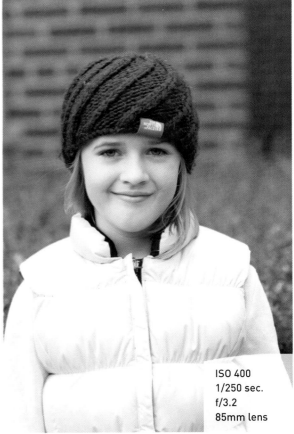

ISO 400
1/250 sec.
f/3.2
85mm lens

FIGURE 6.20
This photograph makes it appear that there is a pole going right through my daughter's head. You may not be aware of it at the time, especially if you're rushing, but it is important to slow down and notice these details.

FIGURE 6.21
By having her take just two steps to the left, I got the pole out of the scene entirely, making for a much improved composition.

FRAME THE SCENE

Using elements in the scene to create a frame around your subject is a great way to draw the viewer in. You don't have to use a window frame to do this. Just look for elements in the foreground that could be employed to force the viewer's eye toward your subject (**Figure 6.22**).

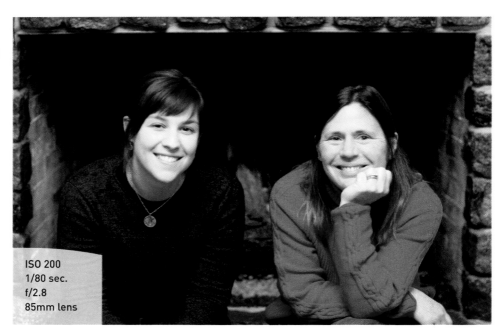

ISO 200
1/80 sec.
f/2.8
85mm lens

MORE THAN JUST A PRETTY FACE

Most people think of a portrait as a photo of someone's face. Don't ignore other aspects of your subject that reflect his or her personality—hands, especially, can go a long way toward describing someone (**Figure 6.23**).

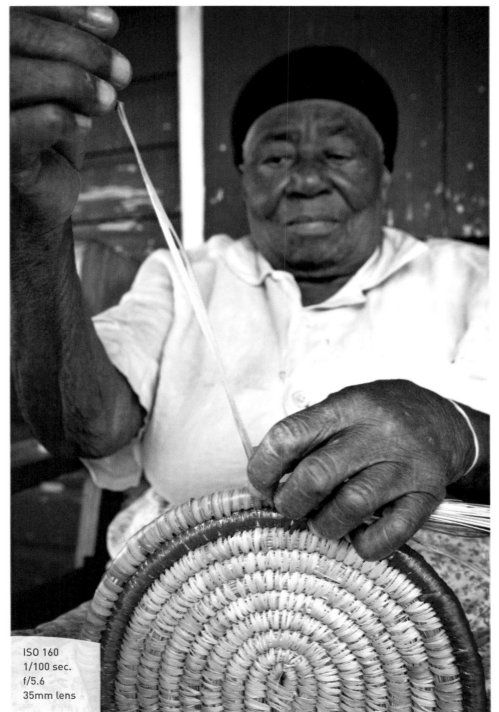

ISO 160
1/100 sec.
f/5.6
35mm lens

FIGURE 6.23
There's more to a person than just a face. When traveling in Cat Island in the Bahamas, I drove up to this family's home because they were selling these beautiful baskets. They happened to be outside making them right then, so I politely asked if I could photograph their process. I wanted to capture the entire scene, but I also wanted to show the weaver's hands. These hands had been making baskets for over 60 years, and I thought they told a story all by themselves.

GET DOWN ON THEIR LEVEL

If you want better pictures of children, don't shoot from an adult's eye level. Getting the camera down to the child's level will make your images look more personal (**Figure 6.24**).

ISO 100
1/400 sec.
f/9
65mm lens

ELIMINATE SPACE BETWEEN YOUR SUBJECTS

One of the problems you can encounter when taking portraits of more than one person is that of personal space. What feels like a close distance to the subjects can look impersonal to the viewer. Have your subjects move very close together, eliminating any open space between them (**Figure 6.25**).

ISO 200
1/100 sec.
f/6.3
68mm lens

Chapter 6 Assignments

Depth of field in portraits

Let's start with something simple. Grab your favorite person and start experimenting with using different aperture settings. Shoot wide open (the widest your lens goes, such as f/2.8 or f/4) and then really stopped down (like f/22). Look at the difference in the depth of field and how it plays an important role in placing the attention on your subject. (Make sure you don't have your subject standing against the background. Get some distance so that there is a good blurring effect of the background at the wide f-stop setting.)

Discovering the qualities of natural light

Pick a nice sunny day and try shooting some portraits in the midday sun. If your subject is willing, have him turn so the sun is in his face. If he is still speaking to you after you blinded him, have him turn his back to the sun. Try this with and without the fill flash so you can see the difference. Finally, move him into a completely shaded spot and take a few more.

Picking the right metering method

Find a very dark or light background and place your subject in front of it. Now take a couple of shots, allowing a lot of space around your subject for the background to show. Now switch metering modes and use the AE Lock feature to get a more accurate reading of your subject. Notice the differences in exposure between the metering methods.

Approach a stranger and practice your street photography. Find a busy, public place and ask someone if you can take her picture. If she declines, find someone else. Remember to smile and be comfortable. Offer her your business card or e-mail address so she can e-mail you to get the portrait. Then, practice taking some shots using some environmental data to tell a story.

If this is the first time you've done this, it's natural to be nervous. Just remember that it becomes easier with practice.

Share your results with the book's Flickr group!

Join the group here: flickr.com/groups/nikond7000_fromsnapshotstogreatshots

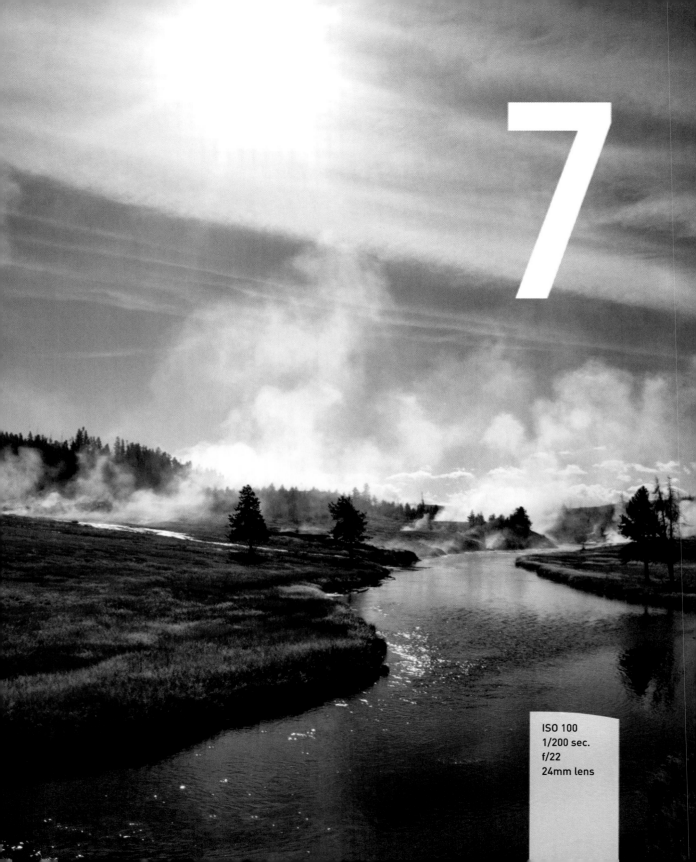

7

ISO 100
1/200 sec.
f/22
24mm lens

Landscape Photography

TIPS, TOOLS, AND TECHNIQUES FOR TAKING BEAUTIFUL LANDSCAPE PHOTOGRAPHS

I grew up in northern Michigan and spent most of my life enjoying the wilderness with my friends and family. On Sundays it was a tradition to load up the station wagon and go for a drive in the countryside. When I wasn't picking on my sister I could be found staring out the backseat window drifting in and out of conscious thought, dreaming of places I wanted to see. Now, some 30 years later, I find myself still drawn to visiting many of nature's true wonders—this time with camera in tow.

In this chapter, we will explore some typical scenarios and discuss methods to bring out the best in your landscape photography. We'll delve into some of the features of the D7000 that not only improve the look of your landscape photography, but also make it easier to take great shots.

PORING OVER THE PICTURE

By using the Exposure Compensation feature I was able to darken the image a bit by stepping down a stop.

I am drawn to images that remind me of my childhood and those long Sunday drives through the countryside, simple images that at times I take for granted until I can hear my late mother's voice reminding me to pause and enjoy life. This was one of those instances where I took the time to really savor the scenery. I was on my way back from photographing the Tetons when I came across these incredible wheat fields in Idaho. I knew the scene was special, so of course I had to capture it in my camera.

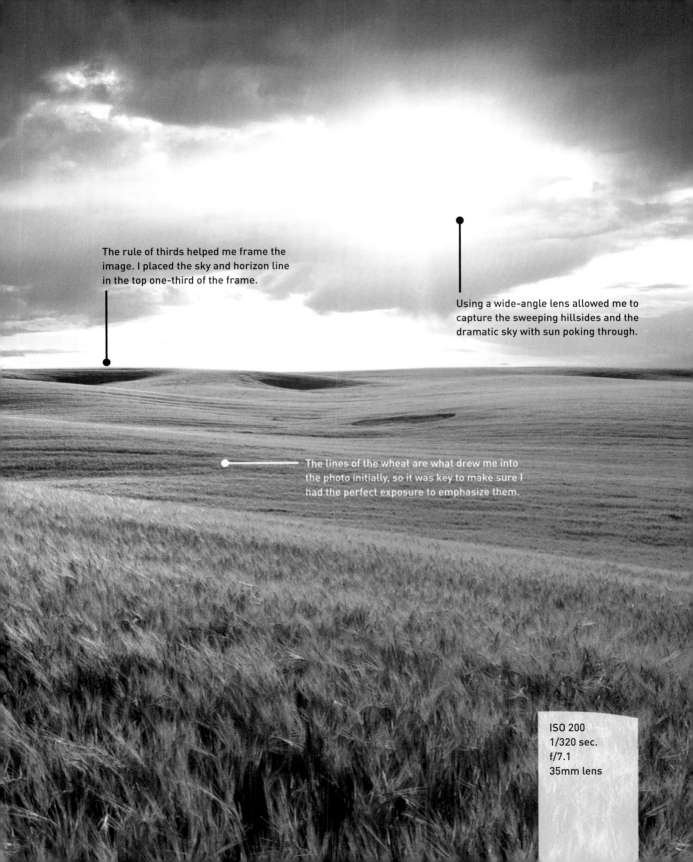

The rule of thirds helped me frame the image. I placed the sky and horizon line in the top one-third of the frame.

Using a wide-angle lens allowed me to capture the sweeping hillsides and the dramatic sky with sun poking through.

The lines of the wheat are what drew me into the photo initially, so it was key to make sure I had the perfect exposure to emphasize them.

ISO 200
1/320 sec.
f/7.1
35mm lens

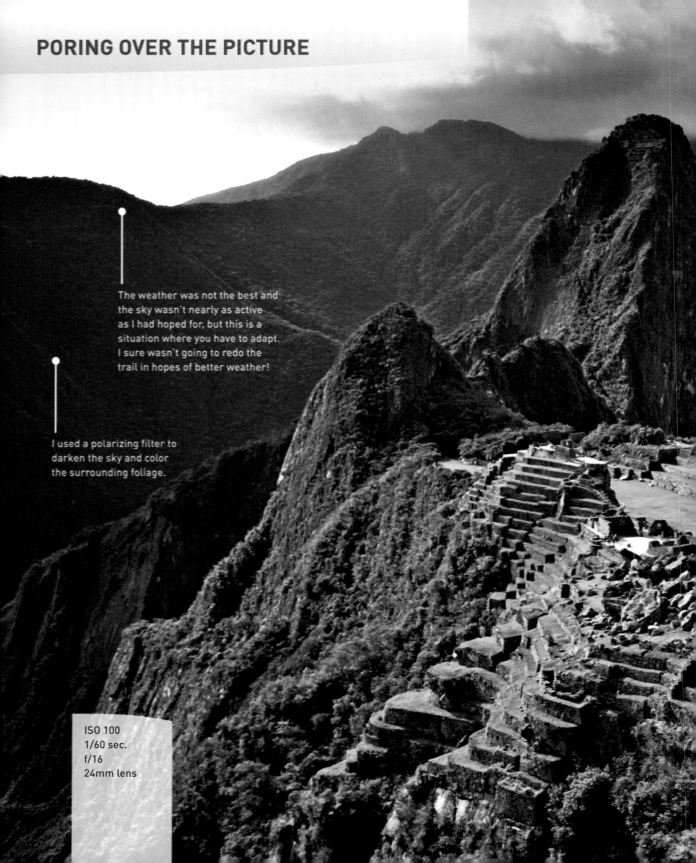

The weather was not the best and the sky wasn't nearly as active as I had hoped for, but this is a situation where you have to adapt. I sure wasn't going to redo the trail in hopes of better weather!

I used a polarizing filter to darken the sky and color the surrounding foliage.

ISO 100
1/60 sec.
f/16
24mm lens

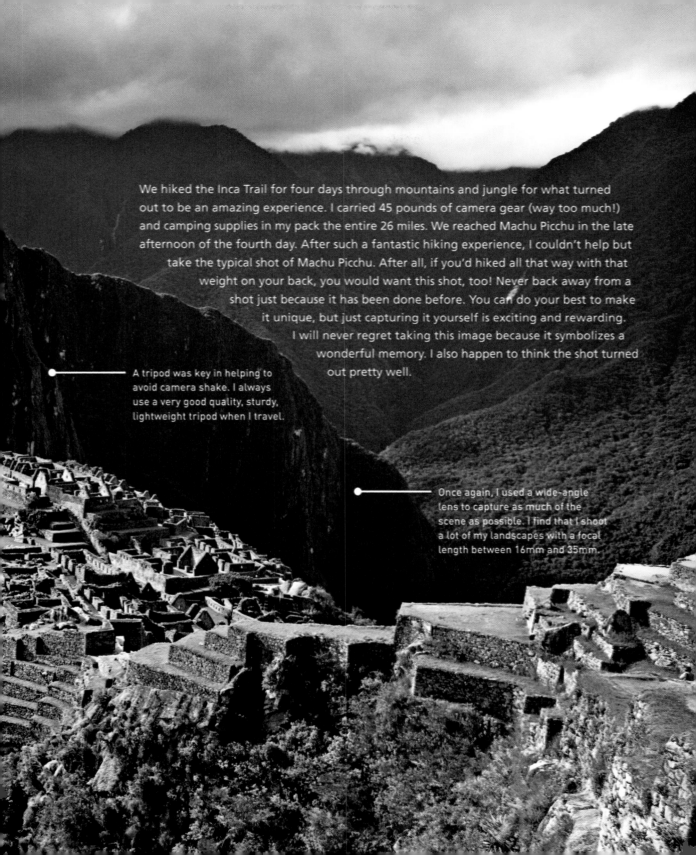

We hiked the Inca Trail for four days through mountains and jungle for what turned out to be an amazing experience. I carried 45 pounds of camera gear (way too much!) and camping supplies in my pack the entire 26 miles. We reached Machu Picchu in the late afternoon of the fourth day. After such a fantastic hiking experience, I couldn't help but take the typical shot of Machu Picchu. After all, if you'd hiked all that way with that weight on your back, you would want this shot, too! Never back away from a shot just because it has been done before. You can do your best to make it unique, but just capturing it yourself is exciting and rewarding. I will never regret taking this image because it symbolizes a wonderful memory. I also happen to think the shot turned out pretty well.

A tripod was key in helping to avoid camera shake. I always use a very good quality, sturdy, lightweight tripod when I travel.

Once again, I used a wide-angle lens to capture as much of the scene as possible. I find that I shoot a lot of my landscapes with a focal length between 16mm and 35mm.

SHARP FOCUS: USING A TRIPOD

Throughout the previous chapters we have concentrated on using the camera to create great images. We will continue that trend through this chapter, but there is one additional piece of equipment that is crucial in the world of landscape shooting: the tripod. There are a couple of reasons tripods are so critical to your landscape work, the first being the time of day that you will be working. As we'll cover later, the best light for most landscape work happens at sunrise and just before sunset. While this is the best time to shoot, it's also kind of dark. That means you'll be working with slow shutter speeds. Slow shutter speeds mean camera shake, unless you take precautions. Camera shake equals bad photos.

The second reason is also related to the amount of light that you're gathering with your camera. When taking landscape photos, you will usually want to be working with very small apertures, as they give you lots of depth of field. This also means that, once again, you will be working with slower-than-normal shutter speeds.

Slow shutter = camera shake = blurry photos.

If you're serious about landscape photography, then the one tool that all landscape photographers have to have is a good tripod. We might argue over what camera or what lens, but we all agree a tripod is key to getting a good image (**Figure 7.1**).

FIGURE 7.1
There is a funny story behind this image, but first notice that all of these photographers are using tripods at the Moulton Barn in Wyoming. You will also notice that it was a low-light situation, taking place as soon as the sun came up.

ISO 200
1/80 sec.
f/2.8
50mm lens

The story regarding Figure 7.1 is that while I thought I was going to beat everyone to the punch and get this shot at just the right time, apparently they had figured this out well before I did and I hadn't set my alarm quite early enough. I lost my place to four other photographers who had done a little more research. I learned my lesson and it's never happened since!

So what should you look for in a tripod? Well, first make sure it is sturdy enough to support your camera and any lens that you might want to use. Most manufacturers will list the weight limits by model. Next, check the height of the tripod. There is nothing worse than having to bend over all day to look through your viewfinder. Think about getting a tripod that uses a quick-release head. This usually employs a plate that screws into the bottom of the camera and then quickly snaps into place on the tripod. This will be especially handy if you are going to move between shooting by hand and using the tripod. Finally, consider the weight of the tripod. If you're traveling a lot or backpacking, having a heavy tripod is a real burden. Carbon fiber tripods are nice since they are very light and incredibly sturdy, but of course that combination comes at an increased cost. There's more information about tripods in the bonus chapter.

VR LENSES AND TRIPODS DON'T MIX

If you are using Vibration Reduction (VR) lenses on your camera, you need to remember to turn this feature off when you use a tripod. This is because Vibration Reduction can, while trying to minimize camera movement, actually create movement when the camera is already stable. To turn off the VR feature, just slide the VR selector switch on the side of the lens to the Off position (**Figure** 7.2).

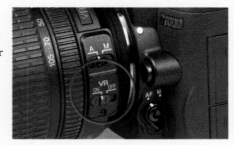

FIGURE 7.2
Turn off the Vibration Reduction feature when using a tripod.

Manual Callout

Another way to reduce camera shake is to use Mirror-up mode with a cable release or remote. Simply turn the Release Mode dial to MUP. Make sure to frame your image, set your exposure, and set your focus before you press the cable release button. Once you're happy with the image then press the release and the camera will raise the mirror. Then, simply press the cable release button one more time to take the picture. For more on Mirror-up mode please review page 83 of your manual.

SELECTING THE PROPER ISO

When shooting most landscape scenes, the ISO is the one factor that should only be increased as a last resort. While it is easy to select a higher ISO to get a smaller aperture, the noise that it can introduce into your images can be quite harmful. The noise is not only visible as large grainy artifacts; it can also be multicolored, which further degrades the image quality.

When shooting landscapes, set your ISO to the lowest possible setting at all times (**Figure 7.3**). Between the use of Vibration Reduction lenses (if you are shooting handheld) and a good tripod, you will seldom need to shoot landscapes with anything above an ISO of 400.

FIGURE 7.3
I used a very low ISO of 200 in order to maintain the best image quality possible given the available light.

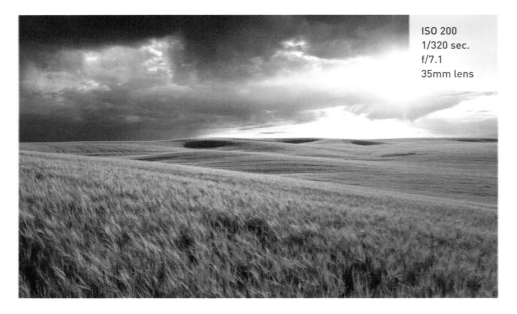

ISO 200
1/320 sec.
f/7.1
35mm lens

USING NOISE REDUCTION

The temptation to use higher ISOs should always be avoided, as the end result will be more image noise and less detail.

There can be an issue when using a low ISO setting: The sometimes lengthy shutter speeds can also introduce noise. This noise is a result of the heating of the camera sensor as it is being exposed to light. This effect is not visible in short exposures, but as you start shooting with shutter speeds that exceed one second, the level of image noise can increase. Your camera has a couple of features that you can turn on to combat noise from long exposures and high ISOs.

SETTING UP NOISE REDUCTION

1. Press the Menu button, then use the Multi-selector to get to the Shooting menu.

2. Using the Multi-selector, select Long Exp. NR and then press OK (**A**). Choose On and press the OK button.

3. Now use the Multi-selector to get to the High ISO NR setting in the Shooting menu and press OK (**B**).

4. ISO noise reduction comes in four options: High, Normal, Low, and Off. Set it to Normal for everyday shooting or High for those instances where you have to significantly raise your ISO (**C**).

SELECTING A WHITE BALANCE

This probably seems like a no-brainer. If it's sunny, select Daylight. If it's overcast, choose the Shade or Cloudy setting. Those choices wouldn't be wrong for those circumstances, but why not get creative? Sometimes you can actually make the mood of the photo more intriguing by selecting a white balance that doesn't quite fit the light for the scene that you are shooting.

Figure 7.4 is an example of a correct white balance. It was late afternoon and the sun was starting to move low in the sky, giving everything that warm afternoon glow. The white balance for this image was set to Daylight.

But what if I want to make the scene look like it was shot in the early morning hours? Simple—I just change the white balance to Fluorescent, which is a much cooler setting (**Figure 7.5**).

FIGURE 7.4
Using the correct white balance produces an appealing image.

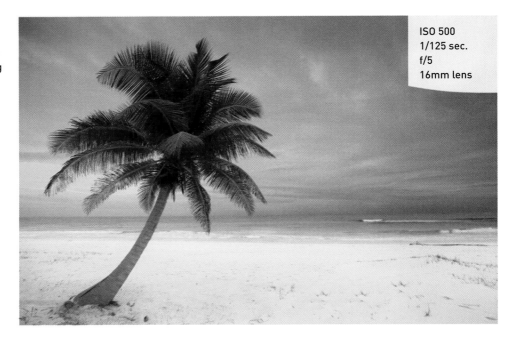

ISO 500
1/125 sec.
f/5
16mm lens

FIGURE 7.5
Changing the white balance to Fluorescent gives the image a totally different look and feel without the need to go into postproduction software to change the look.

ISO 500
1/125 sec.
f/5
16mm lens

You can select the most appropriate white balance for your shooting conditions in a couple of ways. The first is to just take a shot, review it on the LCD, and keep the one you like. Of course, you would need to take one for each white balance setting, which means that you will have to take about seven different shots to see which is most pleasing.

The second method doesn't require taking a single shot. Instead, it uses Live View to get perfectly selected white balances. Live View gives instant feedback as you scroll through all of the white balance settings and displays them for you right on the LCD. Even better, you can choose a custom setting that will let you dial in exactly the right look for your image.

To use Live View to preview the white balance, first you need to turn Live View on or off by simply rotating the Live View switch clockwise as indicated by the arrow in the image of the back of the camera (**Figure 7.6**). Next, simply change your white balance as we discussed in Chapter 1.

FIGURE 7.6
When you switch on Live View, you get feedback on all your white balance options and can even choose a custom setting.

USING THE LANDSCAPE PICTURE CONTROL

When shooting landscapes, I always look for great color and contrast. This is one of the reasons that so many landscape shots are taken in the early morning or during sunset. The light is much more vibrant and colorful at these times of day and adds a sense of drama to an image.

You can help boost this effect, especially in the less-than-golden hours of the day, by using the Landscape picture control (**Figure 7.7**). Just as in the Landscape mode found in the automatic scene modes, you can set up your landscape shooting so that you capture images with increased sharpness and a slight boost in blues and greens. This style will add some pop to your landscapes without the need for additional processing in any software.

Check out page 131 in your camera manual for more information on setting picture controls.

FIGURE 7.7
Using the Landscape picture control can add sharpness and more vivid color to skies and vegetation. Here it helped me capture the orange and turquoise colors that make the Grand Prismatic Spring so amazing.

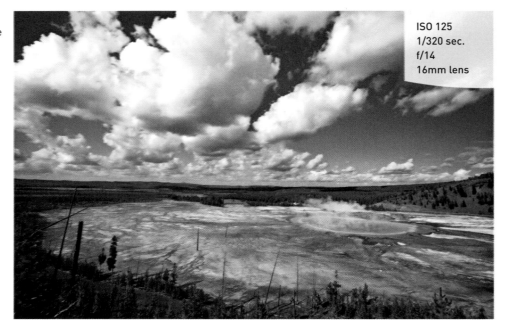

ISO 125
1/320 sec.
f/14
16mm lens

SETTING UP THE LANDSCAPE PICTURE CONTROL

1. Press the Info button twice, then use the Multi-selector to highlight the Set Picture Control feature (this is normally set to SD) and then press OK (**A**).

2. Now use the Multi-controller to scroll down to the LS option and press OK to lock in your change (**B**).

A

B

The camera will now apply the Landscape picture control to all of your photos. This style will be locked in to the camera even after turning it off and back on again, so make sure to change it back to SD when you are done with your landscape shoot.

TAMING BRIGHT SKIES WITH EXPOSURE COMPENSATION

Balancing exposure in scenes that have a wide contrast in tonal ranges can be extremely challenging. The one thing you should never do is overexpose your skies to the point of blowing out your highlights (unless, of course, that is the look you are going for). It's one thing to have white clouds, but it's a completely different, and bad, thing to have no detail at all in those clouds. This usually happens when the camera is trying to gain exposure in the darker areas of the image (**Figure 7.8**).

With this feature, you can force your camera to choose an exposure that ranges, in one-third-stop increments, from five stops over to five stops under the metered exposure (**Figure 7.9**).

The one way to tell if you have blown out your highlights is to turn on the Highlight Alert, or "blinkies,"⁴ feature on your camera (see the "How I Shoot: My Favorite Camera Settings" section in Chapter 4). When you take a shot where the highlights are exposed beyond the point of having any detail, that area will blink in your LCD. It is up to you to determine if that particular area is important enough to regain detail by altering your exposure. If the answer is yes, then the easiest way to go about it is to use some exposure compensation.

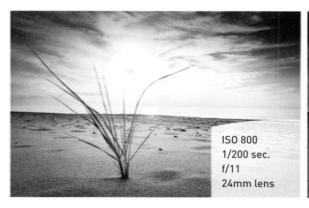

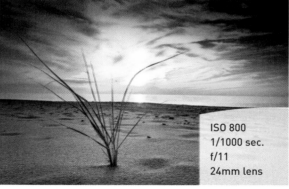

FIGURE 7.8
The sand and the grass are well exposed but the sky is totally blown out. Whenever I'm shooting into a sunset this is a potential problem. I solve it by using exposure compensation to get the entire image exposed correctly.

FIGURE 7.9
I compensated my exposure by two stops (-2 on the Exposure Compensation adjustment) and was able to bring details back into the clouds, sky, and water. You will notice the image itself is darker as a result of this compensation.

USING EXPOSURE COMPENSATION TO REGAIN DETAIL IN HIGHLIGHTS

1. Activate the camera meter by lightly pressing the shutter release button.

2. Using your index finger, press and hold the Exposure Compensation button to change the over-/underexposure setting by rotating the Command dial.

3. Rotate the Command dial counterclockwise one click and take another picture (each click of the Command dial is a one-third-stop change).

4. If the blinkies are gone, you are good to go. If not, keep subtracting from your exposure by one-third of a stop until you have a good exposure in the highlights.

ADJUSTING EXPOSURE COMPENSATION

1. Press the Exposure Compensation button (which has a +/- symbol on it) on the top of the camera to adjust exposure by -5 to +5 stops.

2. Hold the Exposure Compensation button while rotating the Command dial to the left to increase exposure and the right to decrease exposure. Each right click of the Command dial will continue to reduce the exposure in one-third-stop increments for up to five stops (although I rarely need to go past two stops).

It should be noted that any exposure compensation will remain in place even after turning the camera off and then on again. Don't forget to reset it once you have successfully captured your image. Also, the Exposure Compensation feature only works in the Program, Shutter Priority, and Aperture Priority modes. Changing between these three modes will hold the compensation you set while switching from one to the other. When you change the Mode dial to one of the automatic scene modes the compensation will set itself to zero.

SHOOTING AMAZING BLACK-AND-WHITE LANDSCAPES

There is almost nothing as timeless as a beautiful black-and-white landscape photo. For many, it is the purest form of photography. The genre conjures up thoughts of Ansel Adams out in Yosemite Valley, capturing stunning monoliths with his 8 x 10 view camera. Shooting with a digital camera doesn't mean you can't create your own stunning photos using the power of the Monochrome picture control. (See the "Classic Black-and-White Portraits" section of Chapter 6 for instructions on setting up this feature.) Not only can you shoot in black and white, you can also customize the camera to apply built-in filters to lighten or darken elements within your scene, as well as add contrast and definition.

The four filter colors are red, yellow, green, and orange. The most typically used filters in black-and-white photography are red and yellow. This is because the color of these filters will darken opposite colors and lighten similar colors. So if you want to darken a blue sky, use a yellow filter because blue is the opposite of yellow. To darken green foliage, you would use a red filter. Check out the series of shots in **Figure 7.10** with a red filter applied.

You can see that there is no real difference in contrast between the color and the black-and-white image with no filter. The red filter darkened the sky and made the green foliage much darker. I like my images to have strong contrast.

Other options in the Monochrome picture control enable you to adjust the sharpness, contrast, and even add some color toning to the final image. This information is also in the "Classic Black-and-White Portraits" section of Chapter 6. Experiment with the various settings to find the combination that is most pleasing to you.

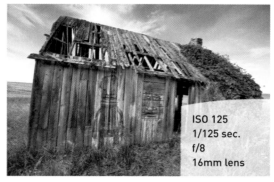

ISO 125
1/125 sec.
f/8
16mm lens

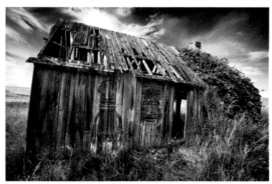

FIGURE 7.10
In the first shot, taken in color, notice the bright blue skies and green grass. The second shot was done with the Monochrome setting. The third image was shot with a red filter applied in the Monochrome setting with contrast increased. Adding color filter settings to the Monochrome picture control allows you to lighten or darken elements in your scene.

THE GOLDEN LIGHT

If you ask any professional landscape photographer what his favorite time of day to shoot is, chances are he will tell you it's the hours surrounding daybreak and sunset (**Figures 7.11**). The reason for this is that the light is coming from a very low angle to the landscape, which creates shadows and gives depth and character. There is also a quality to the light that seems cleaner and is more colorful than what you get when shooting at midday. One thing that can dramatically improve any morning or evening shot is the presence of clouds. The sun will fill the underside of the clouds with a palette of colors and add drama to your skies.

FIGURE 7.11
The last few minutes of light after the sun has set is probably one of my favorite moments to capture images.

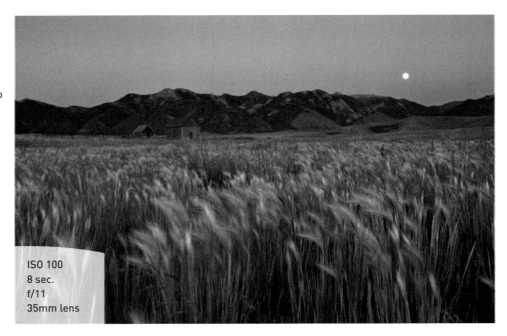

ISO 100
8 sec.
f/11
35mm lens

WARM AND COOL COLOR TEMPERATURES

These two terms are used to describe the overall colorcast of an image. Reds and yellows are said to be *warm*, which is usually the look that you get from the late afternoon sun. Blue is usually the predominant color when talking about a *cool* cast.

WHERE TO PLACE YOUR FOCUS

Large landscape scenes are great fun to photograph, but they can present a problem: Where exactly do you focus when you want everything to be sharp? Since our goal is to create a great landscape photo, we will need to concentrate on how to best create an image that is tack sharp, with a depth of field that renders great focus throughout the scene.

I have already stressed the importance of a good tripod when shooting landscapes. The tripod lets you concentrate on the aperture portion of the exposure without worrying how long your shutter will be open. This is because the tripod provides the stability to handle any shutter speed you might need when shooting at small apertures. I find that for most of my landscape work I set my camera to Aperture Priority mode and the ISO to 100–200 (for a clean, noise-free image).

However, shooting with the smallest aperture on your lens doesn't necessarily mean that you will get the proper sharpness throughout your image. The real key is knowing where in the scene to focus your lens to maximize the depth of field for your chosen aperture. To do this, you must use something called the hyper focal distance of your lens.

Hyper focal distance, also referred to as HFD, is the point of focus that will give you the greatest acceptable sharpness from a point near your camera all the way out to infinity. If you combine good HFD practice in combination with a small aperture, you will get images that are sharp to infinity.

There are a couple of ways to do this, and the one that is probably the easiest, as you might guess, is the one that is most widely used by working pros. When you have your shot all set up and composed, focus on an object that is about one-third of the distance into your frame (**Figure 7.12**). It is usually pretty close to the proper distance and will render favorable results. When you have the focus set, take a photograph and then zoom in on the preview on your LCD to check the sharpness of your image.

One thing to remember is that as your lens gets wider in focal length, your HFD will be closer to the camera position. This is because the wider the lens, the greater the depth of field you can achieve. This is yet another reason why a good wide-angle lens is indispensable to the landscape shooter.

FIGURE 7.12
To get maximum focus from near to far, I manually focused one-third of the way into the frame, or at the beginning of the building structures. I then recomposed the image before taking the picture. Using AF-S focus mode and f/16 gave me a very sharp image throughout the frame.

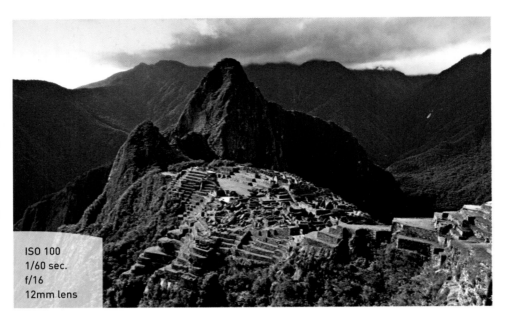

ISO 100
1/60 sec.
f/16
12mm lens

FOCUSING MADE EASY

There's no denying that the automatic focus features on the D7000 are great, but sometimes it pays to turn them off and go manual. Typically I shoot all my landscape images using manual focus because this avoids the hassle of having your camera try to guess what you're focusing on. If you don't prefer manual focus, then make sure to set your camera on AF-S and select one of the 39 focus points (**Figure 7.13**).

GETTING FOCUSED WHILE USING A TRIPOD

1. Set up your shot and find the area that you want to focus on.

2. Pan your tripod head so that your active focus point is on that spot.

3. Press the shutter button halfway to focus the camera.

4. Switch the camera to manual focus by sliding the switch on the lens barrel from A to M.

5. Recompose on the tripod and then take the shot.

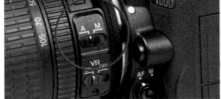

The camera will fire without trying to refocus the lens. This works especially well for wide-angle lenses, which can be difficult to focus in manual mode.

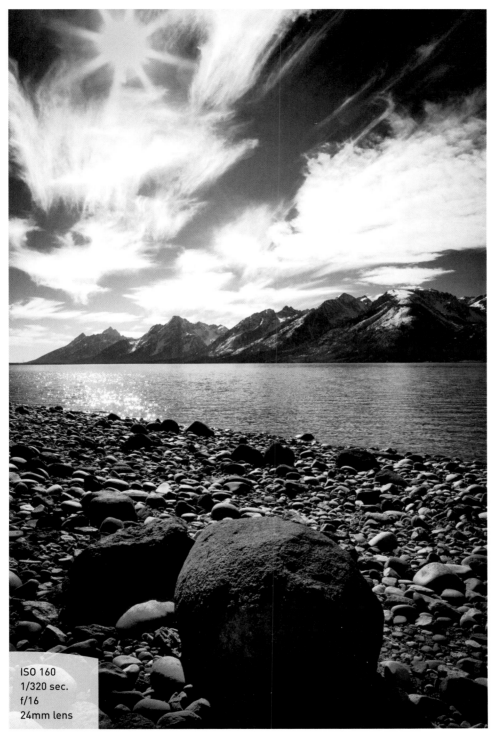

FIGURE 7.13
I was drawn to this boulder and its near perfectly round shape. This was a good time to use the depth of field one-third rule by first focusing on the rock and then switching to manual mode to ensure the remainder of my frame was in focus.

ISO 160
1/320 sec.
f/16
24mm lens

SMOOTH WATER

There's little that is quite as satisfying for the landscape shooter as capturing a smooth waterfall shot. Creating the smooth-flowing effect is as simple as adjusting your shutter speed to allow the water to be in motion while the shutter is open. The key is to have your camera on a stable platform (such as a tripod) so that you can use a shutter speed that's long enough to work (**Figure 7.14**). To achieve a great effect, use a shutter speed that is at least 1/15 of a second or longer.

FIGURE 7.14
I sat my tripod right in the middle of this creek downstream from these small rapids. This allowed me to get the right point of view while using a slow shutter speed to show the movement in the water.

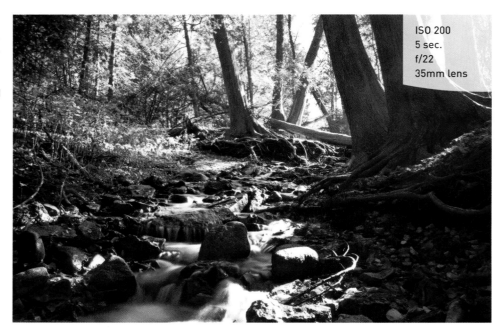

ISO 200
5 sec.
f/22
35mm lens

SETTING UP FOR A WATERFALL SHOT

1. Attach the camera to your tripod, then compose and focus your shot.
2. Make sure the ISO is set to 100 or 200.
3. Using Aperture Priority mode, set your aperture to the smallest opening (such as f/22 or f/36).
4. Press the shutter button halfway so the camera takes a meter reading.
5. Check to see if the shutter speed is 1/15 or slower.
6. Take a photo and then check the image on the LCD.

You can also use Shutter Priority mode for this effect by dialing in the desired shutter speed and having the camera set the aperture for you. I prefer to use Aperture Priority to ensure that I have the greatest depth of field possible.

If the water is blinking on the LCD, indicating a loss of detail in the highlights, then use the Exposure Compensation feature (as discussed earlier in this chapter) to bring details back into the water. You will need to have the Highlight Alert feature turned on to check for overexposure (see "How I Shoot" in Chapter 4).

It is possible that you will not be able to have a shutter speed that is long enough to capture a smooth, silky effect, especially if you are shooting in bright daylight conditions. To overcome this obstacle, you need a filter for your lens—either a polarizing filter or a neutral density filter.

The polarizing filter redirects wavelengths of light to create more vibrant colors, reduce reflections, and darken blue skies, as well as lengthen exposure times by two stops due to the darkness of the filter. It is a handy filter for landscape work. The neutral density filter is typically just a dark piece of glass that serves to darken the scene by one, two, or three stops. This allows you to use slower shutter speeds during bright conditions. Think of it as sunglasses for your camera lens.

DIRECTING THE VIEWER'S EYE: A WORD ABOUT COMPOSITION

As a photographer, it's your job to lead the viewer through your image. You accomplish this by using the principles of composition, which is the arrangement of elements in the scene that draws the viewer's eyes through your image and holds his attention. You need to understand how people see and then use that information to focus their attention on the most important elements in your image.

There is a general order in which we look at elements in a photograph. The first is brightness. The eye wants to travel to the brightest object within a scene. So if you have a bright sky, it's probably the first place the eye will go. The second is sharpness. Sharp, detailed elements get more attention than soft, blurry areas. Finally, the eye will move to vivid colors while leaving the dull, flat colors for last. It is important to know these essentials in order to grab—and keep—the viewer's attention and then direct him through the frame.

In **Figure 7.15**, the eye is drawn to the bright splashes of water and the sharply focused rocks in the foreground. From there it is pulled up the river, where the frame gets darker and the eyes come to rest on the mountains and the shore. Finally, they move up into the active sky, starting with the light fluffy clouds and ending in the dark blue at the very top of the frame.

FIGURE 7.15
I enjoy fly-fishing the Madison River in Montana so much that I decided to photograph my favorite trout stream. Standing in the water with my waders on, I took this shot of the river. When composing it I wanted the viewer's eye to be drawn into the image and pulled up to the mountains and the wispy clouds above.

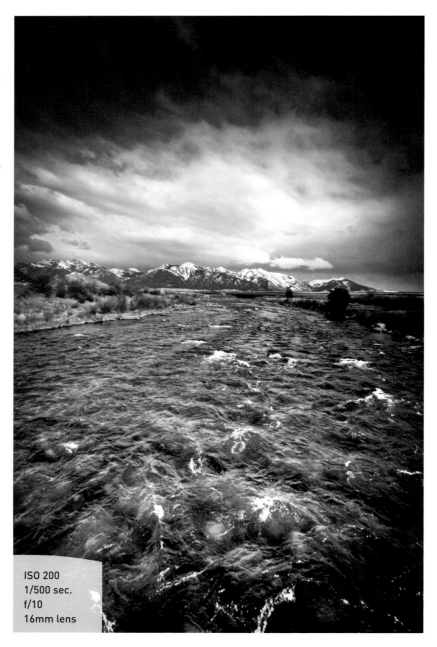

ISO 200
1/500 sec.
f/10
16mm lens

RULE OF THIRDS

There are quite a few philosophies concerning composition. The easiest to begin with is the "rule of thirds." Using this principle, you simply divide your viewfinder into thirds by imagining two horizontal and two vertical lines that divide the frame equally.

The key to using this method of composition is to have your main subject located at or near one of the intersecting points (**Figure 7.16**).

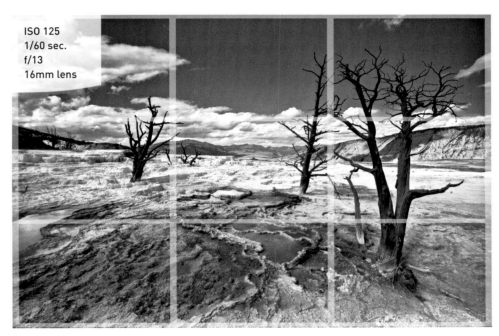

ISO 125
1/60 sec.
f/13
16mm lens

FIGURE 7.16
I wanted to show all the dead trees in the paint pot at Yellowstone National Park, so I decided to compose the image with the nearest tree in the bottom right quadrant. This created a more compelling composition than centering the tree.

By placing your subject near these intersecting lines, you are giving the viewer space to move within the frame. The one thing you normally don't want to do is put your subject smack-dab in the middle of the frame, sometimes referred to as "bull's-eye" composition. Centering the subject is not always wrong, but it will usually be less appealing and may not hold the viewer's attention.

Speaking of the middle of the frame: Another rule of thirds deals with horizon lines. Generally speaking, you should position the horizon one-third of the way up or down in the frame. Splitting the frame in half by placing your horizon in the middle of the picture is akin to placing the subject in the middle of the frame; it doesn't lend a sense of importance to either the sky or the ground.

In **Figure 7.17**, I incorporated the rule of thirds by aligning my horizon in the bottom third of the frame and the sky and steam in the top third. I also placed the river in the foreground to draw the eye to the bottom third of the frame, giving the viewer a chance to travel throughout the frame, ending on the steam, sky, and bright sun. The top two thirds contain the sky and the steam rising from the geothermal features in Yellowstone National Park.

FIGURE 7.17
Putting the horizon of this image at the bottom third of the frame places emphasis on steam rising from the geo-thermal features in the landscape.

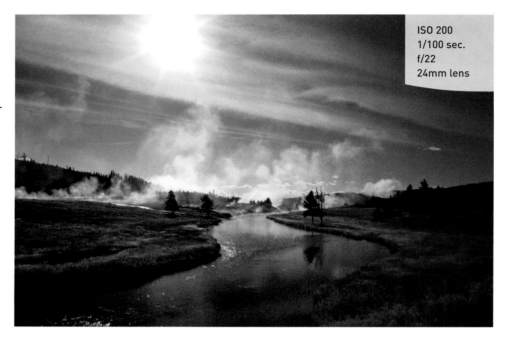

ISO 200
1/100 sec.
f/22
24mm lens

The D7000 has two visual tools for assisting you in composing your photo in the form of grid overlays. These grids can be set to appear in the viewfinder and on the rear LCD when in Live View mode.

USING A GRID OVERLAY IN THE VIEWFINDER

1. Press the Menu button, then use the Multi-selector to navigate to the Custom Settings menu and select D Shooting/Display.

2. Navigate to D2 Viewfinder Grid Display, press OK, set the feature to On, and press OK.

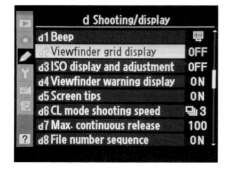

1. Rotate the Live View switch to turn on Live View.
2. Press the Info button until the grid appears on the viewfinder.

Although the grid in the viewfinder and the Live View screen aren't equally divided into thirds, they will give you an approximation of where you should be aligning your subjects in the frame.

CREATING DEPTH

Because a photograph is a flat, two-dimensional space, you need to establish a sense of depth by using the elements in the scene to create a three-dimensional feel. This is accomplished by including different and distinct spaces for the eye to travel to: a foreground, middle ground, and background. By using these three spaces, you draw the viewer in and give your image depth.

This scene of the Badlands National Park in South Dakota, **Figure 7.18**, illustrates this well. The hills in the foreground as well as my point of view helped create a sense of height. The faraway, flat horizon seems miles away, while the sunlight beaming through hit the small rock outcropping right in the center of the frame. All of these factors helped give the image depth and made it feel three-dimensional.

ISO 100
1/180 sec.
f/6.7
15mm lens

FIGURE 7.18
I was visiting the Badlands on a stormy day. There was a break in the clouds where the sunlight was coming through and shining on a small rock outcropping in the distance. The rain increased the colors in the striations of the rock, adding contrast and visual interest.

ADVANCED TECHNIQUES TO EXPLORE

This section comes with a warning attached. All of the techniques and topics up to this point have been centered on your camera. The following two sections, covering panoramas and high dynamic range (HDR) images, require you to use image-processing software to complete the photograph. They are, however, important enough that you should know how to shoot for success should you choose to explore these two popular techniques.

SHOOTING PANORAMAS

I've never been much for panoramas until I visited the Grand Teton National Park. The Tetons are probably one of my favorite mountain ranges and easily identifiable, but a single frame just doesn't do them justice. Only a panorama can truly capture a mountain range, cityscape, or any extremely wide vista.

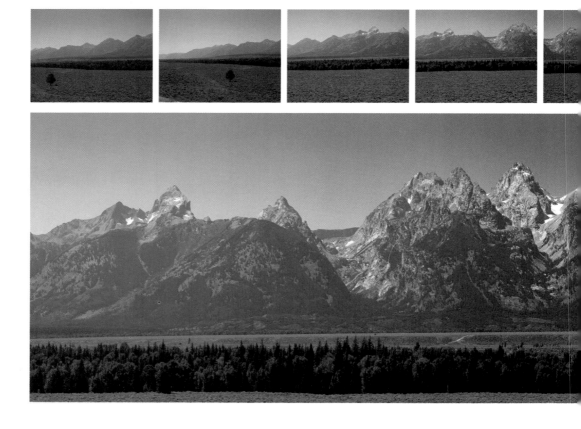

THE MULTIPLE-IMAGE PANORAMA

To shoot a true panorama, you need to use either a special panorama camera that shoots a very wide frame or the following method, which requires the combining of multiple frames.

The multiple-image pano, as photographers often call a panoramic, has gained in popularity in the past few years; this is principally due to advances in image-processing software. Many software options are available now that will take multiple images, align them, and then "stitch" them into a single panoramic image. The real key to shooting a multiple-image pano is to overlap your shots by about 30 percent from one frame to the next (**Figures 7.19** and **7.20**). It is possible to handhold the camera while capturing your images, but the best method for capturing great panoramic images is to use a tripod.

Now that you have your series of overlapping images, you can import them into your image-processing software to stitch them together and create a single panoramic image.

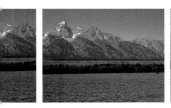

FIGURE 7.19
Here you see the makings of a panorama, with nine shots overlapping by about 30 percent from frame to frame.

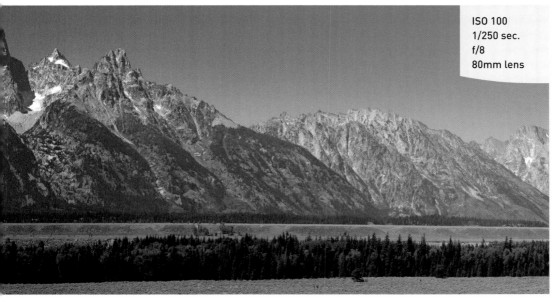

ISO 100
1/250 sec.
f/8
80mm lens

FIGURE 7.20
I used Adobe Photoshop to combine all of the exposures into one large panoramic image.

If you shoot more than one series of shots for your panoramas, it can sometimes be difficult to know when one series of images ends and the other begins. Here is a quick tip for separating your images.

Set up your camera using the steps listed here. Now, before you take your first good exposure in the series, hold up one finger in front of the camera and take a shot. Move your hand away and begin taking your overlapping images. When you have taken your last shot, hold two fingers in front of the camera and take another shot.

Now, when you go to review your images, use the series of shots that falls between the frames with one and two fingers in them. Then just repeat the process for your next panorama series.

SHOOTING PROPERLY FOR A MULTIPLE-IMAGE PANORAMA

1. Mount your camera on your tripod and make sure it is level.

2. In Aperture Priority mode, use a very small aperture for the greatest depth of field. Take a meter reading of a bright part of the scene, and make note of it.

3. Now change your camera to Manual mode (M), and dial in the aperture and shutter speed that you obtained in the previous step.

4. Set your lens to manual focus, and then focus it for the area of interest using the HFD method of finding a point one-third of the way into the scene. (If you use the autofocus, you risk getting different points of focus from image to image, which will make the image stitching more difficult for the software.)

5. While carefully panning your camera, shoot your images to cover the entire area of the scene from one end to the other, leaving a 30 percent overlap from one frame to the next. The final step would involve using your favorite imaging software to take all of the photographs and combine them into a single panoramic image.

SHOOTING HIGH DYNAMIC RANGE (HDR) IMAGES

High dynamic range (HDR) can create stunning images by using the full tonal range of an image. Depending upon your preference they can look quite real or very surreal. I have found people either love or hate HDR, but regardless of what side of the fence you are on it is a wonderful way to understand the effects of exposure on an image.

HDR is used quite often in landscape, cityscape, and, believe it or not, interior design images. Typically, when you photograph a scene that has a wide range of tones from shadows to highlights, you have to make a decision regarding which tonal values you are going to emphasize, and then adjust your exposure accordingly. This is because your camera has a limited dynamic range, at least as compared to the human eye. HDR photography allows you to capture multiple exposures for the highlights, shadows, and midtones, and then combine them into a single image using software (**Figure 7.21**).

A number of software applications allow you to combine the images and then perform a process called "tonemapping," whereby the complete range of exposures is represented in a single image. I will not be covering the software applications, but I will explore the process of shooting a scene to help you render properly captured images for the HDR process. Note that using a tripod is absolutely necessary for this technique, since you need to have perfect alignment of the images when they are combined.

ISO 125
f/8
16mm lens

FIGURE 7.21
This tonemapped HDR image combines several exposures.

SETTING UP FOR SHOOTING AN HDR IMAGE

1. Set your ISO to 100–200 to ensure clean, noise-free images.

2. Set your program mode to Aperture Priority. During the shooting process, you will be taking three shots of the same scene, creating an overexposed image, an underexposed image, and a normal exposure. Since the camera is going to be adjusting the exposure, you want it to make changes to the shutter speed, not the aperture, so that your depth of field is consistent.

3. Set your camera file format to RAW. This is extremely important because the RAW format contains a much larger range of exposure values than a JPEG file, and the HDR software needs this information.

4. Change your shooting mode to continuous. This will allow you to capture your exposures quickly. Even though you will be using a tripod, there is always a chance that something within your scene will be moving (like clouds or leaves). Shooting in the continuous mode minimizes any subject movement between frames.

5. Adjust the Auto Bracketing (BKT) mode to shoot three exposures in two-stop increments. To do this, you will first need to press the BKT button while moving the Command dial to the right.

6. Now use the Sub-command dial to adjust the bracketing to 2.0.

7. Focus the camera using the manual focus method discussed earlier in the chapter, compose your shot, secure the tripod, and hold down the shutter button until the camera has fired three consecutive times. The result will be one normal exposure, as well as one under- and one overexposed image.

A software program such as Adobe Photoshop, Photomatix Pro, or my favorite, Nik Software's HDR Efex Pro, can now process your exposure-bracketed images into a single HDR file. Remember to turn the BKT function back to Off when you are done or the camera will continue to shoot bracketed images.

BRACKETING YOUR EXPOSURES

In HDR, *bracketing* is the process of capturing a series of exposures at different stop intervals. You can bracket your exposures even if you aren't going to be using HDR. Sometimes this is helpful when you have a tricky lighting situation and you want to ensure that you have just the right exposure to capture the look you're after. In HDR, you bracket to the plus and minus side of a "normal" exposure, but you can also bracket all of your exposures to the over or under side of normal. It all depends on what you are after. If you aren't sure whether you are getting enough shadow detail, you can bracket a little toward the overexposed side. The same is true for highlights. You can bracket in increments as small as a third of a stop. This means that you can capture several images with very subtle exposure variances and then decide later which one is best. If you want to bracket just to one side of a normal exposure, set your exposure compensation to +1 or –1, whichever way you need, and the use the bracketing feature to automatically bracket your exposures.

Chapter 7 Assignments

We've covered a lot of ground in this chapter, so it's time to put this knowledge to work in order to get familiar with these new camera settings and techniques.

Comparing depth of field: Wide-angle vs. telephoto

Speaking of depth of field, you should also practice using the hyper focal distance of your lens to maximize the depth of field. You can do this by picking a focal length to work with on your lens.

If you have a zoom lens, try using the longest length. Compose your image and find an object to focus on. Set your aperture to f/22 and take a photo.

Now do the same thing with the zoom lens at its widest focal length. Use the same aperture and focus point.

Review the images and compare the depth of field when using wide angle as opposed to a telephoto lens. Try this again with a large aperture as well.

Applying hyper focal distance to your landscapes

Pick a scene that once again has objects that are near the camera position and something that is clearly defined in the background. Try using a wide to medium wide focal length for this (18–35mm). Use a small aperture and focus on the object in the foreground; then recompose and take a shot.

Without moving the camera position, use the object in the background as your point of focus and take another shot.

Finally, find a point that is one-third of the way into the frame from near to far and use that as the focus point.

Compare all of the images to see which method delivered the greatest range of depth of field from near to infinity.

Using Live View and the rule of thirds

Now let's get some practice using the rule of thirds for improving composition. To do this, you need to employ Live View with the grid overlay turned on for a little visual assistance.

Using the Live View grid, practice shooting while placing your main subject in one of the intersecting line locations. Take some comparison shots with the subject at one of the intersecting locations and then shoot the same subject in the middle of the frame.

Placing your horizons

Finally, find a location with a defined horizon and, using the Live View grid, shoot the horizon along the top third of the frame, in the middle of the frame, and along the bottom third of the frame.

Share your results with the book's Flickr group!

Join the group here: flickr.com/groups/nikond7000_fromsnapshotstogreatshots

8

ISO 400
1/8 sec.
f/4.5
35mm lens

Mood Lighting

SHOOTING WHEN THE LIGHTS GET LOW

There is no reason to put your camera away when the sun goes down. Your D7000 has some great features that let you work with available light as well as the built-in flash. In this chapter, we will explore ways to push your camera's technology to the limit in order to capture great photos in difficult lighting situations. We will also explore the use of flash and how best to use your built-in flash features to improve your photography. But let's first look at working with low-level available light.

This image took place in a matter of seconds, so shooting in Aperture Priority with a high ISO allowed me time to focus on framing.

Is there noise in this image? Yep, but I would rather have the image with a little noise than no image at all. Don't let noise hold you back from taking an image that you only have split seconds to take.

ISO 6400
1/160 sec.
f/1.2
85mm lens

I've traveled quite a bit in my life, but no place has touched me like Varanasi, India. The culture and the wonderful people are a huge draw for a person like me who enjoys taking street portraits. I was walking down a very tight alley filled with merchant shops when all of a sudden the city lost power. It was pitch black, but without missing a beat this young tailor pulled out a candle, lit it, and continued on with his work. I quickly bumped my ISO to 6400 and opened my 85mm to its largest aperture, f/1.2, and began taking photographs. It is a moment I'll never forget, and now I never have to worry about forgetting it—since I have the photograph!

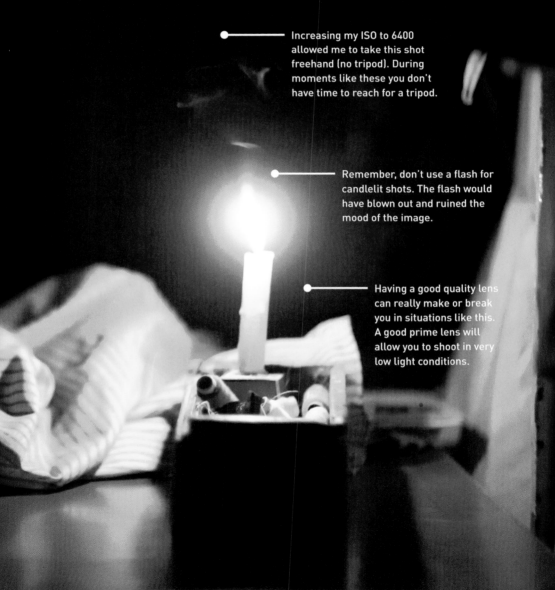

Increasing my ISO to 6400 allowed me to take this shot freehand (no tripod). During moments like these you don't have time to reach for a tripod.

Remember, don't use a flash for candlelit shots. The flash would have blown out and ruined the mood of the image.

Having a good quality lens can really make or break you in situations like this. A good prime lens will allow you to shoot in very low light conditions.

Like most of you I don't own a studio, but that doesn't stop me from clearing the dining room out and setting up shop every couple of months. Home studios are easy to set up; all you need is a wide roll of paper for a background, a light source, of course a subject, your D7000, and voilà—you're in business. What I love about studio photography is it gives you a controlled environment to learn about exposure and composition while developing your skills and having fun.

I photographed this image of my daughter using one external flash, a small softbox, and a black paper background. One of the best things about a home studio is you can get your entire family involved—it was her idea to blow the bubbles.

It is important to avoid wide-angle lenses when shooting portraits, unless you're looking to distort the image. Exposure was vital here. We wanted the background completely black with the light falling off her face on the left. I would be lying if I told you we got it right on the first try. Once again, the benefit of a studio is you measure your results and make adjustments in a controlled environment.

A very simple setup was used, with one external flash and a small softbox.

I placed my daughter a few feet from the black rolled paper to create a nice dark background.

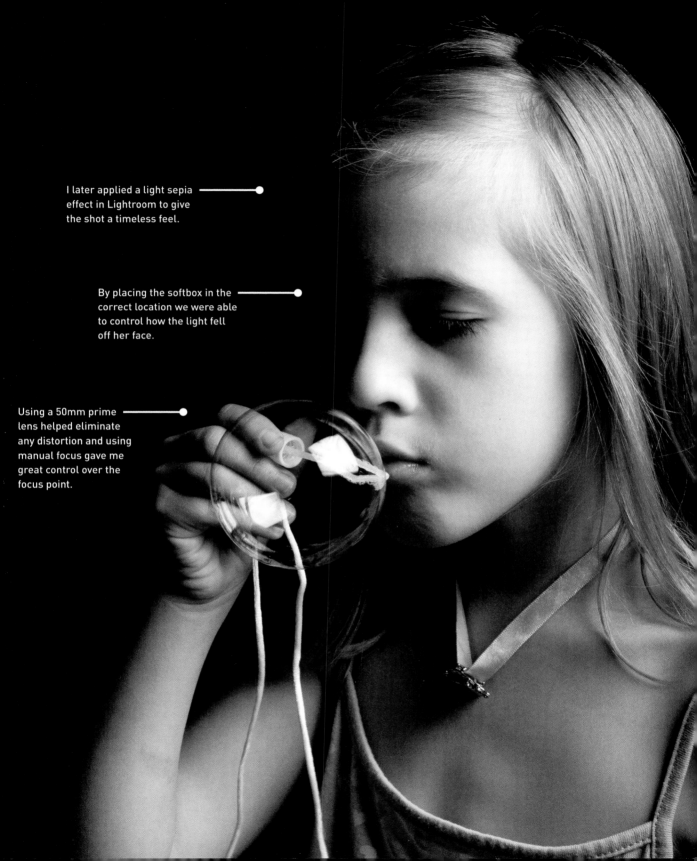

I later applied a light sepia effect in Lightroom to give the shot a timeless feel.

By placing the softbox in the correct location we were able to control how the light fell off her face.

Using a 50mm prime lens helped eliminate any distortion and using manual focus gave me great control over the focus point.

RAISING THE ISO

Let's begin with the obvious way to keep shooting when the lights get low: raising the ISO (**Figure 8.1**). By now you know how to change the ISO by using the ISO button and the Command dial. In typical shooting situations, you should keep the ISO in the 100–1000 range. This will keep your pictures nice and clean by keeping the digital noise to a minimum. But as the available light gets low, you might find yourself working in the higher ranges of the ISO scale, which could lead to more noise in your image.

Everyone has a different tolerance for digital noise, so experiment a bit with different ISO settings and see what your limit is. My tolerance depends on my subject. For my landscape photography I have a very low tolerance for digital noise, but for street photography I have been known to let it slide here and there.

Now, you could use a flash and try to avoid bumping up your ISO, but that has a limited range (15 to 20 feet) that might not work for you. Also, you could be in a situation where flash is prohibited, or at least frowned upon, like at a wedding or in a museum.

And what about a tripod in combination with a long shutter speed? That is also an option, and we'll cover it a little later in the chapter. The problem with using a tripod and a slow shutter speed in low-light photography, though, is that it performs best when subjects aren't moving. Besides, try to set up a tripod in a museum and see how quickly you grab the attention of the security guards.

So if the only choice to get the shot is to raise the ISO to 1000 or higher, make sure that you turn on the High ISO Noise Reduction feature. This custom menu function is set to Standard by default, but as you start using higher ISO values you should consider changing it to the High setting. (Chapter 7 explains how to set the noise reduction features.)

Raising the noise reduction to the High setting slightly increases the processing time for your images, so if you are shooting in continuous mode you might see a little reduction in the speed of your frames per second.

HOT TIP

Don't let digital noise stop you from taking a photo. There are tons of wonderful postproduction software programs that help remove digital noise from your image.

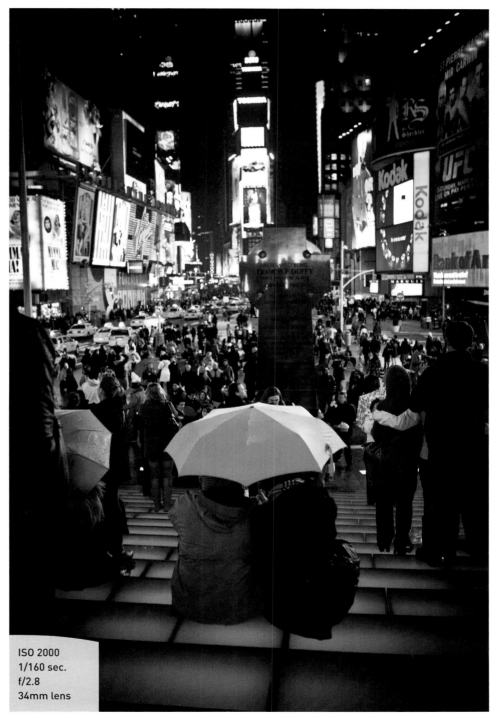

FIGURE 8.1
Wouldn't you
know it—the very
first time I visited
Times Square in
New York City it
decided to rain.
But, the key to good
street photography
is being able to
adapt. I bumped my
ISO up to 2000 and
got lucky.

ISO 2000
1/160 sec.
f/2.8
34mm lens

NOISE REDUCTION SAVES SPACE

When shooting at very high ISO settings, running High ISO Noise Reduction at the Normal or High setting can save you space on your memory card. If you are saving your photos as JPEGs, the camera will compress the information in the image to take up less space. When you have excessive noise, you can literally add megabytes to the file size. This is because the camera has to deal with more information: It views the noise in the image as photo information and tries not to lose that information during the compression process. Thus, more noise equals bigger files. So not only will turning on the High ISO Noise Reduction feature improve the look of your image, it will also save you some space so you can take a few more shots.

USING VERY HIGH ISOS

Is ISO 6400 just not enough for you? Well, in that case, you will need to set your camera to one of the expanded ISO settings. These settings open up another 2 stops of ISO, raising the new limit to 12800. The new settings will not appear in your ISO scale as numbers, but as H 0.3 for 8000, H 0.7 for 10000, H 1 ISO for 12800, and H 2 ISO for 25600.

HOW TO USE THE HIGHER ISO SETTINGS

1. Press and hold the ISO button (**A**). Then rotate the Command dial while observing the control panel. Rotate the dial until you reach the Hi settings, then release the ISO button.

2. Select H 0.3, H 0.7, H 1.0, or H 2.0 (**B**).

A

B

A word of warning about the expanded ISO settings: Although it is great to have these high ISO settings available during low-light shooting, they should always be your last resort. Even with the High ISO Noise Reduction turned on, the amount of visible noise will be extremely high. Try to avoid using high ISO whenever you can, but don't skip an opportunity for a terrific shot because you're afraid to use a higher ISO. The D7000 does remarkably well at 1600 and below, so experiment a little. Remember, a picture never taken is far worse than one with a little noise! (**Figure 8.2**).

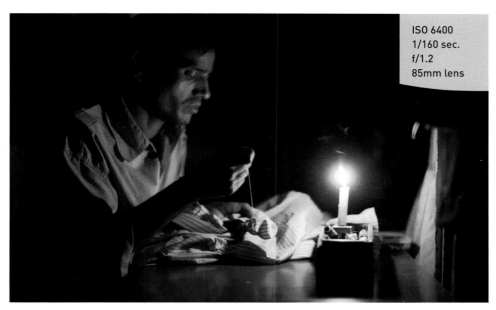

ISO 6400
1/160 sec.
f/1.2
85mm lens

FIGURE 8.2
If I hadn't bumped my ISO up to 6400 I would have missed a great memory. Does the image have a little noise? Sure, but I would rather have it than not have the photo!

STABILIZING THE SITUATION

If you purchased your camera with the Vibration Reduction (VR) lens or if you have the kit lens, you already own a great tool to squeeze two stops of exposure out of your camera when shooting without a tripod. Typically, the average person can hand-hold his camera down to about 1/60 of a second before blurriness results due to hand shake. Even if you have pipes as big as Mr. T's you need to use this feature. As the length of the lens is increased (or zoomed), the ability to hand-hold at slow shutter speeds (1/60 and slower) and still get sharp images is further reduced (**Figure 8.3**).

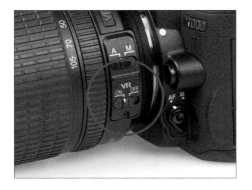

FIGURE 8.3
Turning on the VR switch will allow you to shoot in lower lighting conditions while reducing hand shake. I love this feature—especially if I haven't had my morning coffee.

HANDS OFF TO SHARPER IMAGES

Whether you are shooting with a tripod or even resting your camera on a wall, you can increase the sharpness of your pictures by taking your hands out of the equation. Whenever you use your finger to depress the shutter release button, you are increasing the chances that there will be a little bit of shake in your image. To eliminate this possibility, try setting your camera up to use the Self-timer or Exposure Delay mode (**Figure 8.4**). We're going to discuss the Self-timer feature since we've already covered the Exposure Delay mode in Chapter 1.

FIGURE 8.4
A portrait needs to be sharp, and by using the Self-timer or Exposure Delay you reduce the chances of camera shake.

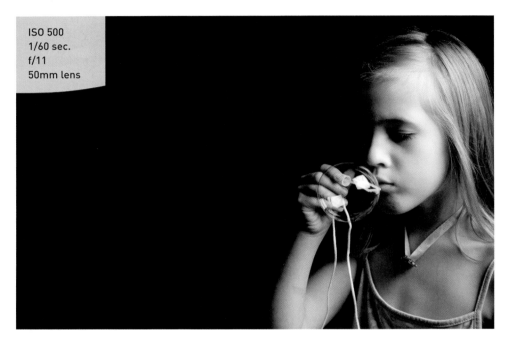

ISO 500
1/60 sec.
f/11
50mm lens

1. To turn on the Self-timer simply press the release dial lock and rotate the release dial to Self-timer (**A**).

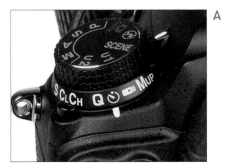

A

2. Press the Menu button to find the Custom Setting menu. Highlight and select C Timers/AE Lock, then press OK (**B**).

3. Select C3 Self-timer and click OK. I generally choose 2S (2 seconds) to cut down on time between exposures (**C**).

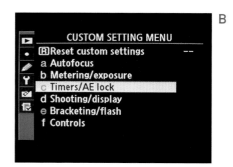

B

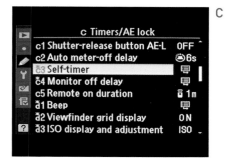

C

FOCUSING IN LOW LIGHT

The D7000 has a great focusing system, but occasionally the light levels are too low for the camera to achieve an accurate focus. There are a few things that you can do to overcome this obstacle.

First, you should know that the camera uses contrast in the viewfinder to establish a point of focus. This is why your camera will not be able to focus when you point it at a white wall or a cloudless sky. It simply can't find any contrast in the scene to work with. Knowing this, you might be able to use a single focus point in AF-S mode to find an area of contrast that is the same distance as your subject. You can then hold that focus by holding down the shutter button halfway and recomposing your image.

Then there are those times when there just isn't anything there for you to focus on. A perfect example of this would be a fireworks display. If you point your lens to the night sky in any AF (Automatic Focus) mode, it will just keep searching for— and not finding—a focus point. On these occasions, you can simply turn off the autofocus feature and manually focus the lens (**Figures 8.5** and **8.6**). Look for the A/M switch on the side of the lens and slide it to the M position.

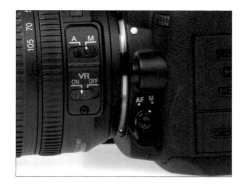

FIGURE 8.5
You can't count on autofocus. If the camera just can't find its focus, take it into your own hands.

FIGURE 8.6
I took this in my
field in Montana
after watching a
magnificent sunset.
Autofocus would
not work because
the light was just
too low. I had to
switch to manual
focus to get the
job done.

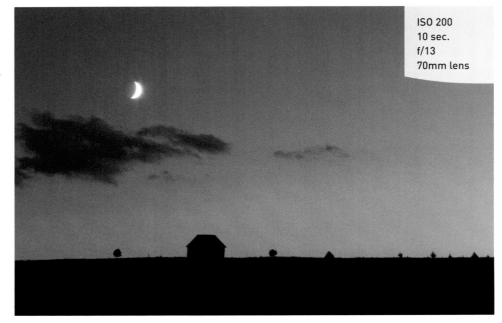

ISO 200
10 sec.
f/13
70mm lens

Now, I don't want any e-mails saying, "John, you broke my camera! It won't focus!"
So make sure to switch your lens back to the A mode at the end of your shoot.

AF ASSIST ILLUMINATOR

I know I told everyone that I am not a huge fan of the AF-assist illuminator in Chapter 1,
but that is primarily when I'm shooting people. The D7000's AF-assist illuminator does
a good job helping with focusing by using a small, bright beam from the front of the
camera to shine some light on the scene. This light enables the camera to find details
to focus on in low-light situations.

This feature is automatically activated when using the flash (except in Landscape,
Sports, and Flash Off modes for the following reasons: In Landscape mode, the
subject is usually too far away; in Sports mode, the subject is probably moving; and
in Flash Off mode, you've disabled the flash entirely). Also, the illuminator will be
disabled when shooting in the AF-C or manual focus mode, as well as when the
illuminator is turned off in the camera menu. The AF-assist should be enabled by
default, but you can check the menu just to make sure.

1. Press the Menu button and access the Custom Setting menu (**A**).

2. Navigate to the item called A Autofocus and press the OK button.

3. Highlight the menu item called A7 Built-in AF-assist illuminator and press the OK button (**B**).

4. Set the option to On and press the OK button to complete the setup.

A

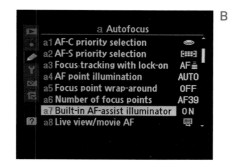
B

DISABLING THE FLASH

If you are shooting in one of the automatic scene modes, the flash might be set to activate automatically. If you don't wish to operate the flash, you will have to turn it off in the information screen.

TO TURN OFF FLASH

To disable the flash when shooting in Auto mode, turn the Mode dial to the Flash Off symbol (a circle containing a flash with a slash through it).

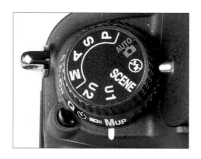

Remember, if you are shooting in a professional mode, the only way to get the flash to fire is to turn it on yourself. If you are shooting in an automatic scene mode, depending on the mode, it will come on automatically. For example in Candlelight and Landscape modes it does not come on, whereas in Pet mode or Night Portrait it is automatically on. If the small flash icon appears on the control panel when you are shooting in a particular mode, it means the setting calls for it and the flash will fire automatically.

SHOOTING LONG EXPOSURES

We have covered some of the techniques for shooting in low light, so let's go through the process of capturing a night or low-light scene for maximum image quality (**Figure 8.7**). The first thing to consider is that in order to shoot in low light with a low ISO, you will need to use shutter speeds that are longer than you could possibly hand-hold (longer than 1/15 of a second). This will require the use of a tripod or stable surface for you to place your camera on. For maximum quality, the ISO should be low, somewhere below 400. The long exposure noise reduction should be turned on to minimize the effects of exposing for longer durations. (To set this up, see Chapter 7.)

Once you have noise reduction turned on, set your camera to Aperture Priority (A) mode. This way, you can concentrate on the aperture that you believe is most appropriate and let the camera determine the best shutter speed. If it is too dark for the autofocus to function properly, try manually focusing. Finally, consider using a cable release (see the bonus chapter) to activate the shutter. If you don't have one, use either the Self-timer mode or Exposure Delay mode (covered later in this chapter and in Chapter 1). Once you shoot the image, you may notice some lag time before it is displayed on the rear LCD. This is due to the noise reduction process, which can take anywhere from a fraction of a second up to 30 seconds, depending on the length of the exposure.

FLASH SYNC

The basic idea behind the term *flash synchronization* (*flash sync* for short) is that when you take a photograph using the flash, the camera needs to ensure that the shutter is fully open at the time that the flash goes off. This is not an issue if you are using a long shutter speed such as 1/15 of a second but does become more critical for fast shutter speeds. To ensure that the flash and shutter are synchronized so that the flash is going off while the shutter is open, the D7000 implements a top sync speed of 1/250 of a second. This means that when you are using the flash, you will not be able to have your shutter speed be any faster than 1/250. If you did use a faster shutter speed, the shutter would actually start closing before the flash fired, which would cause a black area to appear in the frame where the light from the flash was blocked by the shutter.

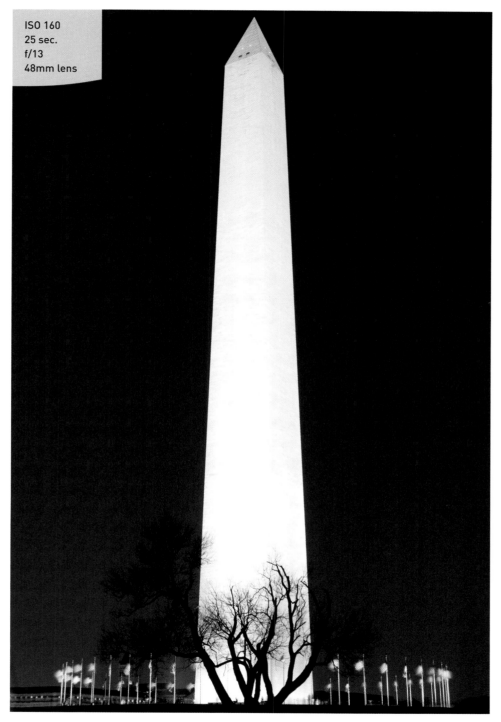

ISO 160
25 sec.
f/13
48mm lens

FIGURE 8.7
This exposure took several tries until I finally got it right. Using a tripod was an absolute must. The longer exposure really helped with silhouetting the tree at the bottom of the frame.

USING THE BUILT-IN FLASH

There are going to be times when you have to turn to your camera's built-in flash to get the shot. The pop-up flash on the D7000 is not extremely powerful, but with the camera's advanced metering system it does a pretty good job of lighting up the night…or just filling in the shadows.

If you are working with one of the automatic scene modes, the flash should automatically activate when needed. If, however, you are working in one of the professional modes you will have to turn the flash on for yourself. To do this, just press the pop-up flash button located on the front of the camera (**Figure 8.8**). Once the flash is up, it is ready to go. It's that simple.

FIGURE 8.8
A quick press of the pop-up flash button will release the built-in flash to its ready position.

SHUTTER SPEEDS

The standard flash synchronization speed for your camera is between 1/60 and 1/250 of a second. When you are working with the built-in flash in the automatic and scene modes, the camera will typically use a shutter speed of 1/60 of a second. The exception to this is when you use Night Portrait mode, which will fire the flash with a slower shutter speed so that some of the ambient light in the scene has time to record in the image.

The real key to using the flash to get great pictures is to control the shutter speed. The goal is to balance the light from the flash with the existing light so that everything in the picture has an even illumination. Let's take a look at the shutter speeds in the professional modes.

 Program (P): The shutter speed stays at 1/60 of a second. The only adjustment you can make in this mode is overexposure or underexposure using the Exposure Compensation setting or Flash Compensation settings.

 Shutter Priority (S): You can adjust the shutter speed to as fast as 1/200 of a second all the way down to 30 seconds. The lens aperture will adjust accordingly, but typically at long exposures the lens will be set to its smallest aperture.

 Aperture Priority (A): This mode will allow you to adjust the aperture but will adjust the shutter speed between 1/200 and 1/60 of a second in the standard flash mode.

FLASH RANGE

Because the pop-up flash is fairly small, it does not have enough power to illuminate a large space (**Figure 8**.9). The effective distance varies depending on the ISO setting and aperture. At ISO 200, f/4, the range is about 14 feet. This range can be extended to as far as 20 feet when the camera is set to an ISO of 1600, f/8. For the best image quality, your ISO setting should not go above 1600. Anything higher will begin to introduce excessive noise into your photos. Check out page 147 of your manual for a chart that shows the effective flash range for differing ISO and aperture settings.

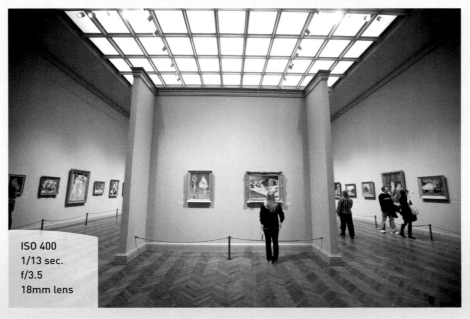

ISO 400
1/13 sec.
f/3.5
18mm lens

FIGURE 8.9
The pop-up flash was used to fill in shadows. The longer exposure time allowed the ambient light to illuminate the rest of the scene.

METERING MODES

The built-in flash uses a technology called TTL (Through The Lens) metering to determine the appropriate amount of flash power to output for a good exposure. When you depress the shutter button, the camera quickly adjusts focus while gathering information from the entire scene to measure the amount of ambient light. As you press the shutter button down completely, the flash uses that exposure information and fires a predetermined amount of light at your subject during the exposure.

The default setting for the flash meter mode is TTL. The meter can be set to Manual mode. In Manual flash mode, you can determine how much power you want coming out of the flash ranging from full power all the way down to 1/128 power. Each setting from full power on down will cut the power by half. This is the equivalent of reducing flash exposure by one stop with each power reduction.

SETTING THE FLASH TO THE MANUAL POWER SETTING

1. Press the Menu button and then navigate to the Custom Setting menu.

2. Using the Multi-selector, highlight the item labeled E Bracketing/Flash and press the OK button (**A**).

3. Highlight item E3 Flash Cntrl for Built-in Flash and press OK (**B**).

4. Change the setting to Manual (**C**) and then press the OK button to adjust the desired power—Full, ½, ¼, and so on—and press the OK button (**D**).

Don't forget to set it back to TTL when you are done because the camera will hold this setting until you change it.

COMPENSATING FOR FLASH EXPOSURE

The TTL system will usually do an excellent job of balancing the flash and ambient light for your exposure, but it does have the limitation of not knowing what effect you want in your image. You may want more or less flash in a particular shot. You can achieve this by using the Flash Compensation feature.

Just as with Exposure Compensation, the Flash Compensation feature allows you to dial in a change in the flash output in increments of 1/3 of a stop. You will probably use this most often to tone down the effects of your flash, especially when you are using the flash as a subtle fill light (**Figures 8.10–8.12**). The range of compensation goes from +1 stop down to –3 stops.

ISO 200
1/100 sec.
f/1.4
85mm lens

FIGURE 8.10
This image was taken with no flash. The exposure is too dark although we have plenty of detail in highlights.

ISO 200
1/100 sec.
f/1.4
85mm lens

FIGURE 8.11
This image was taken using the flash and now the image appears too light or "blown out." There's very little detail in the highlights.

ISO 200
1/100 sec.
f/1.4
85mm lens

FIGURE 8.12
By reducing the flash by one stop I was able to achieve the exposure I wanted without losing details in the highlights.

1. With the flash in the upright and ready position, press and hold the flash button while viewing the control panel.

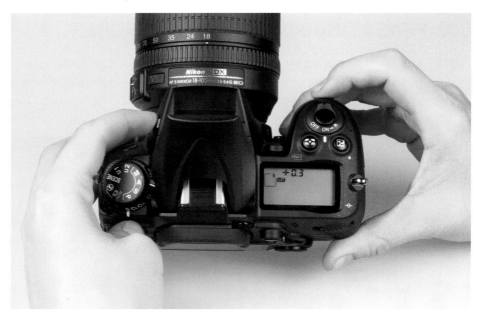

2. While holding down the flash button, rotate the Sub-command dial to set the amount of compensation you desire. Turning to the right reduces the flash power 1/3 of a stop with each click of the dial. Turning left increases the flash power. Release the button when you have made your selection.

3. Press the shutter button halfway and then take the picture.

4. Review your image to see if more or less flash compensation is required, and repeat these steps as necessary.

The Flash Compensation feature does not reset itself when the camera is turned off, so whatever compensation you have set will remain in effect until you change it. Your only clue to knowing that the flash output is changed will be the presence of the Flash Compensation symbol in the viewfinder. It will disappear when there is zero compensation set.

REDUCING RED-EYE

We've all seen the result of using on-camera flashes when shooting people: the dreaded red-eye! This demonic effect is the result of the light from the flash entering the pupil and then reflecting back as an eerie red glow. The closer the flash is to the lens, the greater the chance that you will get red-eye. This is especially true when it is dark and the subject's pupils are fully dilated. There are two ways to combat this problem. The first is to get the flash away from the lens. That's not really an option, though, if you are using the pop-up flash. Therefore, you will need to turn to the Red-eye Reduction feature.

This is a simple feature that shines a light from the camera at the subject, causing his or her pupils to shrink, thus eliminating or reducing the effects of red-eye (**Figure 8.13**).

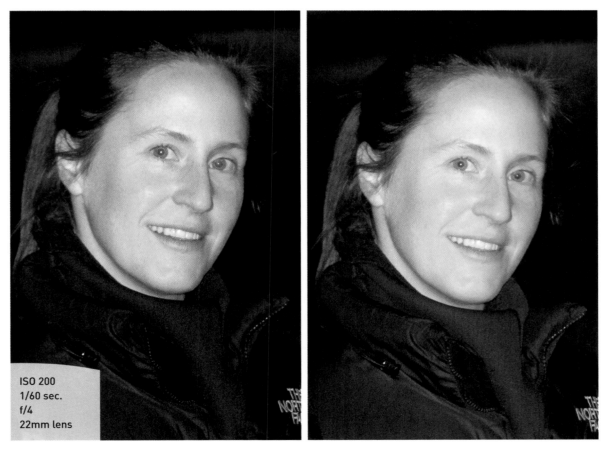

ISO 200
1/60 sec.
f/4
22mm lens

FIGURE 8.13
Notice that the pupils on the image without red-eye are smaller as a result.

This small adjustment can make a big difference in time spent post-processing. You don't want to have to go back and remove red-eye from both eyes of every subject!

The feature is set to Off by default and needs to be turned on by using the information screen or by using a combination of the flash button and the Command dial.

TURN ON THE LIGHTS!

When shooting indoors, another way to reduce red-eye, or just shorten the length of time that the reduction lamp needs to be shining into your subject's eyes, is to turn on a lot of lights. The brighter the ambient light levels, the smaller the subject's pupils will be. This will reduce the time necessary for the red-eye reduction lamp to shine. It will also allow you to take more candid pictures because your subjects won't be required to stare at the red-eye lamp while waiting for their pupils to reduce.

TURNING ON THE RED-EYE REDUCTION FEATURE

1. Press and hold the flash button while viewing the control panel.

2. While holding the flash button, rotate the Command dial until the small eye appears in the box. This means Red-eye Reduction is on. Release the flash button.

3. With Red-eye Reduction activated, compose your photo and then press the shutter release button to take the picture.

When Red-eye Reduction is activated, the camera will not fire the instant that you press the shutter release button. Instead, the red-eye reduction lamp will illuminate for a second or two and then fire the flash for the exposure. This is important to remember as people have a tendency to move around, so you will need to instruct them to hold still for a moment while the lamp works its magic.

Truth be told, I rarely shoot with Red-eye Reduction turned on because of the time it takes before being able to take a picture. If I am after candid shots and have to use the flash, I will take my chances on red-eye and try to fix the problem in my image processing software or even in the camera's retouching menu. The Nikon Picture Project software that comes with your D7000 has a feature to reduce red-eye that works really well, although only on JPEG images.

FLASH AND GLASS

If you find yourself in a situation where you want to use your flash to shoot through a window or display case, try placing your lens right against the glass so that the reflection of the flash won't be visible in your image. This is extremely useful in museums and aquariums.

A FEW WORDS ABOUT EXTERNAL FLASH

We have discussed several ways to get control over the built-in pop-up flash on the D7000. The reality is that, as flashes go, it will only render average results. For people photography, it is probably one of the most unflattering light sources that you could ever use. This isn't because the flash isn't good—it's actually very sophisticated for its size. The problem is that light should come from any direction besides the camera to best flatter a human subject. When the light emanates from directly above the lens, it gives the effect of becoming a photocopier. Imagine putting your face down on a scanner: The result would be a flatly lit, featureless photo.

To really make your flash photography come alive with possibilities, you should consider buying an external flash such as the Nikon SB700 AF Speedlight. The SB700 has a swiveling flash head, more power, and communicates with the camera and the TTL system to deliver balanced flash exposures.

Manual Callout

For more information on the use of external Speedlight flashes on your D7000, check out pages 275–279 of your manual.

Chapter 8 Assignments

Now that we have looked at the possibilities of shooting after dark, it's time to put it all to the test. These assignments cover the full range of shooting possibilities, both with flash and without. Let's get started.

How steady are your hands?

It's important to know just what your limits are in terms of hand-holding your camera and still getting sharp pictures. This will change depending on the focal length of the lens you are working with. Wider angle lenses are more forgiving than telephoto lenses, so check this out for your longest and shortest lenses. Using the 18–55mm zoom as an example, set your lens to 55mm and then, with the camera set to ISO 200 and the mode set to Shutter Priority, turn off the VR and start taking pictures with lower and lower shutter speeds. Review each image on the LCD at a zoomed-in magnification to take note of when you start seeing visible camera shake in your images. It will probably be around 1/60 of a second for a 55mm lens.

Now do the same for the wide-angle setting on the lens. My limit is about 1/30 of a second. These shutter speeds are with the Vibration Reduction feature turned off. If you have a VR lens, try it with and without the VR feature enabled to see just how slow you can set your shutter while getting sharp results.

Pushing your ISO to the extreme

Find a place to shoot where the ambient light level is low. This could be at night or indoors in a darkened room. Using the mode of your choice, start increasing the ISO from 200 until you get to 6400 Hi 1. Make sure you evaluate the level of noise in your image, especially in the shadow areas. Only you can decide how much noise is acceptable in your pictures. I can tell you from personal experience that I never like to stray above that ISO 800 mark.

Getting rid of the noise

Turn on High ISO Noise Reduction and repeat the previous assignment. Find your acceptable limits with noise reduction turned on. Also pay attention to how much detail is lost in your shadows with this function enabled.

Long exposures in the dark

If you don't have a tripod, find a stable place to set your camera outside and try some long exposures. Set your camera to Aperture Priority mode and then use the Self-timer to activate the camera (this will keep you from shaking the camera while pressing the shutter button).

Shoot in an area that has some level of ambient light, be it a streetlight or traffic lights, or even a full moon. The idea is to get some late-night low-light exposures.

Reducing the noise in your long exposures

Now repeat the last assignment with the Long Exposure Noise Reduction set to On. Look at the difference in the images that were taken before and after the noise reduction was enabled. For best results, perform this assignment and the previous assignment in the same shooting session using the same subject.

Testing the limits of the pop-up flash

Wait for the lights to get low and then press that pop-up flash button to start using the built-in flash. Try using the different shooting modes to see how they affect your exposures. Use the Flash Exposure Compensation feature to take a series of pictures while adjusting from –3 stops all the way to +1 stops so that you become familiar with how much latitude you will get from this feature.

Getting the red out

Find a friend with some patience and a tolerance for bright lights. Have her sit in a darkened room or outside at night and then take her picture with the flash. Now turn on Red-Eye Reduction to see if you get better results. Don't forget to have her sit still while the red-eye lamp does its thing.

Share your results with the book's Flickr group!

Join the group here: flickr.com/groups/nikond7000_fromsnapshotstogreatshots

9

ISO 100
1/250 sec.
f/10
80mm lens

Creative Compositions

BETTER PHOTOGRAPHY STARTS WITH BETTER COMPOSITION

Creating a good image requires you to go beyond your camera settings. A skilled photographer has an intimate knowledge of his or her camera capabilities coupled with a sound understanding of composition. Some people have a natural eye for composition, while others struggle with how to frame an image. Composition can be taught—I'm proof of that! This chapter will cover a few of the basic rules of composition and serve as a nice refresher for the more experienced photographer.

This image of "The Weather Project" was taken at the Tate Modern in London. I was immediately drawn to it. I mean, who wouldn't be interested in photographing a giant sun in the middle of a steel building? I rarely recommend centering your subject in the middle of your frame, but in this case it worked. The sun was the predominate piece of art, and the lines of the steel building draw you into the center of the image.

The lines of the building draw the viewer's eyes into the frame.

The wide-angle lens allowed me to capture more of the environment while creating a better understanding of the scene.

The contrasting soft glow of the sun against the steel structure creates a dynamic feeling.

Placing the subject dead center of a frame can be a big "no-no," but in this case it works.

ISO 100
1/40 sec.
f/4
28mm lens

A good image needs to convey a story or evoke an emotion—it's not just about being a technician. Smokey was a stray dog my family adopted. He has a funny personality, with the dominant feature being a strong need to please. This makes him pretty easy to photograph. I wanted to get a shot that showed his eyes. I got him to sit still, made sure to focus on the eyes, and opened up my aperture to f/1.4 in order to blur the background.

His eyes are framed in the top third of the image because they are the main focus.

Very little environmental information is in the frame because the dog's eyes are the main focus.

The shallow depth of field draws attention to the eyes while blurring the background.

An open or large aperture was used to create a shallow depth of field.

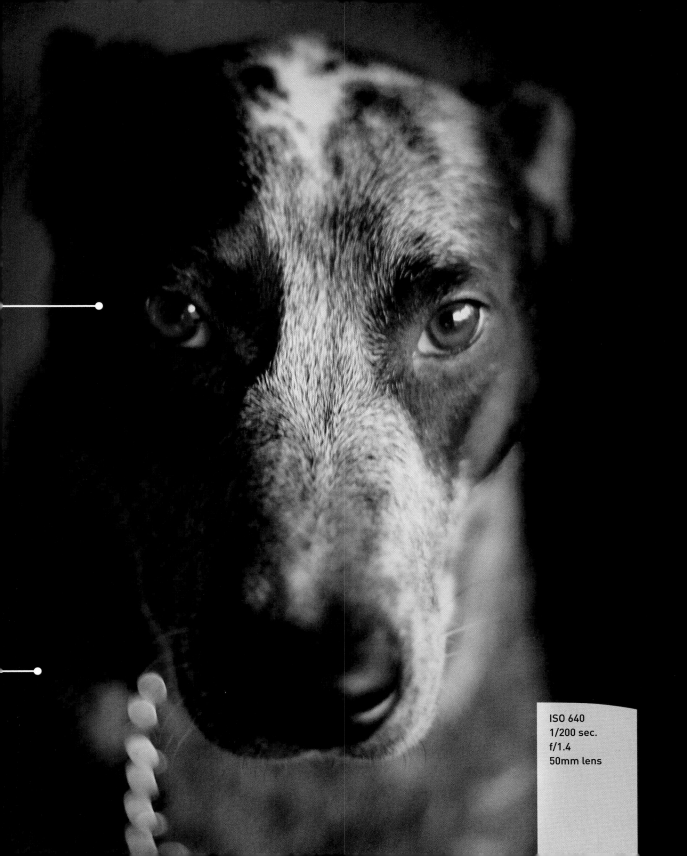

ISO 640
1/200 sec.
f/1.4
50mm lens

DEPTH OF FIELD

I shoot a majority of my photography using Aperture Priority, and my number one concern beyond how to frame the shot is what depth of field to use. Depth of field can be critical in telling a story. If I want to create a portrait with a blurry background, I use a large or open aperture, such as f/1.2–2.8, to create what we call a shallow depth of field, meaning an in-focus foreground with a blurry background (**Figure 9.1**). If I'm shooting a landscape and the whole scene needs to be sharp, then I'll use a smaller or less open aperture, such as f/16, to ensure sharpness.

ISO 640
1/200 sec.
f/1.4
50mm lens

Occasionally a greater depth of field is required to maintain a sharp focus across a farther distance. This might be due to the sheer depth of your subject, where you have objects that are near the camera but sharpness is desired at a greater distance as well (**Figure 9.2**).

Or perhaps you are photographing a reflection. With a shallow depth of field, I could only get the reflected mountains and the mirror in focus. By making the aperture smaller, you will be able to maintain acceptable sharpness in both the subject and the reflection (**Figure 9.3**).

ISO 160
1/500 sec.
f/14
24mm lens

FIGURE 9.2
Typically we want landscape photos to be very sharp, so use a tripod and shoot at a very small aperture to allow for maximum clarity.

ISO 100
1/80 sec.
f/16
24mm lens

FIGURE 9.3
Getting a distant subject in focus in a reflection, along with the reflective surface, requires a small aperture. Keep an eye out for opportunities like this—these are always fun and creative shots.

ANGLES

Having strong angular lines in your image can add to the composition, especially when they are juxtaposed (**Figure 9.4**). This can create a tension that is different from the standard horizontal and vertical lines that we are so accustomed to seeing in photos.

POINT OF VIEW

Sometimes the easiest way to influence your photograph is to simply change your perspective. Instead of always shooting from a standing position, try moving your camera to a totally different point of view. Try getting down on your knees or even lying on the ground. This low angle can completely change how you view your subject and create a new interest in common subjects (**Figure 9.5**).

FIGURE 9.4
The strong angular lines of the Lincoln Park Conservatory building create a dynamic composition.

ISO 320
1/8 sec.
f/13
200mm lens

FIGURE 9.5
Put your camera in a position that presents an unfamiliar view of your subject or exaggerates an element in the photo. By taking this shot from a low point of view, I exaggerated the height of the man on stilts.

ISO 400
1/60 sec.
f/5.0
18mm lens

PATTERNS

Rhythm and balance can be added to your images by finding the patterns in everyday life and concentrating on the elements that rely on geometric influences. Try to find the balance and patterns that often go unnoticed (**Figure 9.6**).

FIGURE 9.6
These piled bricks showed a repeating pattern. They were not piled perfectly, which adds visual interest to the pattern.

ISO 400
1/800 sec.
f/4.0
180mm lens

COLOR

Color works well as a tool for composition when you're dealing with very saturated colors. Some of the best colors are those within the primary palette. Reds, greens, and blues, along with their complementary colors (cyan, magenta, and yellow), can all be used to create visual tension (**Figure 9.7**). This tension between bright colors will add visual excitement, drama, and complexity to your images when combined with other compositional elements.

Color can make an image more compelling. I photographed these two Volkswagen bugs in Peru (**Figure 9.8**) partly because the image struck me as comical, but the contrast of the red- and blue-colored cars is really what made the image. Color can add balance, which is pleasing to the eye, or act as a contrast to a subject, adding visual interest.

ISO 125
1/50 sec.
f/10
66mm lens

FIGURE 9.7
Cropping in tight on this lock allowed me to use the colors as the primary influence in the image. The bright blue is complemented by the rusty orange.

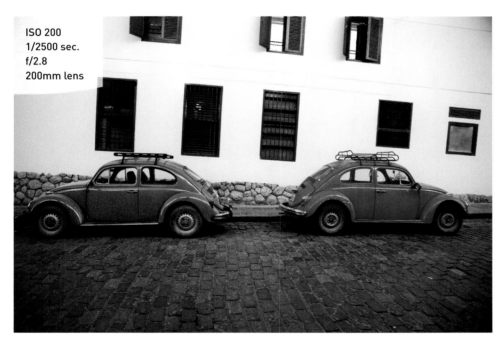

ISO 200
1/2500 sec.
f/2.8
200mm lens

FIGURE 9.8
Bright primary colors playing off one another can make for a strong image.

CONTRASTING AND COMPLEMENTING

We just saw that you can use color as a strong compositional tool. One of the most effective uses of color is to combine two complementary colors that make the eye move back and forth across the image (**Figure 9.9**). There is no exact combination that will work best, but consider using dark and light colors, or red and green or blue and yellow, to provide the strongest visual. Studying a color wheel or color theory can help you to strengthen your color images.

FIGURE 9.9
The contrasting colors complement each other and add balance to the scene. This photo was taken with two filters on the camera, and then processed as HDR to really increase the contrast.
The blue sky and yellow grass are complementary because blue and yellow are across from one another on a color wheel.

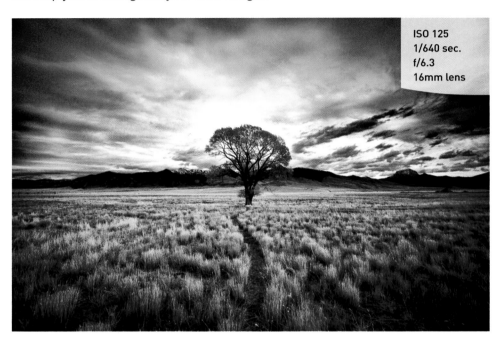

ISO 125
1/640 sec.
f/6.3
16mm lens

You can also introduce contrast through different geometric shapes that battle (in a good way) for the attention of the viewer. You can combine circles and triangles, ovals and rectangles, curvy and straight, hard and soft, dark and light, and so many more (**Figure 9.10**). You aren't limited to just one contrasting element either. Combining more than one element of contrast will add even more interest. Look for these contrasting combinations whenever you are out shooting, and then use them to shake up your compositions.

ISO 125
1/125 sec.
f/10
23mm lens

FIGURE 9.10
This photo was taken in the Badlands of South Dakota on a June day. The angular lines of the red mountains play against the green, soft grass and the perfectly smooth blue sky to create contrast not only with color, but also with texture. A gradient filter was used to increase the saturation of the blue sky and help create the shadow below the mountain.

LEADING LINES

One way to pull a viewer into your image is to incorporate leading lines. These are elements that come from the edge of the frame and then lead into the image toward the main subject (**Figure 9.11**). This can be the result of vanishing perspective lines, an element such as a river, or some other feature used to move from the outer edge in to the heart of the image.

SPLITTING THE FRAME

Generally speaking, splitting the frame right down the middle is not necessarily your best option. While it may seem more balanced, it can actually be pretty boring. Consider using the rule of thirds when deciding how to divide your frame (**Figure 9.12**).

FIGURE 9.11
The bicycle rack leads the eye through the frame toward the bicycle at the very end. This is interesting not only because the bicycle is in the snow, but also because the dark black rack creates a visual contrast against the white snow. The wavy line of the rack helps draw our eye to the bicycle.

ISO 500
1/50 sec.
f/1.6
50mm lens

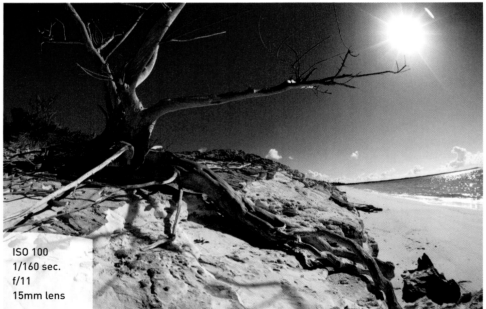

ISO 100
1/160 sec.
f/11
15mm lens

FIGURE 9.12
This photo of a dead tree on the beach was taken on Cat Island, Bahamas. By placing the tree in the left third of the frame, it draws your eye down the roots and out the branches to the sand and the ocean. The rule of thirds applies to both vertical and horizontal framing. If the tree had been in the middle, the eyes would not have anywhere to travel in the frame, creating a boring image. Framing the image in the left third makes the image more visually appealing.

With horizons, a low horizon will give a sense of stability to the image. Typically, this is done when the sky is more appealing than the landscape below. When the emphasis is to be placed on the landscape, the horizon line should be moved upward in the frame, leaving the bottom two-thirds to the subject below (**Figure 9.13**).

ISO 125
1/160 sec.
f/14
16mm lens

FIGURE 9.13
I placed the horizon in the bottom third of the frame with the sky taking up most of the top two-thirds. This helps balance the frame, and also let me capture the active sky. While the barn is in the middle of the frame, the photo remains well balanced from top to bottom because of the use of the rule of thirds.

FRAMES WITHIN FRAMES

The outer edge of your photograph acts as a frame to hold all of the visual elements of the photograph. One way to add emphasis to your subject is through the use of internal frames (**Figure 9.14**). Depending on how the frame is used, it can create the illusion of a third dimension to your image, giving it a feeling of depth.

FIGURE 9.14
By positioning myself between the two trees, I was able to use them as a frame to give emphasis to the barn. It also gives us a story about the environment surrounding the barn.

ISO 100
1/80 sec.
f/10
35mm lens

Chapter 9 Assignments

Apply the shooting techniques and tools that you have learned in the previous chapters to these assignments, and you'll improve your ability to incorporate good composition into your photos. Make sure you experiment with all the different elements of composition and see how you can combine them to add interest to your images.

Learning to see lines and patterns

Take your camera for a walk around your neighborhood and look for patterns and angles. Don't worry so much about getting great shots as developing an eye for details.

Point of view

Next time you're out shooting and you see something interesting, force yourself to shoot at least 25 frames of the same subject. Vary your point of view as much as possible. Lie on the ground, climb up high, get close up, get farther away; force yourself to try different points of view. This will train your eye to see these points of view more often. You may be surprised and get an image that you didn't imagine before.

Finding the square peg and the round hole

Circles, squares, and triangles. Spend a few sessions concentrating on shooting simple geometric shapes.

Using the aperture to focus attention

Depth of field plays an important role in defining your images and establishing depth and dimension. Practice shooting wide open, using your largest aperture for the narrowest depth of field. Then find a scene that would benefit from extended depth of field, using very small apertures to give sharpness throughout the scene.

Leading them into a frame

Look for scenes where you can use elements as leading lines and then look for framing elements that you can use to isolate your subject and add both depth and dimension to your images.

Share your results with the book's Flickr group!

Join the group here: flickr.com/groups/nikond7000_fromsnapshotstogreatshots

10

ISO 160
1/100 sec.
f/4.5
85mm lens

Lights, Camera, Action

GETTING THE MOST OUT OF THE D7000'S VIDEO CAPABILITIES

I don't shoot videos professionally, but like many of you I've taken my share of home videos of my family. Once you had to have a camera for your still photos and a camcorder for your video. Well, that's all changed within the last few years, and your D7000 is equipped with amazing video technology. I'm going to cover some of the basics in this chapter to get you started. If you're super serious about video, then I recommend getting your hands on Peachpit's *From Still to Motion: A Photographer's Guide to Creating Video with Your DSLR*.

RECORDING WITH LIVE VIEW

Video recording is a feature of the Live View capabilities of the camera, so you'll have to put it into active Live View mode to begin capturing video. This is done by rotating the Live View switch to the right, which will activate Live View on the rear display (**Figure 10.1**).

FIGURE 10.1
Rotate the Live View switch to the right to activate Live View.

Next, you need to focus the camera by placing the red focus box on the subject and holding down the shutter button halfway until the focusing box turns green, indicating your subject is in focus. New to your D7000 is its ability to continue focusing on your subject when you simply keep the shutter button pressed down halfway. (Pressing the shutter button down all the way will take a photo as usual, so make sure to press the shutter only halfway when making movies.)

Once your subject is in focus, you can push the red button located on the Live View switch to begin recording. As the camera begins to record, you will notice a few new icons on the LCD. At the top left is a blinking red Record icon to let you know that the camera is in active recording mode. At the upper right, a timer counts down your remaining recording time. The recording time is directly related to the quality of video you have selected as well as the capacity of your memory card. Lower quality video and larger memory cards equal more recording time. To stop recording, simply press the red button on the Live View switch a second time, which takes you back to Live View mode. To turn off Live View, rotate the Live View switch to the right, the same way you turned it on, or simply turn off the camera.

HOLD IT STEADY

I know a lot of people are just going to start shooting video right out of the box without adjusting the settings, so before I move on I have one word of advice: Use a tripod. Have you ever felt like you just finished riding the Cyclone at Coney Island after watching a home video? Handheld video is rough to watch unless the person behind the camera knew what he or she was doing. Buy a tripod or a tripod head that is constructed for video. Typically these tripods will have what's called fluid, smooth, or shake-free panning and tilt features. Trust me, a good investment in a nice tripod for your video will make the difference between professional-looking video and *The Blair Witch Project*.

DEDICATING A SECOND CARD TO VIDEO

I'm not a huge fan of having all my video and photos on one SD card because often I'm using two different programs for editing: one for video and one for photos. It's just easier for importing to have one card dedicated to photos and the other to video. Plus, it allows me to dedicate my fastest SD card to video.

TO DEDICATE A VIDEO CARD

1. To assign your video recording to a specific SD card slot, press the Menu button. Use the Multi-selector to highlight Movie Settings, under the Shooting Menu and click OK (**A**).

2. Use your Multi-selector to highlight Destination and click OK (**B**).

3. Select your desired SD card slot, and press OK (**C**).

4. Click the Menu button twice or simply rotate the Live View switch to turn on Live View/ Movie Mode.

VIDEO QUALITY

The best quality your D7000 is capable of is high-definition video with a resolution of 1920 x 1080 pixels, aka 1080p. The 1080 represents the height of the video image in pixels, and the P stands for progressive, which is the method the camera uses to draw the video on the screen (more on this later). You can select a lower resolution video depending on your needs.

The other two video resolutions are 1280 x 720 and 640 x 424 (standard definition). For high-definition television and computer/media station viewing, you will be best served by using 1920 x 1080. If you plan on recording for the Internet or portable media devices, first check the appropriate upload to that medium or device. Many social sites such as YouTube and Facebook support HD video, as do the iPad, iPod touch, and competing devices. But before you decide to render HD video you should know the key benefit of using the lower resolutions: Lower resolution video requires less physical storage due to a smaller pixel count. This means you can fit more video on the storage card, as well as take less time to upload the video to the Internet.

WHAT'S THE DIFFERENCE BETWEEN 1080P AND 1080I?

When it comes to video, two terms describe its quality and how it is captured and displayed on a monitor or screen: progressive and interlaced. Unlike a photo, a video frame is not displayed all at once but instead is drawn sequentially. Interlaced video first draws the odd-numbered lines and then the even-numbered lines. This odd-even drawing is what we sometimes call screen flicker. In progressive video, the type your D7000 produces, the lines are drawn in sequence from top to bottom, usually resulting in better image quality and less screen flicker. For viewing purposes progressive video is preferred, especially with higher definition images.

SETTING MOVIE QUALITY

1. Start by pressing the Menu button. Using your Multi-selector, navigate to the Shooting menu.

2. Using the Multi-selector, highlight Movie Settings and press OK (**A**).

3. Highlight Movie Quality and press OK (**B**).

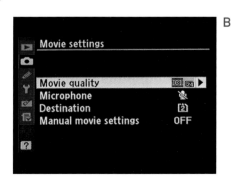

4. Select the video quality of your choice and press OK (**C**).

5. Press the Menu button twice to exit Menu mode and return to shooting, or rotate the Live View switch to the right to jump to the Live View/Movie mode.

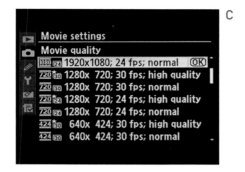

C

SOUND

The D7000 can record audio to go along with your video, but there are a couple of things to keep in mind while using the built-in microphone. The first is to make sure you don't block the microphone. If you look closely at the front of the camera body, you'll notice three small holes right below the silver D7000 nameplate, located above the lens release button. This should not be a problem if you are holding the camera as we discussed in Chapter 1. Be aware, though, that it is easy to place a finger right on top of the microphone, muffling any sounds you are hoping to capture.

The next thing you need to know about sound is that it is mono, not stereo. This is lower quality sound than you are used to hearing in movies and music. To get stereo quality audio you will need to use an external microphone. I use a Rode shotgun microphone (**Figure 10.2**) that mounts to the camera's hot shoe and plugs into the stereo audio jack. These mics do a very nice job of recording audio for your videos and are one of the least expensive options.

FIGURE 10.2
The Rode shotgun microphone mounts to the camera's hot shoe and plugs into the stereo audio jack for recording high-quality sound.

TURNING OFF THE SOUND

Sometimes you may wish to turn the sound off altogether—maybe sound would be distracting or you plan on adding your own soundtrack later. This comes in handy when I add the *Chariots of Fire* soundtrack to my daughter's cross-country videos.

TO TURN OFF SOUND

1. Following the directions for setting the movie quality above, locate the Movie Settings menu and press OK.

2. Highlight Microphone and press OK again (**A**).

3. Select the Microphone Off option and press OK to lock in the change (**B**).

4. Press the Menu button twice or the Live View switch to return to shooting mode.

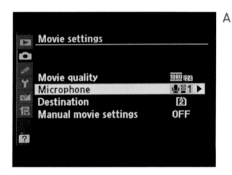

A

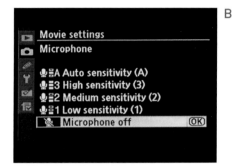

B

PLAYBACK

There are a couple of options for reviewing your video once you have finished recording. The first, and probably the easiest, is to press the Image Review button to bring up the recorded image on the rear LCD, and then use the OK button to start playing the video. The Multi-selector acts as the video controller and allows you to rewind and fast-forward as well as stop the video altogether (see page 62 of your manual for more information).

If you would like to get a larger look at things, you will need to either watch the video on your TV or move the video files to your computer. To watch low-res video on your TV, you can use the video cable that came with your camera and plug it into the small port on the side of the camera body (**Figure 10.3**). To get the full effect from your HD video, you will need to buy an HDMI cable (your TV needs to support at least 720HD and have an HDMI port to use this option). Once you have the cable hooked up, simply use the same camera controls that you use for watching the video on the rear LCD.

If you want to watch a video on your computer, you will need to download it using Nikon software or an SD card reader attached to the computer. The video file will have the extension .avi at the end of the filename. These files should play on either a Mac or a PC using software that came with your operating system (QuickTime for Mac and Windows Media Player for PC).

FIGURE 10.3
Plug your cable into this port to watch videos on your television.

FOCUSING

Your D7000 has given you several focusing options for Live View/Movie mode. There are benefits to each focus-point option. You can choose Face-priority AF, Wide-area AF, Normal-area AF, and Subject-tracking AF. You will want to choose your focus mode depending on the subject of your video. Face-priority will search for faces within the frame and place a box around each face. When you depress the shutter button halfway, the box will turn from red to green once the face is in focus. This is one of the slower focusing modes, so if you have a fast-moving subject, this may not be your first choice. If you want to follow your subject through the frame and keep his face in focus at all times, Subject-tracking AF would be a good option. Wide-area AF and Normal-area AF allow you to choose the subject that you want to focus on. Wide-area provides a larger focusing area than Normal-area AF. Again, the box surrounding your focus point will turn green when the subject is in focus. See pages 49–55 in your manual for more details on the AF-area modes.

1. Press the Menu button and use the Multi-selector to choose the Custom Settings menu.

2. Highlight A Autofocus, and hit OK (**A**).

3. Use the Multi-selector to scroll down to A8 Live View/Movie AF, and press OK (**B**).

4. You can make custom selections for both Autofocus mode and AF-area mode. Highlight AF-area mode, and press OK (**C**).

5. Select your preferred AF-area mode, and press OK (**D**).

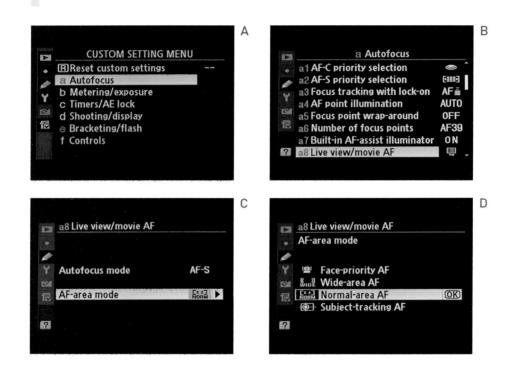

EDITING

You can do limited editing with Nikon's Movie Editor that came with your Nikon View NX2 installation CD. This is a great way to do some quick editing without spending money on external software.

If you are serious about editing your videos, I recommend checking out Apple's Final Cut Express or Adobe's Premiere Elements. Both of these software packages will give you excellent control as well as more options for video editing.

Chapter 10 Assignments

Hold it steady

Shoot a video where you are hand-holding the camera to the best of your abilities. Now practice with the camera on a tripod. Play back the videos and look for differences in ease of viewing.

Video quality

Shoot video using both the highest quality setting and the lowest quality setting. Then, view your video on the LCD on the back of the camera. Watch to see the difference in the HD quality video versus the lower quality. Also note how much space was used on your memory card between the two videos. Now, connect your camera to your TV and watch the videos. If you have HDMI cable and a high definition TV, you will see what a drastic difference the quality makes. Once you see the difference, you will know when you want to use lower quality video versus the highest quality.

Share your results with the book's Flickr group!

Join the group here: flickr.com/groups/nikond7000_fromsnapshotstogreatshots

11

ISO 160
1/200 sec.
f/13
70mm lens

Advanced Techniques

IMPRESS YOUR FAMILY AND FRIENDS

We've covered a lot of ground in the previous chapters, especially on the general photographic concepts that apply to most, if not all, shooting situations. There are, however, some specific tools and techniques in this chapter (aka "the bonus chapter") that will give you an added advantage in obtaining a great shot. Additionally, we will look at how to customize certain controls on your camera to reflect your personal shooting preferences so you will always have them at the ready.

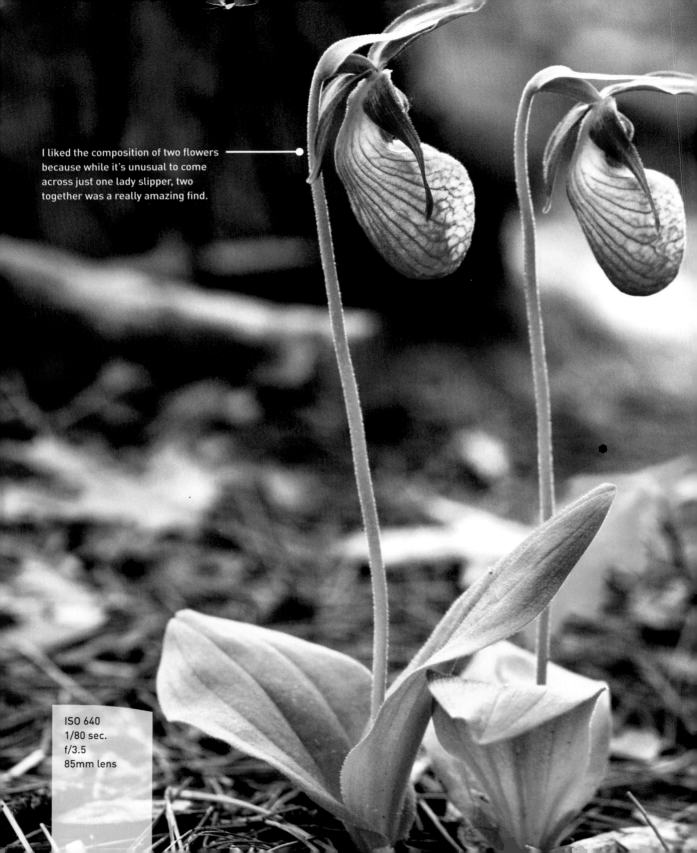

I liked the composition of two flowers because while it's unusual to come across just one lady slipper, two together was a really amazing find.

ISO 640
1/80 sec.
f/3.5
85mm lens

PORING OVER THE PICTURE

As mentioned earlier, I've always been very fond of the outdoors. Growing up in Michigan, my sister and I would spend countless hours wandering the woods at our cabin. A lady slipper orchid growing in the wild was a rare find and one that would gain us instant praise from our parents. Many years later on an early spring evening, I stumbled upon this pair of lady slippers growing in a shady area in the pines. I had been shooting portraits in the woods earlier in the day and all I had on me was my 85mm lens. The light was waning so I had to bump up my ISO, and the fast prime lens ended up coming in handy as I opened the aperture up to ensure a suitable speed.

This image would not have worked if I simply photographed it from where I was standing. I was able to create a more interesting point of view (POV) by shooting it at ground level. This meant literally lying on the ground.

Having a fast prime lens ended up working to my advantage, given the low-light conditions I was facing.

As you can see, there is a shallow depth of field due to using a large aperture. When really zooming in on a subject, depth of field is highly important.

Whenever I'm shooting wildlife I'm always very conscious of the animals' well-being and I do my best to avoid stressing them out.

Reducing vibration is critical when shooting freehand, especially for close-up images like this one.

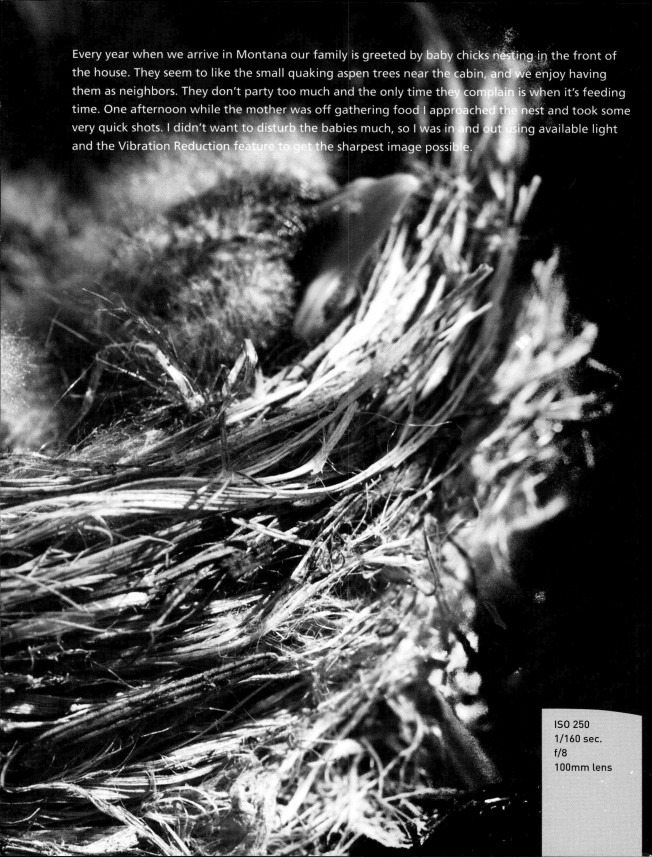

Every year when we arrive in Montana our family is greeted by baby chicks nesting in the front of the house. They seem to like the small quaking aspen trees near the cabin, and we enjoy having them as neighbors. They don't party too much and the only time they complain is when it's feeding time. One afternoon while the mother was off gathering food I approached the nest and took some very quick shots. I didn't want to disturb the babies much, so I was in and out using available light and the Vibration Reduction feature to get the sharpest image possible.

ISO 250
1/160 sec.
f/8
100mm lens

SPOT METER FOR MORE EXPOSURE CONTROL

Generally speaking, Matrix Metering mode provides accurate metering information for the majority of your photography. It does an excellent job of evaluating the scene and then relating the proper exposure information to you. The only problem with this mode is that, like any metering mode on the camera, it doesn't know what it is looking at. There will be specific circumstances where you want to get an accurate reading from just a portion of a scene and discount all of the remaining area in the viewfinder. To give you greater control of the metering operation, you can switch the camera to Spot Metering mode. This allows you to take a meter reading from a very small circle in the center of the viewfinder, while ignoring the rest of the viewfinder area.

So when would you need to use this? Think of a person standing in front of a very dark wall. In Matrix Metering mode, the camera would see the entire scene and try to adjust the exposure information so that the dark background is exposed to render a lighter wall in your image. This means that the scene would actually be overexposed and your subject would then appear too light. To correct this, you can place the camera in Spot Metering mode and take a meter reading right off of—and *only* off of—your subject, ignoring the dark wall altogether. Spot Metering will read the location where you have your focus point, placing all of the exposure information right on your point of interest.

Other situations that would benefit from Spot Metering mode include:

- Snow or beach environments where the overall brightness level of the scene could fool the meter (**Figure 11.1**)

- Strongly backlit subjects that leave the subject underexposed

- Cases where the overall feel of a photo is too light or too dark

SETTING UP AND SHOOTING IN SPOT METERING MODE

1. Make sure the camera is in one of the professional shooting modes, as indicated by M, A, S, or P on the Mode dial. You cannot change metering in the automatic modes.

2. Press and hold the Metering button while rotating the Command dial with your thumb. Select Spot Metering by watching the control panel as you turn the Command dial.

3. Once you have selected Spot Metering, release the meter button.

4. Now use the Multi-selector to move the focus point on to your subject and take your photo. The meter reading will come directly from the location of the focus point.

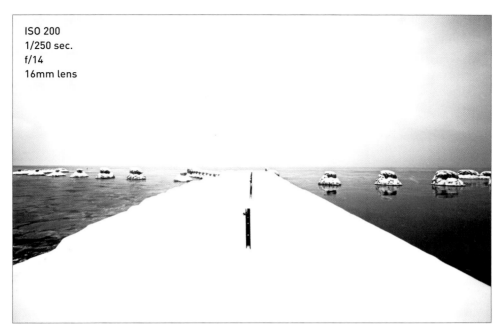

ISO 200
1/250 sec.
f/14
16mm lens

FIGURE 11.1
Snowy images can be extremely difficult to expose correctly, so I'll often use Spot Metering like I did with this image. Knowing that the sky was probably going to be blown out, I took a meter reading off the water. Later I converted this image to black and white, something I frequently do with images featuring snow.

Note that if you are using the Auto-area AF mode, the camera will use the center focus point as the Spot Metering location.

When using Spot Metering mode, remember that the meter believes it is looking at a middle gray value, so you might need to incorporate some exposure compensation of your own to the reading that you are getting from your subject. This will come from experience as you use the meter.

METERING FOR SUNRISE OR SUNSET

Capturing a beautiful sunrise or sunset is all about the sky. If there is too much foreground in the viewfinder, the camera's meter will deliver an exposure setting that is accurate for the darker foreground areas but leaves the sky looking overexposed, undersaturated, and generally just not very interesting (**Figure 11.2**). To gain more emphasis on the colorful sky, point your camera at the brightest part of it and take your meter reading there. Use the AE Lock to meter for the brightest part of the sky and then recompose. The result will be an exposure setting that underexposes the foreground but provides a darker, more dramatic sky (**Figure 11.3**).

FIGURE 11.2

By metering with all the information in the frame, you get bright skies and more detail in the ground. In this image of a rower taken in India, the sunset really made it amazing. You can see that because I exposed for him, the sky is much brighter and the colors are less saturated.

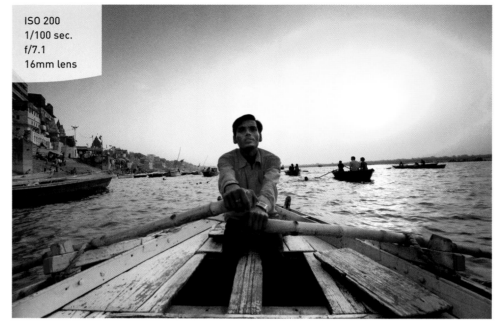

ISO 200
1/100 sec.
f/7.1
16mm lens

FIGURE 11.3

By taking the meter reading from the brightest part of the sky, I got a darker, more colorful sunset. You can still see detail in the man and the boat, but the beautiful sunset is more colorful and dramatic.

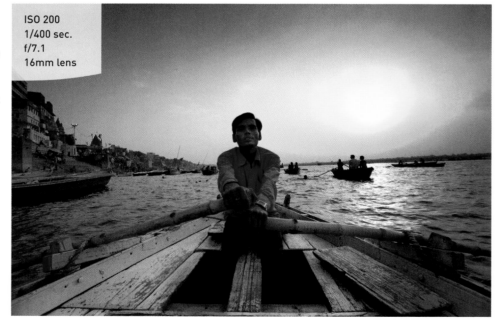

ISO 200
1/400 sec.
f/7.1
16mm lens

MANUAL MODE

Probably one of the most advanced, and yet most basic, skills to master is shooting in Manual mode. With the power and utility of most of the automatic modes, Manual mode almost never sees the light of day. I have to admit that I don't use it very often, but there are times when no other mode will do. One of the situations that works well with Manual is studio work with external flashes. I know that when I work with studio lights, my exposure will not change, so I use Manual to eliminate any automatic changes that might happen from shooting in Program, Shutter Priority, or Aperture Priority mode.

This image (**Figure 11.4**) was taken in my home studio using a simple portable shooting table and two external flashes. One flash was used underneath the transparent table and the other flash was used with a small soft box. Manual mode allowed me to avoid changes in my setup.

Since I knew the light was a constant, it allowed me to take the time to make adjustments manually to expose the image exactly how I wanted it. Manual mode gives you ultimate creative control.

ISO 100
1/100 sec
f/18
80mm lens

FIGURE 11.4
These tulips provided a nice subject for a studio still life. In order to expose the flowers correctly and get the look I wanted, I used manual mode.

BULB PHOTOGRAPHY

If you want to work with long shutter speeds that don't quite fit into one of the selectable shutter speeds, you can choose Bulb. This setting is only available in Manual mode, and its sole purpose is to open the shutter at your command and then close it again when you decide to. I can think of several scenarios where this would come in handy: shooting fireworks, shooting lightning, capturing the movement of the stars at night, and any other very long exposure.

If you are photographing fireworks, you could certainly use one of the longer shutter speeds available in Shutter Priority mode, since they are available for exposure times up to 30 seconds. That is fine, but sometimes you don't need 30 seconds' worth of exposure and sometimes you need more.

If you open the shutter and then see a great burst of fireworks, you might decide that that is all you want for that particular frame, so you click the button to end the exposure. Set the camera to 30 seconds and you might get too many bursts, but if you shorten it to 10 seconds you might not get the one you want (**Figure 11.5**).

FIGURE 11.5
It took me several attempts to get this exposure right, but using my Bulb setting allowed me to capture the image I had in mind.

ISO 100
30 sec.
f/9
70mm lens

To select the Bulb setting, simply place your camera in Manual mode, press the shutter release halfway to activate metering, and then rotate the Command dial to the left until the shutter speed displays Bulb on the control panel.

When you're using the Bulb setting, the shutter will only stay open while you are holding down the shutter button. You should also be using a sturdy tripod or shooting surface to eliminate any self-induced vibration while using the Bulb setting. Pressing the shutter button down opens the shutter, and releasing it closes the shutter.

I want to point out that using your finger on the shutter button for a bulb exposure will definitely increase the chances of getting some camera shake in your images. To get the most benefit from Bulb, I suggest using a remote cord such as the Nikon MC-DC2 Remote Switch or the Nikon ML-L3 Wireless Remote. For more information on using bulb exposures with the different Nikon remotes, see pages 73 to 74 in the manual. You'll also want to turn on Long Exposure Noise Reduction (aka Long Exp. NR), as covered in Chapter 7.

AVOIDING LENS FLARE

Lens flare is one of the problems you will encounter when shooting in bright sunlight. Lens flare will show itself as bright circles on the image (**Figure 11.6**). Often you will see multiple circles in a line leading from a very bright light source such as the sun. The flare is a result of the sun bouncing off the multiple pieces of optical glass in the lens and then being reflected back onto the sensor. You can avoid the problem using one of these methods:

- Try to shoot with the sun coming from over your shoulder, not in front of you or in your scene.

- Use a lens shade to block the unwanted light from striking the lens. You don't have to have the sun in your viewfinder for lens flare to be an issue. All the sunlight has to do is strike the front glass of the lens to make flare happen.

- If you don't have a lens shade (hood), try using your hand or some other element to block the light.

FIGURE 11.6
I shoot a lot of images with sunbursts, and one of the problems I deal with is flare spots. The spots are visible as small circles of light coming down from the sun. While some like this look on occasion, you will want to know how to shoot in the sun without it as well.

ISO 400
1/400 sec.
f/14
15mm lens

BRACKETING EXPOSURES

So what if you are doing everything right in terms of metering and mode selection, yet your images still sometimes come out too light or too dark? There is a technique called bracketing that will help you find the best exposure value for your scene by taking a normal exposure as well as one that is over- and underexposed. Having these differing exposure values will most often present you with one frame that just looks better than the others. If I am in a tricky situation when I have to get the exposure right, such as an outdoor wedding, then I'll use bracketing. I'll start by spacing my exposures apart by one to two stops and taking three images: one normal exposure, one underexposure, and one overexposure. This is exactly the same technique we use in Chapter 7 for HDR (**Figure 11.7**).

FIGURE 11.7
The control panel shows you just how much bracketing is being applied on an over/under scale in the upper right corner of the screen. The number and letter to the left tells you how many frames you're shooting; here, it's three frames, shown as 3F.

As you are viewing the control panel and holding the exposure button, you can decide how much variation you want between bracketed exposures. You can choose from one-third of a stop all the way to two full stops of exposure difference between each bracketed exposure. If I am in a particularly difficult setting, I will typically bracket in two-stop increments to help zero in on that perfect exposure, and then just delete the ones that didn't make the grade (**Figures 11.8–11.10**). Remember, your lighting will dictate how many stops you want between exposures.

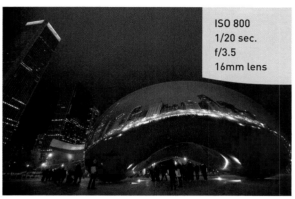

ISO 800
1/20 sec.
f/3.5
16mm lens

FIGURE 11.8
Two stops of exposure below normal, creating a much darker image.

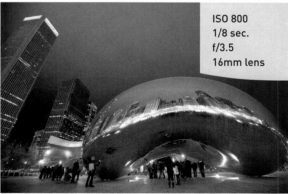

ISO 800
1/8 sec.
f/3.5
16mm lens

FIGURE 11.9
Normal exposure, as indicated by the camera meter.

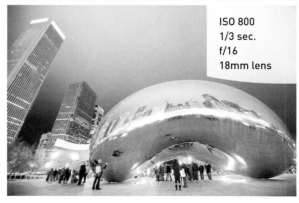

ISO 800
1/3 sec.
f/16
18mm lens

FIGURE 11.10
Two stops of exposure above normal, creating a much lighter image.

SETTING AUTO-EXPOSURE BRACKETING

1. You can quickly set your bracketing by holding the BKT button (on the front of your camera directly below the flash button) while rotating the Command dial to 3F (three exposures).

2. Next, continue holding your BKT button down while rotating your Sub-command dial to the 2.0 setting (two stops between each exposure). For more information on bracketing, please review pages 109–110 of your manual.

3. If you are in Single Frame shooting mode, you will have to press the shutter three times, one for each exposure. If you are in continuous shooting mode, you will press and hold the shutter button and the camera will take all three exposures with one press of the button.

When I am out shooting in the RAW file format, I typically shoot with my camera set to an exposure compensation of –1/3 stop to protect my highlights. If I am dealing with a subject that has a lot of different tonal ranges from bright to dark, I will often bracket by one stop over and under my already compensated exposure. That means I will have exposures of –1 1/3, –1/3, and +2/3.

Another thing to remember is that auto exposure bracketing will use the current mode for making exposure changes. This means that if you are in Aperture Priority mode, the camera will make adjustments to your shutter speed. Likewise, if you are in Shutter Priority, the changes will be made to your aperture value. This is important to keep in mind since it could affect certain aspects of your image such as depth of field or camera shake. You also need to know that AE bracketing will remain in effect until you set it back to zero, even if you turn the camera off and then on again.

MACRO PHOTOGRAPHY

Put simply, macro photography is close-up photography. Depending on the lens or lenses that you got with your camera, you may have the perfect tool for macro work. Some lenses are designed to shoot in a macro mode, but you don't have to feel left out if you don't have one of those. Check the spec sheet that came with your lens to see what its minimum focusing distance is.

If you have a zoom, you should work with the lens at its longest focal length. Also, work with a tripod because handholding will make focusing difficult. The easiest way

to make sure that your focus is precisely where you want it to be is to use manual focus mode.

Since I am recommending a tripod for your macro work, I will also recommend using A (Aperture Priority) mode so that you can achieve differing levels of depth of field. Long lenses at close range can make for very shallow depth of field, so you will need to work with apertures that are probably much smaller than you would normally use. If you are shooting outside, try shading the subject from direct sunlight by using some sort of diffusion material, such as a white sheet or a diffusion panel. By diffusing the light, you will see much greater detail because you will have a lower contrast ratio (softer shadows), and detail is often what macro photography is all about (**Figure 11.11**).

ISO 100
1/80 sec.
f/18
80mm lens

FIGURE 11.11
A good macro shot is all about details. I want you to meet my very own lady slipper orchid, which I've been nursing along for more than two years since her last bloom. Using a low ISO and high f-stop allowed me to capture the great details of the bloom.

ACTIVE D-LIGHTING

Your camera provides a function that can automatically make your pictures look better: Active D-Lighting. It works this way: The camera evaluates the tones in your image and then underexposes for the highlight areas while lightening any areas that it believes are too dark or lacking in contrast (**Figures 11.12** and **11.13**). Active D-Lighting is automatically applied to images that are shot in any of the automatic scene modes except for High Key, Low Key, and Silhouette.

FIGURE 11.12
Without Active D-Lighting, the shadows are very dark and lack contrast.

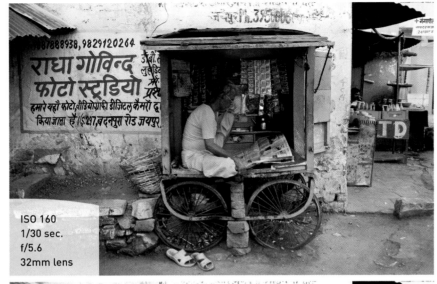

ISO 160
1/30 sec.
f/5.6
32mm lens

FIGURE 11.13
With D-Lighting set to Normal you will see shadows become lighter. Notice how we can see more detail in the vendor's face and within the booth.

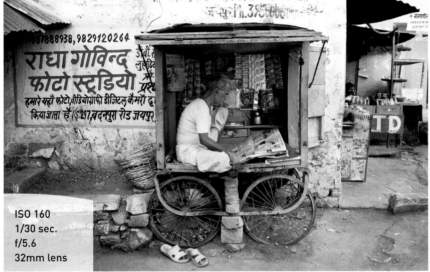

ISO 160
1/30 sec.
f/5.6
32mm lens

You can choose from six levels: Off, Low (L), Normal (N), High (H), Extra High (H*), and Auto (A). You will need to evaluate the strength of the effect on your images and change it accordingly. I typically leave it set to Normal so that I have brighter, more detailed shadow areas in my photographs while still maintaining good exposure in my skies. You should know that Active D-Lighting can only be adjusted when using one of the professional modes. Also, you will want to turn it off if you are using flash exposure compensation since it will work against you when you alter the flash strength.

1. Press the Info button twice to activate the cursor in the information screen, then navigate to the Active D-Lighting setting by using the Multi-selector (**A**).

2. Press the OK button and then move the Multi-selector up or down to select the level of Active D-Lighting that you desire (**B**).

3. Press the OK button to lock in your changes and resume shooting.

A

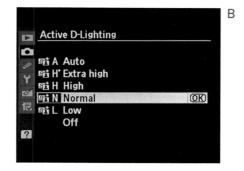

B

The Active D-Lighting setting can also be changed in the Shooting menu.

CONCLUSION

As my mother used to say, "You'll never be content doing something you don't enjoy." You may have noticed I quote my mom a lot—she was a wise lady! Photography has always been an enjoyable outlet for me. My photographic journey has been filled with its share of mistakes. The learning curve can be steep, so don't beat yourself up as you're learning a new camera. It all takes time, and you're taking the right steps by doing research like reading this book to guide you along in your journey.

We've covered a lot of ground over these last few chapters, and not everything is going to sink in overnight. After all, it took me 20 years to learn it! Take a breather, do the practice assignments at the end of the chapters, reflect upon your progress, and most importantly remember what Mom said: "Enjoy."

The reality is, mastering a skill takes time. I have over 75,000 images to my name. Steve McCurry has over 1,000,0000. The bottom line is, the more you shoot, the better you'll be at your craft. Who knows, maybe one day your hobby will become your full-time job, or maybe you'll even be the next Henri Cartier-Bresson. The main thing to remember is all photographers start at the same point, but one thing all the greats have in common is they know their equipment inside and out. I hope you enjoy your new D7000 and I can't wait to see your photographic journey on our Flickr group.

Chapter 11 Assignments

Many of the techniques covered in this chapter are specific to shooting situations that may not come about very often. That doesn't mean you shouldn't learn them. It is even more reason to practice them so that when the situation does present itself you will be ready.

Adding some drama to the end of the day

Most sunset photos don't reflect what the photographer saw because he or she didn't meter correctly for them. The next time you see a colorful sunset, pull out your camera and take a meter reading from the sky, then one without, and see what a difference it makes.

Making your exposure spot on

Using the Spot Metering mode can give accurate results, but only when pointed at something that has a middle tone. Try adding something gray to the scene and taking a reading off it. Now switch back to your regular meter mode and see if the exposure isn't slightly different.

Using the Bulb setting to capture the moment

This is definitely one of those settings that you won't use often, but it's pretty handy when you need it. If you have the opportunity to shoot a fireworks display or a distant storm, try setting the camera to Bulb and then play with some long exposures to capture just the moments that you want.

Bracketing your way to better exposures

Why settle for just one variation of an image when you can bracket to get the best exposure choice? Set your camera up for a 1/3-bracket series and then expand it to a one-stop series. Review the results to see if the normal setting was the best—or maybe one of the bracketed exposures was even better.

Moving in for a close-up

Macro photography is best practiced on stationary subjects, which is why I like flowers. If you have a zoom lens, check the minimum focusing distance and then try to get right to that spot to squeeze the most from your subject. Try using a diffuse light source as well to minimize shadows.

Share your results with the book's Flickr group!

Join the group here: flickr.com/groups/nikond7000_fromsnapshotstogreatshots

INDEX

B

backgrounds
 blurring, 114–115, 138, 139
 isolating subjects from, 114–115
 portrait, 138, 139, 157
Beach/Snow scene mode, 65
BKT button, 192, 264
black-and-white images
 landscape photos as, 177
 portraits as, 146–147
blinkies, 99–100, 175, 183
Blossom scene mode, 68, 69
blur
 background, 114–115, 138, 139
 motion, 47, 85, 86, 125–127, 131
bracketing exposures, 71, 192, 193, 262–264, 268
brightness, 16, 183
buffer, 124
Bulb setting, 260–261, 268

C

cable release, 210
Candlelight mode, 68, 69
catchlight, 151
Center-weighted metering mode, 141–142
Child mode, 64
children
 action portraits of, 151–152
 shooting at their level, 160
cleaning the sensor, 32–33, 49
clipping, 16–17
Close Up mode, 60–61, 72
close-up photography. See macro photography
Cloudy setting, 6, 171
color composition, 232–233, 234
color elements in images, 183
color temperatures, 5, 178
complementary colors, 234
composition, 223–239
 action photo, 128–130
 angles and, 230, 231
 annotated examples of, 224–227
 assignments on, 239

color and, 232–233, 234
contrast and, 234–235
creating depth through, 187
depth of field and, 228–229
framing and, 235–237, 238
landscape, 183–187
leading lines and, 235, 236
patterns and, 232
point of view and, 230, 231
portrait, 152–160
rule of thirds and, 185–187
continuous shooting modes, 122–124
contrast, 234–235
cool colors, 178

D

Data display mode, 15
Daylight setting, 6, 171
deleting images, 15
depth, creating, 187
depth of field
 action photography and, 114–115
 aperture settings and, 48, 89, 91
 composition and, 228–229
 landscape photography and, 179–181, 194
 macro photography and, 265
 portrait photography and, 138, 161
 telephoto lenses and, 42
 wide-angle lenses and, 40
display modes, 14–15
distance compression, 42
distortion, 39, 140, 154
drive modes, 122
dSLR cameras, 20, 38
dual image formats, 36–38
Dusk/Dawn scene mode, 65
dynamic range, 34

E

environmental portraits, 140
exposure, 43–47
 bracketing, 71, 192, 193, 262–264
 calculating, 45–47
 factors of, 44–45
 histograms and, 16–17
 long, 85, 87, 210–211, 260